Digital Wedding Photography FOR DUMMIES®

by Amber Murphy

WILEY

John Wiley & Sons, Inc.

Digital Wedding Photography For Dummies®

Published by
John Wiley & Sons, Inc.
111 River St.
Hoboken, NJ 07030-5774
www.wiley.com

Copyright © 2013 by John Wiley & Sons, Inc., Hoboken, New Jersey

Published simultaneously in Canada

For general information on our other products and services, please contact our Customer Care Department within the U.S. at 877-762-2974, outside the U.S. at 317-572-3993, or fax 317-572-4002.

For technical support, please visit www.wiley.com/techsupport.

Wiley publishes in a variety of print and electronic formats and by print-on-demand. Some material included with standard print versions of this book may not be included in e-books or in print-on-demand. If this book refers to media such as a CD or DVD that is not included in the version you purchased, you may download this material at http://booksupport.wiley.com. For more information about Wiley products, visit www.wiley.com.

Library of Congress Control Number: 2012956415

ISBN 978-0-470-63146-1 (pbk); ISBN 978-0-470-63158-4 (ebk); ISBN 978-0-470-88735-6 (ebk); ISBN 978-0-470-88736-3 (ebk)

Manufactured in the United States of America

10 9 8 7 6 5 4 3 2 1

WILEY

About the Author

Amber Murphy is a professional wedding and portrait photographer who is known for bringing a fresh and unique perspective to the art of photography. Her work moves past the traditional stiff posing and incorporates the distinct personalities of the people she photographs. Amber holds a bachelor of arts degree in communication and is a member of the Wedding Photography Association (WPPI) and Professional Photographers of America (PPA).

Amber currently lives with her family in Boise, Idaho.

Dedication

To Andrew, my best friend, soul mate, and husband. Thank you for all of your encouragement and support. I couldn't have gotten this book done without you!

Author's Acknowledgments

First I'd like to thank my acquisitions editor, Stacy Kennedy, for seeking me out and giving me the opportunity to write this book. I feel incredibly blessed to have been a part of this project! I'd also like to thank Georgette Beatty, my project editor, Caitie Copple, my copy editor, and Hillary Gordon, my technical reviewer, for all of their hard work.

I'd also like to thank all of the couples I've had the privilege of working with over the last few years. It was a joy to shoot each and every one of your weddings, and I appreciate you all more than words can say!

To Dr. Jack Simons, thank you for teaching me everything I know about writing.

Last, but certainly not least, to my family. Thank you all for sharing in my excitement with this project and for being willing photography subjects over the years so I could develop my skill. I love you!

Publisher's Acknowledgments

We're proud of this book; please send us your comments at `http://dummies.custhelp.com`. For other comments, please contact our Customer Care Department within the U.S. at 877-762-2974, outside the U.S. at 317-572-3993, or fax 317-572-4002.

Some of the people who helped bring this book to market include the following:

Acquisitions, Editorial, and Vertical Websites

Senior Project Editor: Georgette Beatty

Acquisitions Editor: Stacy Kennedy

Copy Editor: Caitlin Copple

Assistant Editor: David Lutton

Editorial Program Coordinator: Joe Niesen

Technical Editor: Hillary Gordon

Editorial Manager: Michelle Hacker

Editorial Assistant: Alexa Koschier

Cover Photo: Amber Murphy

Cartoons: Rich Tennant (`www.the5thwave.com`)

Composition Services

Senior Project Coordinator: Kristie Rees

Layout and Graphics: Joyce Haughey, Jennifer Henry

Proofreaders: Lauren Mandelbaum, Penny L. Stuart

Indexer: Christine Karpeles

Photographer: Amber Murphy

Special Help
Megan Knoll

Publishing and Editorial for Consumer Dummies

> **Kathleen Nebenhaus,** Vice President and Executive Publisher

> **David Palmer,** Associate Publisher

> **Kristin Ferguson-Wagstaffe,** Product Development Director

Publishing for Technology Dummies

> **Andy Cummings,** Vice President and Publisher

Composition Services

> **Debbie Stailey,** Director of Composition Services

Contents at a Glance

Table of Contents

Part III: Creating the Package for the Newlyweds: Editing and Album Design 165

Introduction

So there you are, at a sunset ceremony in the little chapel down by the creek, where you've always dreamed of photographing a wedding. The doors in the back open, and you raise your camera to start capturing what you're sure will be award-winning shots of the bride as she enters. At that moment, you realize you have forgotten batteries for your camera. It won't turn on, and to make matters worse, you aren't wearing pants. Everyone is looking at you! The granny in the front row is having a heart attack! And then you wake up in a cold sweat, terrified that someday you'll find yourself unprepared, ruining a couple's wedding day.

I've had variations of this dream before almost every wedding I've photographed. Shooting weddings is stressful. A lot is on the line, and people have high expectations. But that's no reason to panic!

Wedding photography, unlike other forms of portraiture, certainly comes with some added stresses, but none are insurmountable when you go into a wedding prepared. This book is designed to help with that. Because being prepared makes pretty much everything more enjoyable and more successful, I focus a lot of attention on helping get you ready to shoot a wedding. I also help you look ahead at potential situations you may experience so you can devise appropriate plans for reacting. I include instructions, directions, suggestions, and guidance aplenty. Enjoy!

About This Book

Digital Wedding Photography For Dummies gives you a comprehensive look at the skills needed to photograph and process a wedding, from beginning to end. In this book, I break down all the details of shooting weddings and some of the key points of photography in general, in simple and easy-to-understand terms. My goal is to help you to be prepared for the next (or first) wedding you plan to shoot. Whether you're an amateur helping your friends save some money by taking their pictures for them or you're an established photographer looking for a different take on what you've already been doing, you'll find something useful in here. If you're considering photographing your first wedding, maybe you'll find a new passion. After my first wedding job, I was hooked!

This book follows a natural progression from beginner to advanced topics, starting with an overview of basic photography principles and followed by an in-depth look at what to take with you on a wedding day and how to get great results while shooting. I also explain what to do after the wedding and give you a few ideas of how to turn your passion into a business, if you so desire.

You don't have to read this book cover to cover (although I won't complain if you do!); simply find the details you need and put away the book until you need it again.

Writing *Digital Wedding Photography For Dummies* was especially satisfying because I was essentially able to write the book I wished were available when I first started out as a photographer. I hope it gets you going, literally and figuratively, on your way to shooting great weddings!

Conventions Used in This Book

Throughout this book, I use the following conventions to ensure that the text is consistent and easy to understand:

- ✔ The photos in the book are followed by information in small print that looks like this: *35mm, 1/150 sec., f/2.4, 200*. These terms describe the settings at which the camera was set when I took that picture. The first number is the focal length of the lens, the second is the shutter speed, the third is the aperture, and the fourth is the ISO. (Flip to Chapter 2 for details on these settings.)

- ✔ New terms in the book appear in *italics* and are followed by a simple definition.

- ✔ I use **bold** text to highlight key words in bulleted lists and the action steps in numbered lists.

- ✔ All web addresses in the book appear in `monofont`.

- ✔ When this book was printed, some web addresses may have needed to break across two lines of text. If that happened, rest assured that I haven't put in any extra characters (such as hyphens) to indicate the break. So when using one of these web addresses, just type in exactly what you see in this book, pretending as though the line break doesn't exist.

What You're Not to Read

What you read (and what you don't read) is really up to you! I absolutely love wedding photography and put as much useful information into this book as I possibly could, but I realize that some information may not be relevant to everyone. So feel free to skip anything that you already know or that you don't find helpful. You can also pass over the shaded boxes known as *sidebars,* which usually contain technical information about a particular topic in a chapter. (The same goes for any text marked with the Technical Stuff icon.)

Foolish Assumptions

I assumed a few things about you as I wrote this book:

✔ You love weddings and want to start photographing them.

✔ You may want to go into the wedding photography business full-time.

✔ You either already own, or are looking to purchase, a digital SLR camera.

✔ Your knowledge of photography is anywhere between complete beginner and advanced.

✔ You want to learn the ins and outs of wedding photography and how to do the job well.

If any or all of those descriptions apply to you, you'll find the information you need in this book.

How This Book Is Organized

In order to make the information in this book easy to understand, I broke the content down into five parts. You may notice that the information follows a natural progression from basic information to principles to follow while shooting a wedding to the editing process after the big day. However, you should always feel free to dive into any part, chapter, or section that is useful to you, no matter what order it's in!

Part 1: Getting the Big Picture: Becoming a Wedding Photographer

This part is where I go over the information that lays the groundwork for the rest of the book. I cover what to look for when purchasing your photography equipment and tips on how to use it along with an overview of specific techniques you need in order to capture a wedding effectively, including those related to lighting and composition.

Part II: Lights, Camera, Action: Capturing the Wedding Day

This part is the place where I get down to the nuts and bolts of shooting a wedding. I include a detailed checklist of things to do before the day arrives,

and then you find out all about capturing the wedding day itself. I give you a lot of example pictures and outline how you can achieve similar results. If you like lists, Chapter 9 gives you a detailed shot list so that you can be sure to photograph all the important moments of the day.

Part III: Creating the Package for the Newlyweds: Editing and Album Design

In this part I cover what to do after the wedding is over. I take you through downloading and backing up all your images, editing them, and delivering them to your clients (a couple of ways), and I discuss a few things to consider as you design the wedding album.

Part IV: Building Your Portfolio and Business

Here you find a few chapters devoted to making wedding photography into a business. I go over how to put together a portfolio and ways to get your portfolio seen by prospective clients. I also outline all the nitty-gritty details of starting a wedding photography business, from establishing a business identity to getting your work published.

Part V: The Part of Tens

In true *For Dummies* fashion, this part of the book is where I share useful information that is broken down into concise ten-item lists. Here you discover ways to avoid common mistakes and how to work with a second shooter.

Icons Used in This Book

You'll probably notice the following little icons scattered throughout the text. Their job is to point you to ideas and information that I think are important.

This icon points to key information that you want to make sure you don't forget.

Every once in a while, I include information that's interesting but not a necessity. Feel free to skip this info if you don't want to get into too much photography jargon.

This icon highlights information that can save you money, time, or frustration. It may also point out creative ways of getting certain shots or handling specific situations you encounter on a wedding day.

This icon is like a little red flag that alerts you to situations that can damage your gear, your photos, or even yourself.

Where to Go from Here

Where you go from here really depends on what information you want first. If you already have a camera and basic knowledge of how it works and want to jump right in to shooting a wedding, you can start with Chapter 7. If you want more information on building your portfolio, check out Chapter 14. And if you want a solid grasp on wedding photography from beginning to end, start with Chapter 1 and read on through!

Part I
Getting the Big Picture: Becoming a Wedding Photographer

The 5th Wave By Rich Tennant

"I think I'd be a very good wedding photographer. I have people skills, I love photography, and I've got the equipment — an iPhone 4, a Nokia E71, a Sony Ericcson, a Samsung Solstice a887..."

In this part . . .

*B*efore you can dive in and start shooting pictures of gorgeous brides, dashing grooms, and everything a wedding day entails, a few foundations need to be laid first. In this part I cover it all. I give you an overview of what the wedding photographer's "toolbelt" looks like, from camera equipment to editing software. I also cover some basic photography concepts, such as lighting and composition, and teach you how to apply them to any given wedding day.

1

The Wide-Angle View of Wedding Photography

In This Chapter

▶ Understanding what wedding photographers do

▶ Discovering the skills necessary for navigating a wedding

*W*edding photography has become increasingly popular in the last decade, and it's no surprise given that the advances in digital technology have made capturing a wedding and sharing the photos easier than ever. The explosion of social media allows a couple to share the details of their special day with anyone they choose, anywhere in the world. The growth and change in the wedding industry are exciting things to be a part of.

Although wedding photos have become more accessible to the public than they were when just the couple's relatives and close friends might get to flip through a wedding album, capturing the images of a couple is still as personal as it was the first time a wedding was photographed. As a wedding photographer, you have the opportunity to be a part of each unique wedding and build relationships with many different couples. You get to witness the celebration of love and the joining of two lives while the couple is surrounded by family and friends. I can't imagine a better job!

In this chapter, I talk about what it takes to be a wedding photographer: from the ways you'll be involved before and after the wedding day and the types of pictures you need to be comfortable taking to having an artistic vision and honing your storytelling abilities. I also go over the responsibilities you take on for each wedding and the specific skills you should have, with and without your camera.

Grasping the Scope of the Wedding Photographer's Job

At first glance, being a wedding photographer may seem pretty easy. You buy a camera and show up for a wedding, take some pictures, and give them to the happy couple, right? Well . . . not exactly.

When I was asked to shoot my first wedding, I thought, "I've done families and portraits, so how hard can a wedding be?" Much harder than I anticipated, it turned out. Halfway through the wedding, I found myself wondering what I'd gotten myself into, and when the wedding was over I was completely overwhelmed by the editing process. Your job includes a lot of work that takes place before and after the wedding and requires a handle on photographing a variety of subjects. To spare you the mid-wedding freak-out and to help you get prepared, the following sections tackle the specifics of the wedding photographer's job.

Getting involved before the wedding day

Much of the work of a wedding photographer starts long before the wedding day. It begins with the initial client inquiry, which can be months to years in advance. Always have an up-to-date calendar of your bookings so you can let prospective clients know your availability immediately. After you let a client know that you're available to photograph the wedding, you can take a few steps to prepare for the big day, as you find out in the following sections.

Setting up a consultation

Having a consultation is a great way to get some face time with your clients. After I receive an inquiry from a prospective couple, I ask if we can meet up for lunch or coffee to go over the packages I offer. If your clients live in a different state, setting up a web meeting (on something like Skype or Face Time) also works well. Either way, the consultation offers you the opportunity to get to know your clients and show that you're genuinely interested in them, and it gives them the chance to ask you questions directly, without having to go back and forth through e-mail. It also allows you to fully explain each photography package you offer, the approximate turnaround time for giving them their photos, prints, and albums, and your pricing. (See Chapter 15 for details on establishing packages and prices.) Getting to know your prospective clients in a consultation can also help the couples you meet with feel more comfortable with you, which can lead to better pictures on the day of the wedding.

Because you're trying to sell yourself as the photographer, be sure to bring examples of your previous work. Show clients your work in formats that they're likely to want themselves, such as a tablet or laptop with a slideshow as well as a wedding album or prints.

During the consultation, you'll also want to go over the wedding contract (which is covered more fully in Chapter 15) and, after the contract is signed, collect the deposit to hold the wedding date. In addition, you should make sure to get the following information:

- ✔ Time of the wedding
- ✔ Location of the ceremony, reception, and where the bride is getting ready
- ✔ Whether or not the couple is doing a First Look (a private moment when the bride and the groom see each other before the ceremony; see Chapter 9)
- ✔ Full contact information for the couple
- ✔ Contact information for the wedding coordinator, if applicable

Let the couple know at this time that you need a list of people for the family pictures along with a schedule of the wedding day (which I cover in more detail in Chapter 8). And if you're going to photograph the couple's engagement pictures (see the next section), start communication about the time and place that works for both parties.

Shooting the engagement pictures

Engagement photos are like a trial run before the wedding day. Doing an engagement session gives you the opportunity to learn more about the couple and get a feel for how comfortable (or uncomfortable) they are in front of the camera (see Figure 1-1 for an example of an engagement photo). Similarly, the engagement session allows the couple to learn how you set up and pose portraits in a more relaxed environment. They also get the opportunity to communicate what kind of pictures they do and don't like.

24mm, 1/100 sec., f/4.5, 125

Figure 1-1: Shooting an engagement session helps to break the ice with your couple.

You can schedule the engagement session any time between the consultation date and the wedding day, depending on your clients' availability. Some couples like to use their engagement pictures as a "Save the Date" card or may want to include a photo with the invitations, so make sure to take that into consideration as you schedule the session. Engagement pictures usually take two to three hours, so schedule your session accordingly.

Finalizing the schedule

In the months leading up to the wedding, follow up with the couple to remind them that you need a list of who to include in family portraits and a schedule of the wedding day. Ask to be notified of any changes as soon as possible. I recommend requiring a final schedule at least two weeks prior to the wedding, just to make sure that you and the couple are on the same page. For more on creating a wedding schedule, check out Chapter 8.

Scoping out the wedding location and visualizing the big day

Always try to be familiar with the setting of the wedding beforehand, including the ceremony location, reception area, and extra locations for portraits, such as a nearby park. If you don't know what the venue looks like, try to visit around the time of day the wedding will take place so you can evaluate the lighting and find good locations to shoot the portraits. After you've scoped out the location of the wedding, use the knowledge you've gained to plan out and visualize how you can use certain elements in the area to arrange your photos. Doing your homework ahead of time helps you feel more comfortable on the wedding day, and you won't have to scramble to find spots with decent lighting.

For example, if you know that the couple's portraits are taking place around 2:00 p.m. when the sunlight is harsh, and you noticed a lovely gazebo that offers some shade, you can plan ahead to take some of the couple's portraits at the gazebo. Or if you observed a gorgeous spiral staircase, you can visualize how to pose the bride on the stairs for her bridal portraits. Being armed with a plan helps to ease the stress of the wedding day.

Figure 1-2 is a great example of possibilities that open up if you plan ahead. In this image you will see a couple posed on a piano. The bride and I communicated in the months leading up to the wedding and picked out several spots to take pictures after the wedding. They ended up being some of the most fun shots of the day!

If the wedding isn't taking place in your area, most venues have pictures up on their website. Consider browsing through the photos and showing up early on the actual wedding day to scout for picturesque spots.

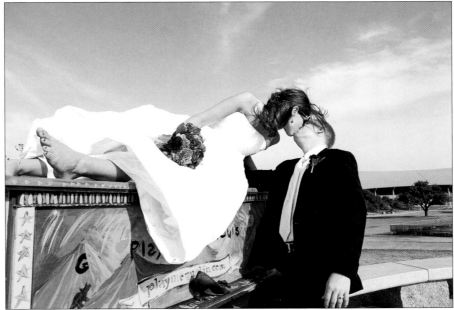

17mm, 1/800 sec., f/5.0, 125

Figure 1-2: Planning and visualizing ahead of time can lead to great photo opportunities.

Telling stories through pictures

When the wedding day arrives, your primary job is to be the storyteller. You get to narrate the couple's love story with each photo that you take, capturing each little moment to make it last forever. Most couples, when looking back on their wedding, recall very little of the details of the day and say that it was all such a blur. That's why your job is so important! Your photos help keep their story consistently tied to the present and immortalize the things that otherwise may have been missed or forgotten.

Because your clients rely on you to document their story, you have to be able to communicate a narrative well. The elements of a photographic narrative are the same as a book or movie, and identifying these key components will be helpful to you as you photograph the wedding:

- **The characters:** The star roles are, of course, given to the bride and groom. But don't forget the people in the supporting roles as well: the family, friends, officiant, guests, and so on. Be sure to capture the interactions between the bride and groom and the rest of the cast and include detailed photos that describe the relationship between them.

- **The plot:** In this case, the plot of the story is how the wedding day unfolds. The climax of the wedding story arc is at the ceremony when the couple says "I do" and officially starts a new life together.

So consider the points before the ceremony that build up the story's tension (like the bride putting on her dress and the groom anxiously waiting to see his bride) and catch those moments as they happen. The highest point of the story arc is the moment when the bride and groom are announced as Mr. and Mrs., and afterward the story moves toward the resolution. Look for those congratulatory hugs, toast, laughs, and smiles that depict the closing of the story.

✔ **The setting:** Wedding narratives tend to feature a couple of different settings, like the bride's house or hotel room where she gets ready, the ceremony location, and reception site. Make sure to grab a few photos that encompass the entire area at each location as well as a few detail shots of things that make the venues unique. You can also include some exterior shots of the venue that help to create a mood for your pictures. Photographing the sunset or snow falling outside of the church is always a nice addition to the overall story.

✔ **The theme:** Each wedding has two themes. The first is the overarching idea of love and the joining of two lives as one. The second is the theme that the couple has chosen for the event, such as a nautical theme, or a rustic-chic theme set in a barn. It can even be as simple as the color palette the couple chose. These ideas are usually a reflection of the bride and groom's personalities, so be sure to document these details that add to the overall story as well as focus on the theme of love.

✔ **The tone:** As you narrate the wedding, be aware of the tone, or mood, of what is taking place, and make sure your photos reflect the right emotion. For example, if you take a candid of the groom making his bride laugh, you probably don't want to edit your photo to be in black and white with stark contrasts and shadows, which would give the photo a more somber look. Instead, you want to give the picture a clean and bright look that reflects the happiness of the couple.

Flip to Chapter 7 for full details on shooting scenes to tell a wedding story, and check out the must-have moments to photograph in Chapter 9.

Taking a variety of photos

Not only do you need to be able to communicate a narrative well, but you must also know how to photograph a variety of subjects. The wedding photographer is a Jack (or Jane) of all trades. Here are the types of photography you should be familiar with:

✔ **Portrait photography:** A wedding photographer should know how to pose and frame individuals in a way that catches their expressions and presents them in a flattering light (see Figure 1-3). Chapter 8 contains a list of portraits to shoot at a wedding.

✔ **Candid photography:** Most of the pictures you'll take at a wedding are candids, where the subjects are not looking at the camera (check out

Figure 1-4). You must be able to quietly observe the people interacting in a scene without drawing attention to yourself. When people don't know you're snapping photos, you'll get the most genuine emotions from them.

✔ **Fashion photography:** Fashion photography is all about the clothes and accessories. At a wedding, you want to showcase the bride's dress and shoes as well as the groom in his tux and the bridal party all dressed to the nines. When photographing the clothing, imagine that you're a vendor trying to sell the item and be sure to look for aspects of the clothing that make it unique. The bride chose her dress and the bridesmaids' dresses for a reason, so pay attention to the details.

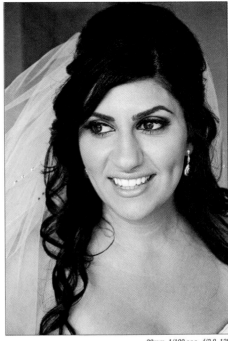

28mm, 1/100 sec., f/2.8, 125

Figure 1-3: A wedding photographer needs to be able to capture people effectively.

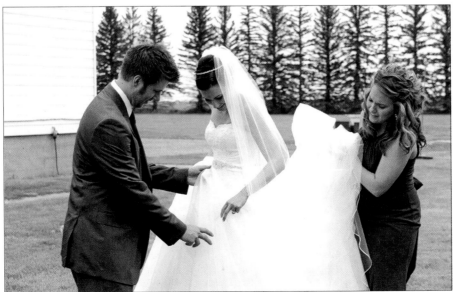

50mm, 1/200 sec., f/5.0, 100

Figure 1-4: A wedding photographer should be able to capture candids of the little moments that make up a wedding day.

✔ **Food photography:** Some weddings have a lot of food and beverages: hors d'oeuvres, a main course, signature drinks, champagne, and cake, to name a few. The meal is a detail you don't want to miss. But although taking pictures of food may seem pretty simple, in reality, making it look good in pictures can be tricky. Luckily, this type of photography is also one of the easiest to practice at home!

Because you are alive and reading this book, I'm assuming you eat on a regular basis, so whip out your camera and practice on your dinner. Keep in mind when photographing food that you want to use natural light whenever possible and to get up close and personal with the subject (Figure 1-5 is a good example). I suggest picking up a culinary magazine the next time you're checking out at the grocery store and observing the angles and details food photographers choose when arranging their photos.

31mm, 1/100 sec., f/3.2, 250

Figure 1-5: When photographing food at a wedding, use natural light if possible and use a tight shot to show detail.

✔ **Architectural photography:** As I mention in the previous section, you want to make sure you take some photos of the setting of the wedding. When you're getting the shots of the venue, keep in mind that when photographing building and structural details, you need to focus on lines and symmetry. If you have the option to use grid lines in your viewfinder, now would be the time to turn that on. The grid lines help you to keep your vertical and horizontal lines straight.

You can take the preceding types of photos in different styles, such as traditional and artistic; check out Chapter 5 for more information. Chapter 3 talks about lighting and composition techniques, and Chapter 4 provides guidance on capturing a wedding's excitement and emotions.

Processing your photos

Even when the wedding day has come and gone, your work is far from over. Now you must sort through all your photos and begin to process them in a streamlined manner. Here are the different tasks left to complete:

✔ **Downloading your photos and getting organized:** Before you can start editing, you need to transfer the photos from your memory card to your computer and organize them into folders so that you can find them easily.

✔ **Editing:** Even if your photos look good straight out of the camera, you can make some adjustments with photo-editing software to make your pictures fabulous. At the very least, you'll want to check exposure and white balance and boost the color and sharpness of your photos. (For more tips on editing photos, check out Chapters 11 and 13.)

✔ **Putting together the wedding package:** When the editing process is complete, you can move on and begin putting together the wedding package. This process is different for each photographer, depending on what you decide to include in your packages. For some photographers, it simply means burning the images to a DVD and sending them to the client (see Chapter 12). For others, it involves designing a wedding album (see Chapter 13) and ordering prints for the couple.

✔ **Posting photos online:** The Internet is the digital photographer's BFF (best friend forever). Showcase your work on a variety of social media websites to get your name out there and prompt people to talk about you and your business. (If you'd like to know more, Chapter 12 covers sharing photos online with your couple, and Chapter 16 covers social media outlets that a photographer can use.)

Knowing your other responsibilities

Though I cover the brunt of the wedding photographer's job in the preceding sections, you need to be able to handle a few miscellaneous responsibilities. In this list I go over the final tasks required:

✔ **The ability to work long hours:** A lot of people think that photographers get to pick their own hours. Although that's true to some extent (like editing photos and managing the business from your home or studio), your clients pick their wedding date and the hours they'll need you, and most of the time, it is a looooong day. I once worked a wedding where I arrived at 8:30 a.m. for the getting-ready photos and didn't leave until 11:30 p.m. when the reception was over! So be aware of the lengthy workday and prepare for the "wedding hangover" the following morning.

✔ **Prompt communication:** Whether you receive an initial inquiry from a prospective couple or an e-mail from a past couple about an album, your response time to the client should always be quick so that they know that you value them as clients and view their inquiries as important.

✔ **Staying organized:** As a wedding photographer, you have to manage your wedding contracts, booking calendar, gear, and wedding schedules as well as memory cards, lighting equipment, and more. Staying well organized is an absolute must. Though everyone has a different organizational style, find what works for you and stick with it.

✔ **Purchasing the proper attire:** There is no photography commandment that says, "Thou shalt wear black pants and a white shirt to a wedding." However, you are required to look respectable and professional. As you prepare for a wedding, make sure you have the right outfit. Dress in a way that reflects your personality: If you're a dress and boots kind of gal or a vest and slacks kind of guy, go for it! You can even coordinate your clothing choice to match the colors of the wedding. Just be sure that your choices aren't distracting. Also, as I mention earlier, the wedding day is a long one, so make sure that you have comfortable shoes.

Developing Skills You Need to Excel

You need a particular set of skills in order to do any job well, and wedding photography is certainly no exception. As you start out in the wedding photography business, I encourage you to evaluate your strengths and weaknesses in the skills I mention in the following sections. If you find that one of these skills is not a strength of yours at present, don't worry! All it takes is some practice. With some time and effort, you'll be well on your way.

Feeling passionate about photography

If you've ever had a deep longing to create something beautiful, you know what it means to have passion. The desire to shape and mold the world around you into a work of art is essential for the photographer. There's a difference between a photographer who works merely to get the job done and one who is driven by a creative vision, and that difference will be reflected in your photographs.

A passion for photography can be something that is part of your nature, or it can be something you develop. If you fall into the latter category (or are in a season of life when your passion has waned), here are a few ways you can develop your love of this art form:

✔ **Doing it anyway:** The more you pick up your camera and learn the intricacies of photography, the more likely you are to develop a passion for it.

✔ **Trying something new:** If you find yourself stuck in a rut, try photographing a subject that you haven't shot before, or pick up a vintage camera and try shooting in black and white. When you explore the depths of an art form and the many ways you can communicate a thought or feeling, your appreciation will grow.

✔ **Connecting with others who share your passion:** Being around others who understand you and the things you value always helps instill passion. Finding a community of other photographers (whether it be a local group of people or a group online) can give you a platform to discuss what you love and what you find difficult. (Chapter 14 has guidance on finding mentors.)

Helping people feel at ease

Wedding photographers are in the people business, so it only makes sense that good interpersonal skills are a necessity on the job. You don't have to be the most outgoing person in the world, but you do need to be able to make those around you feel comfortable (because if they feel uncomfortable around you, discomfort will show in your photos). Here are a few tips for making people around you feel at ease:

- ✔ **Have relaxed body language:** People read a lot about you from the way you hold yourself. If you want to show that you're friendly and open, don't assume postures such as standing with arms crossed or hands on hips.

- ✔ **Smile and make eye contact:** Having a real smile on your face while making eye contact can make people feel that you're genuinely interested in them.

- ✔ **Listen well:** Listen to what people say and how they say it. You can show that you're listening by asking the right questions and repeating parts of what they say back to them.

- ✔ **Be helpful:** Helping out can go a long way to making someone feel at ease around you. At a wedding, simple things like carrying the bride's bouquet if she needs to hold up her dress while walking or saying, "Sure, no problem" if the mother-in-law asks for a specific picture will make you seem more approachable.

- ✔ **Choose carefully what to (and what not to) say:** You've probably heard the saying, "If you don't have anything nice to say, don't say anything at all." If you're photographing your subjects and you take a moment to look at the image on the LCD panel, never say things like "Oops," "That doesn't look good," or "I don't like that picture." This can make your subjects feel like they did something wrong or that they don't look good. Instead, when appropriate, say things like "Wow, that looks great!" or "Beautiful!"

Getting comfortable with your camera, lenses, and more

I don't mean to point out the obvious here, but a wedding photographer has to know how to work a camera, lenses, and flash. You'll have no time on the wedding day to fumble with a manual. Lack of knowledge of your equipment can result in missing key photos. I go over the basics of exposure, specific camera settings, lenses, and flash in Chapter 2, and I explain how to prep your gear for a wedding in Chapter 6, but here is an outline of what you need to know:

✔ **Shutter speed, aperture, and ISO:** You need to know how these three components work together to create the desired look in a photo, along with how to change each setting quickly.

✔ **Camera settings:** Taking great pictures involves a lot more than just getting the exposure right. You need to know how to select the correct autofocus points, set white balance, and use different drive modes to capture the desired effect.

✔ **Lenses and flash:** During a wedding, you need to be able to decide which lens to use for different situations, be able to switch them quickly, and determine whether or not the use of a flash is necessary.

Sharpening your business acumen

Honing your skills with a camera is very important, but don't forget that a photography business is just that: a business. As you start out, you'll likely want to sharpen your business sense in order to book weddings and earn a profit. I cover the business side of wedding photography in more detail in Chapter 15, but here are a few things you should know:

✔ **Writing a business plan:** With any business, you need to establish your goals and outline how you plan to achieve them.

✔ **Getting a business license:** Decide which kind of business to set up and research your state's business laws.

✔ **Building a portfolio:** A tangible way to demonstrate your abilities is necessary in order to bring in more clients. Whether you work with another photographer or take pictures of your friends, put together a portfolio that shows what you're capable of. (Chapter 14 has the scoop on portfolios.)

✔ **Marketing:** After you establish your business, you need to be able to put your name out there so you can start building your client base. Decide what, if any, kind of advertising is best for your business and what kind of marketing materials (such as business cards, a website, or a blog) you want to use. See Chapter 16 for details.

✔ **Managing a business:** Many tasks are involved in running a successful business. You need to have the ability to book appointments, manage client e-mails and phone calls, do your bookkeeping, and much more.

2

Basic Photographic Equipment and Know-How

*Y*ou may not need a master's degree in photography or a boatload of experience to start a career in the wedding business, but a few things are absolute musts. In this chapter, I give an overview of the types of equipment you need to acquire, from the camera body and lenses down to memory cards and lighting gear. If you're a beginner in the field of photography (or if you just want to brush up on a few fundamental techniques), I also cover the basics of exposure and give you a breakdown of the camera settings you need to be familiar with. I also suggest ways you can practice before a wedding. (For full details on lighting and composition techniques, flip to Chapter 3.)

Stocking Up on Tools of the Trade

Choosing the right equipment can be a bit daunting. The different brands and multitude of camera models and lenses, all with tech specs, can leave you scratching your head and wondering where to start. Though I believe that doing your own research to find what works best for you is important, I can take out some of the guesswork by outlining features to look for in the gear that you choose.

As you look over the equipment list and do a price check online or at your local camera store, you'll probably notice that most of these pieces are worth a pretty penny. You may find yourself in the Catch-22 of needing the gear to

shoot the wedding but needing the wedding job to pay for the gear! I'd like you to keep this phrase in mind: "Those who can't buy, rent." Don't feel the need to spend your life savings on your photography tools. Instead, buy what you can afford and rent the rest. As you book weddings, set aside part of your earnings to pay for the rentals, and then set aside a separate portion in a savings account that will go toward purchasing new equipment. If you don't live near a store that rents photography equipment, you can check out an affordable online rental company such as www.lensrentals.com or www.borrow lenses.com.

Choosing your cameras

The first step in acquiring gear is choosing the right camera (or two). Because a wedding photographer should have two cameras on hand during a wedding day, consider working the purchase of two cameras into your budget. However, don't feel the need to buy two right off the bat. I recommend buying one camera to start off with and then purchasing another as your business grows.

Because this book is *Digital Wedding Photography For Dummies,* I don't talk about any cameras that use film; rather, I focus on DSLRs, which is photographer-speak for *digital single-lens reflex* cameras.

DSLRs use a mirror behind the lens that reflects the light to a five-sided prism, the *pentaprism,* and on through to the viewfinder. When you snap a picture, the mirror behind the lens flips up so that the light follows the path straight to the shutter. When the shutter opens, the light hits the digital sensor and an image is captured. The wonderful thing about DSLR cameras is that what your sensor captures is almost exactly what you see in the viewfinder. These cameras also have the ability to shoot in several modes (manual, program, aperture, shutter, auto), and they include an LCD panel on the back, a hot-shoe mount for an external flash, and the use of interchangeable lenses.

A few brands dominate the DSLR market, and each brand makes many models, so the following sections list things to keep in mind as you narrow down your options.

Sizing up the sensor

The *sensor* is what actually captures light from the scene before you and turns it into an electronic image. The size of your camera's sensor can have quite an impact on your photographs.

In the old days when film cameras were king, the standard frame size was 36mm x 24mm, otherwise known as a 35mm. When digital cameras arrived on the market, most of them were made with a sensor smaller than 35mm. These sensors became known as *crop sensors,* because if you put a lens made for a 35mm body on a camera with a smaller sensor, the sensor captures the middle of the image and basically crops out the rest of the photo (see Figure 2-1 for an example).

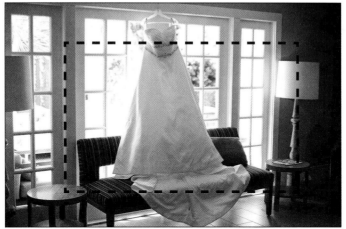

50mm, 1/250 sec., f/2.2, 400

Figure 2-1: A smaller sensor crops the field of view in your image.

People didn't like always having their photos cropped, so these days you can choose between *full-frame* and *crop-factor* sensors. The difference between a full-frame sensor and a crop-factor sensor is most apparent when you look at *focal length,* which is the distance from the surface of the lens to where the rays of light cross inside the lens (usually shown as a number on the lens, such as 50mm or 35mm). Because the crop sensor is capturing only the middle of what you see in your lens, the final image has a "zoomed in" look. To see an example, look at Figure 2-2. Both pictures were taken from the same spot with a 50mm lens, but the end result is quite different. Figure 2-2a was taken with a full-frame sensor, while Figure 2-2b was taken with a cropped sensor.

a b

50mm, 1/50 sec, f/2.8, 400

Figure 2-2: A crop sensor has a "zoomed in" effect when compared to a full-frame sensor.

The size of your sensor also affects the quality of your images. If you use a crop sensor, you capture a smaller scene, so the pixels (the pieces of information that make up the picture; see the later section "Counting up the megapixels") are small so that they can all fit into the image. But if you use a full-frame sensor, which

captures a larger scene, you get the same number of pixels, only they have to be bigger in order to cover the whole sensor image. The bigger pixels allow the camera to capture more light, which results in images that have less noise (little specks all over your image), higher ISO capabilities, and better tonal range, which gives you a full range of black to white values. (Not sure what I mean by ISO capabilities? Keep reading.)

Because a larger sensor size results in higher quality images and more versatility in ability to capture light, I recommend that wedding photographers use a full-frame camera rather than a crop-sensor camera.

Evaluating ISO capabilities

ISO stands for *International Standards Organization,* and it refers to a standardized method of measuring sensitivity to light on film or digital sensor. The lower numbers, like 100, mean less sensitivity, whereas the higher numbers, like 6400, mean greater sensitivity to light.

So how does this apply to you, wedding photographer? Suppose you are shooting a ceremony in a dark church, and flash isn't allowed. You've already set your aperture and shutter speed as low as you can, but the image would still be underexposed. (I talk about aperture and shutter speed later in this chapter.) Here's where ISO comes in. You can bump up your ISO to make your sensor more sensitive to the available light, thus creating the proper exposure. But here's the downside: The higher you push your ISO, the more noise (also called *grain*) your image has.

Using a camera with excellent ISO and low-light capabilities is so important, because during the course of a wedding, you'll encounter many situations that aren't ideally lit. Having a camera with a large ISO range that retains clarity in the image even at a higher ISO is a definite must. (See the later section "Using ISO" for more information.)

As you look for a camera, the ISO range is always mentioned in the camera specifications. The lowest ISO usually starts at 100, but the higher range is what matters most. Look for cameras with ISO capabilities that go up to at least 6400 or more.

Looking at autofocus

Although autofocus is a standard feature among most DSLR cameras, you're going to want to do some research to figure out which camera body has the best autofocus system. A wedding day is fast paced and includes a lot of different situations you want to capture. The last thing you want is to look over your photos after the wedding and find that the kiss at the altar is blurry because the camera didn't focus quickly!

As you read reviews for different cameras (and you should!), note the cameras that users say focus well in dim lighting. A camera that takes a long time "hunting" for focus could result in a missed moment.

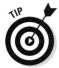

Also find out how many autofocus points the camera has. Having many autofocus points spread across the entire viewfinder instead of just nine points in the middle allows you to select more areas within the frame to focus on (check out Figure 2-3). This function allows for more creativity in choosing subjects in different parts of the frame to focus on and allows for better tracking if your subject is on the move.

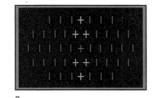 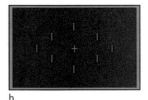

Illustration by Wiley, Composition Services Graphics

Figure 2-3: You have more areas to focus on with 45 autofocus points (left) than with 9 autofocus points (right).

Counting up the megapixels

Megapixels are commonly misunderstood. Just because a camera has a lot of megapixels doesn't necessarily mean that the camera gives you high-quality images. However, the number of megapixels is still important when taken into consideration along with the points listed in the preceding sections.

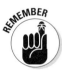

Megapixels have an impact on your ability to crop and enlarge photos for print. A *pixel* (also known as a picture element) is basically a tiny dot of information, and a megapixel is made of up a million of these pixels. If you have a camera with 5 megapixels, you get images with enough information to print a high-quality picture up to 5 x 7 inches. But if you decide you want to blow up that picture to 16 x 20 inches, the photo will look *pixelated,* or blocky (see Figure 2-4). If you take a photo with a 15-megapixel camera, your image contains more information and you can print that 16-x-20 photo at high quality.

Figure 2-4: Enlarging a photo with a limited number of megapixels can result in a pixelated print.

Handling the camera

How the camera handles is simply a matter of preference. Before you purchase a camera, consider heading to your local camera shop and asking to look at a few cameras from different companies. Note the weight of the camera and how it feels in your hands. Also, try changing the camera settings to see which camera's setup makes the most sense to you.

Gathering a selection of lenses

The key to sharp and accurate pictures lies not only with the camera body but also with the lenses you choose. Photography is all about capturing and bending light, and the lens helps make it happen. Though the price tag for quality lenses may seem a bit high, keep in mind that your lenses will most likely outlive your camera body, so they are truly worth the investment.

You need to consider two primary aspects of lenses: the f-stop and the focal length. The *f-stop* refers to how wide the aperture can open, and *focal length* refers to the amount of magnification of your subject or how wide your frame is. If you see a lens with the brand name followed by *50mm f/1.2,* it tells you that the focal length is 50mm and the widest aperture is an f-stop of 1.2. When buying a lens, you need to look at both factors and to decide which lenses will work best in different situations. (See the later section "Examining aperture" for more details.)

In this section I outline the types of lenses a wedding photographer should have. I also explain moments during the wedding day when each lens will be most useful (see Part II for details on taking these shots) and give you examples of each kind of lens.

- **Portrait lenses:** A portrait lens is almost always a *prime lens,* which means it has a fixed focal length (in other words, it has no zoom). These lenses are useful to the wedding photographer because they often have a very wide aperture, which is helpful in low-light conditions and can give you a very shallow depth of field. Prime lenses also tend to produce sharper images than zoom lenses, which is essential for portraiture.

 The only downside to a prime lens is that because the focal length is fixed and you can't zoom, you have to move around more to compose your shot. However, I believe it's a small price to pay for sharp photos at wide-open apertures.

 In wedding photography, you use portrait lenses for the bridal portraits, groom's portraits, and posed shots of the couple. These lenses can also be used to shoot details such as the wedding dress and shoes, the table settings at the reception, food and drinks, and other situations where lighting is very dim and a wider aperture is needed.

 Two examples of a portrait lens are 50mm f/1.2 and 85mm f/1.2.

✔ **Wide-angle lenses:** A wide-angle lens gives you (as you may have guessed) a shot with a wide angle of view, which allows you to capture more of the scene in your frame. These lenses are particularly helpful during the family photos and wedding party photos where you may need to fit a large group of people in the frame. They're also useful when you are shooting both outside and inside of venues, like the outside of a church and the inside of a reception ballroom. They can also be used for unique portraits or other creative uses.

Three examples of wide-angle lenses are 24mm f/1.4, 35mm f/1.4, and 14–24mm f/2.8 (an ultrawide zoom lens).

✔ **Macro lenses:**
Macro lenses are designed for photographing small details up close. They are also fixed-length, like the portrait lenses, which makes them incredibly sharp. Macro lenses are wonderful tools for taking pictures of wedding rings (see Figure 2-5) and other jewelry, bouquets, wedding programs, the cake topper, and

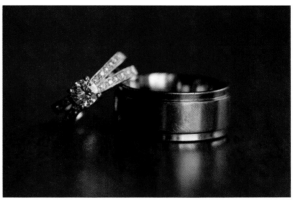

100mm, 1/80 sec., f/5.6, 320

Figure 2-5: A macro lens can focus clearly on small details like these wedding rings.

any other small details incorporated into the wedding. I encourage you to look for a macro lens that has image stabilization, IS (also known as vibration reduction, or VR).

An example of a macro lens is the 100mm f/2.8.

✔ **Telephoto zoom lenses:** A telephoto zoom lens allows you to capture up close and personal photos from a distance. This type of lens is crucial for capturing the ceremony and other segments of the wedding day when you want to give your subjects space. It also works well for candids because you can snap pictures of people without getting in their faces, thus letting you be a quiet observer. As with a macro lens, I encourage you to purchase a telephoto lens with image-stabilization technology.

A good example of a telephoto zoom lens is a 70–200mm f/2.8.

✔ **Standard zoom lenses:** A standard zoom lens allows you to go from a wide angle to a short telephoto range, all in one compact design. It can be very handy for a wedding day because you can capture so many different kinds of photos without having to change your lens.

A 24mm–70mm f/2.8 is a great example of a standard zoom lens.

As you look over lenses to purchase, remember that certain lenses are made for certain camera bodies. Though prime lenses fit on any DSLR of the same brand, some zoom lenses are made for crop-sensor or full-frame cameras only. For example, a crop-sensor camera made by Nikon (identified as *DX* by this particular brand) only takes certain zoom lenses. To figure out which lenses work on a DX Nikon, you look at the full name of the lens. If that particular zoom lens is made for crop-sensor cameras, *DX* is included in the full lens name, like this: Nikon 17–55mm f/2.8 ED-IF AF-S **DX** Nikkor Zoom Lens. Become familiar with how your particular brand of camera refers to its crop-sensor and full-frame cameras and choose lenses accordingly.

Investing in lighting equipment

After you choose your camera body and an arsenal of lenses, you're ready to start looking at lighting equipment. At a wedding, you'll encounter a variety of lighting situations — some perfect, some . . . not so perfect. When you're attempting to capture quality images, you don't want to be at the mercy of the condition of the light. Instead, you should have a few pieces of equipment that let you establish some control. Here I outline different types of gear available for wedding photographers, and I address a few techniques on how to create your own light later on in Chapter 3.

As you look over the following list, please don't feel like you need to run out and buy everything on it. Every photographer has a different method he or she prefers to shape and control light. Consider what pieces of equipment will work best for you and your shooting style.

- **External flash:** An external flash is the first piece of lighting gear I recommend purchasing. It's a separate piece of equipment, powered by batteries, that attaches to your camera via the hot shoe (the little U-shaped metal device located above your viewfinder). It has a rotating head and uses TTL *(through the lens)* technology to determine the intensity of the flash but can also be set manually. If you plan to use an on-camera external flash in conjunction with an off-camera flash (as discussed in the next bullet), you'll want to purchase two external flash units.

 As you shop around for a DSLR camera, you may notice that a few come with a built-in flash. However, the built-in flash doesn't have the power behind it that you need for wedding photography, so you'll always want to have the built-in flash turned off.

- **Off-camera external flash with light stand:** An adjustable light stand lets you set up an external flash somewhere besides the top of your camera. An external flash attaches to the top of the light stand the same way it attaches to a camera, and you control it with a flash trigger (see the following bullet). Having an off-camera flash can be very useful on a wedding day, especially during family photos (if they're taken inside a dark church) or the reception.

✔ **Flash trigger:** Along with the light stand, if you want to use an off-camera flash, you also need a wireless trigger to fire the flash from a distance.

✔ **Video light:** Many photographers also incorporate a video light into their rotation during a wedding day. It's a steady source of light that can be used along with available light as a fill to create a natural look. You can also use it to create a dramatic effect for the couple's portraits.

Looking at light modifiers

As you invest in lighting equipment (see the preceding section), you also want to consider purchasing a few light modifiers, which help to soften and shape the light. A flash both on and off the camera can have a very harsh effect on your subject if used directly. Wedding photographers utilize a variety of light modifiers to help the light fall evenly on the subject.

✔ **Flash diffuser:** A *flash diffuser* is an opaque device that you place over the head of your on-camera flash that helps to spread out the light and prevent it from being too concentrated.

✔ **Bounce card:** A bounce card, which is a white piece of plastic that you attach to your flash, can also be used in conjunction with your on-camera flash. When you have the flash angled upward, the card bounces the light toward the subject, which makes the light look more natural. Take a look at Figure 2-6 for an example of a bounce card with an external flash.

✔ **Umbrella/softbox:** To diffuse the light coming from your off-camera flash system, you can purchase an umbrella or softbox (which is a fabric box you place around the flash to spread out the light) and attach it to your light stand with the second flash.

Illustration by Wiley, Composition Services Graphics

Figure 2-6: A bounce card softens the light from your flash so it falls evenly on your subject.

✔ **Reflectors:** Reflectors are not used with flashes, but they're typically used outdoors to redirect sunlight toward your subject. To use a reflector, you'll probably need an assistant to hold the reflector and bounce the light toward your subject.

Identifying other items you may need

Though your camera, lenses, and lighting equipment are the most obvious pieces of equipment you need to shoot a wedding, you also need a whole slew of other items to complete your toolkit. Here are a few other pieces of gear you should consider.

✔ **Extra batteries:** The wedding day is often a long one, and the last thing you want is for your camera or flash batteries to die in the middle of the day! Be sure to have at least one extra battery for your camera (and possibly your charger, just in case) as well as a pack of AA batteries for your flash system.

✔ **Memory cards:** Your camera can only hold a few pictures on its own memory, so you need to purchase several memory cards to hold all your images. Be sure to buy the right kind of card for your camera; most DSLR cameras take either an SD (secure digital) or CF (compact flash) card.

How much memory you require depends on your camera and what file format you use (for more on file format see "Storing the photo information: File formats"). For example, a crop-sensor camera with 12 megapixels shooting in JPEG format will produce much smaller file sizes than a full-frame camera with 22 megapixels shooting in RAW. To calculate how much memory you need for your own camera, turn the gigabyte number (GB) into megabytes (MB) by multiplying by 1,000. Then divide that number by your camera's typical file size in the file format you use (you may need to refer to your camera manual for this number). For example, if your camera produces RAW files of about 32MB in size, a 32GB memory card will hold about 1,000 pictures ($32 \times 1,000 = 32,000 \div 32 = 1,000$). I shoot roughly 2,500 to 3,000 pictures during a full wedding day, so I need at least 112GB of memory!

✔ **Filters:** Most filters attach to the front of your lens. They can add effects to your photos, and they can also be a source of protection for the glass of your lens and keep it free from dust, water, and fingerprints. Following are the three filters most commonly used:

• The polarizing filter eliminates glare from nonmetal reflective objects or water and can also add saturation and contrast to your image.

• The UV filter protects your sensor from UV light but does little to change the image, which makes this a great filter to keep on your lens at all times to protect it from dust or fingerprints.

• The graduated neutral-density filter is gray on the top and clear on the bottom, which is useful for outdoor photos when you want the sky to be properly exposed.

- ✔ **Lens-cleaning kit:** Bring a lens-cleaning kit with you when shooting a wedding in the event that dust gets on your lens. These kits usually include a blower brush, cleaning fluid, lens tissue, a lens cloth, and cotton swabs.

- ✔ **Tripod:** The use of a tripod during the wedding day is a matter of preference among photographers. Because you're on the move for the majority of the day, you won't be able to use a tripod very much; however, it can be very useful during the family photos when slower shutter speeds may be needed.

- ✔ **Camera bags:**
 You absolutely need a good bag (or two) to tote around all your gear during a wedding (see Figure 2-7). I recommend keeping the bulk of your equipment in a large bag and carrying a smaller bag while shooting that holds your

Illustration by Wiley, Composition Services Graphics

Figure 2-7: Many kinds of camera bags are out there; find which one works just right for you.

lenses, memory cards, and other items you need on hand at all times. Popular brands of camera bags that come in all different styles include Lowepro, Tamrac, Think Tank, and Kelly Moore Bags.

Although you don't bring them to weddings, you also need a computer, editing software, a card reader, and an external hard drive to process and save the images after the wedding day. Check out Chapter 10 for details on these items.

Getting Yourself Up to Speed on Exposure and Camera Settings

After you've amassed your photography gear, the next step to getting yourself ready to shoot weddings is making sure you have the knowledge and skills needed to actually take good photos! In this section, I go over the basics of exposure and different camera settings you should know.

Exploring the basics of exposure

Exposure deals with the amount of light that is permitted to fall on your sensor. That light is regulated by three things in your camera: aperture, shutter speed, and ISO.

Examining aperture

Aperture refers to the size of the opening in your lens through which the light travels to the sensor. The larger the opening, the more light comes through. The smaller the opening, the less light that comes through. The sizes of the aperture are called f-stops and are expressed as f/number, such as f/1.2, f/2.8, f/4, f/16, f/22.

Here's where the numbers can get a little confusing: A larger f-stop number, like f/22, means a smaller aperture, whereas a small f-stop number, like f/1.2, is a very large aperture (check out Figure 2-8 for an illustration). Try to remember, *larger number = less light; smaller number = more light.*

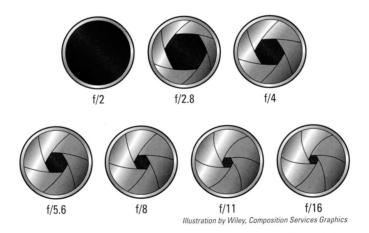

f/2 f/2.8 f/4

f/5.6 f/8 f/11 f/16

Illustration by Wiley, Composition Services Graphics

Figure 2-8: A larger f-stop number means a smaller opening, and vice versa.

In photography, the aperture controls your depth of field. *Depth of field* refers to how much of the foreground and background of your picture is acceptably sharp in relation to the subject on which you are focused. A larger depth of field, like f/22, has more of the foreground and background in focus. Meanwhile, a smaller depth of field, like f/2.8, has less of the foreground and background in focus. Figure 2-9 demonstrates how apertures can affect your image. A smaller aperture (like in Figure 2-9a) puts more of your picture in focus, and a larger aperture (like in Figure 2-9b) blurs out more of the foreground and background.

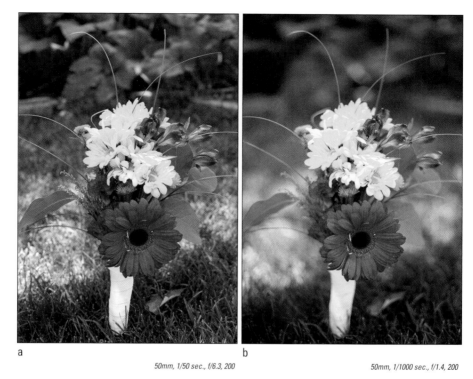

a b

50mm, 1/50 sec., f/6.3, 200 *50mm, 1/1000 sec., f/1.4, 200*

Figure 2-9: The size of the aperture affects how much of your photo is in focus.

Ask yourself two questions when determining your aperture: "How much light is available?" and "How much of the scene do I want in focus?" For example, say you're shooting the family portraits outdoors on a sunny day. Plenty of light is available to you, so you don't need to worry about having a wide open aperture to get the correct exposure. Then you determine that because you want all of the family in focus but want to soften the background, you should choose an aperture of around f/5.6. This aperture gives you enough depth of field to keep the faces of your subjects sharp while putting the background just slightly out of focus. However, if you were photographing just one subject in the same location but wanted to keep some of the background detail, you could also shoot at f/5.6.

For another example, say you're shooting a picture of the bride's bouquet. You place the bouquet by an open window and have plenty of light to shoot the picture. However, you want the background to be completely blurred out and to focus solely on the flowers of the bouquet. So you select an aperture of f/1.4. This aperture will let in a lot of light, so you'll need to increase the shutter speed (see the next section) to keep the photo from being overexposed.

Although having plenty of light to shoot your pictures is an ideal situation, it doesn't always happen at a wedding. So what do you do if you need a larger depth of field in a low-light situation? Keep in mind that aperture is only one aspect of exposure. For example, suppose you are shooting a family portrait indoors and need an aperture of f/5.6 to get everyone in focus. To compensate for the smaller aperture, you need to slow down your shutter speed or increase your ISO (see "Using ISO"), or do both, to properly expose your photograph.

Understanding shutter speed

Shutter speed refers to the amount of time a camera's shutter is open. The longer a shutter is open, the more light your sensor picks up, and vice versa.

A camera's shutter can open and close extremely fast. If you take a look at the top of your camera, you'll probably see the shutter speed expressed as a whole number, such as 100, 200, 250, 400, or maybe even 8,000. These shutter speeds are actually fractions, so a speed of 200 is a 200th of a second, or 1/200. Your shutter can also be open for longer periods of time, say 30 seconds (though slower speeds are more commonly used for landscape and night photography rather than wedding photography). Slower shutter speeds give you movement blur, like in Figure 2-10a, and faster shutter speeds allow you to freeze action, like in Figure 2-10b.

As a rule of thumb, if you're aiming for a sharp photo and you shoot at shutter speeds slower than 1/60, you need to use a tripod to prevent blur.

To determine your shutter speed, take these factors into consideration:

- ✔ **Movement:** First, determine whether your subject is moving and whether you want to show movement or freeze action. For example, if you're shooting a portrait, you'll want a sharp picture with no blur but may be able to shoot at a slower speed because your subject is stationary. However, if you're photographing a couple walking toward the camera, you have two options based on the effect you want in the photo. If you want to have some intentional blur to show movement, use a slower shutter speed. If you want to freeze the action, use a faster shutter speed.

- ✔ **Light:** The second factor to take into consideration is the amount of available light. If you're outdoors and the sun is bright, you need a faster shutter speed to have the correct exposure than you would if you were indoors in dim light.

a

b

Top: 50mm, 1/8 sec., f/2.0, 100
Bottom: 50mm, 1/320 sec., f/2.8, 100

Figure 2-10: With a moving subject, a slower shutter speed results in movement blur (top) and a faster shutter speed freezes the action (bottom).

Using ISO

Though I touch on ISO in the earlier section "Evaluating ISO capabilities," it's an important setting to take into account when determining exposure. ISO refers to your camera sensor's sensitivity to light. Lower ISO numbers, like 100, give you a crisp image, and higher ISO numbers, like 3200, give your photo "noise," thus reducing the clarity of the image, like in Figure 2-11.

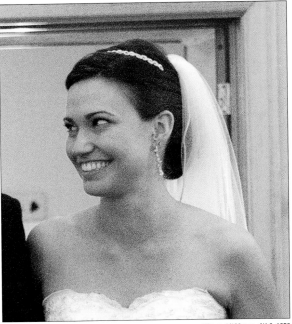

50mm, 1/100 sec., f/4.0, 1250

Figure 2-11: Using a high ISO can result in more "noise" in your final image.

When shooting in bright daylight, keep your ISO around 100. As you encounter lower-light situations, feel free to bump up the ISO as needed, but always keep the noise factor in mind.

Putting it all together

Aperture, shutter speed, and ISO affect exposure separately, and you need to know how they all come together when taking a picture. Let's say you're taking a portrait of the bride in her hotel room by an open window. Follow these steps to adjust your exposure settings:

1. **Always start the process by asking yourself: "How much light is available?"**

 The answer gives you a general idea of where to start with your aperture and shutter speed choices. Remember that aperture and shutter speed are like balances on a scale: If you increase one, you must decrease the other (and vice versa) to get the correct exposure.

2. **Continue by addressing your aperture: "How much of the scene do I want in focus?"**

 For example, if you only want the bride's face to be sharp, select a large aperture of f/2.

3. **Look at shutter speed: "Is my subject moving? If so, do I want to show that movement with blur or do I want my subject to be sharply in focus?"**

 In this case, the bride is standing still, but a decent amount of light is coming from the open window. To keep your photo properly exposed, you choose a shutter speed of 1/125. (If the bride were walking and you wanted to show movement, you could lower the shutter speed to, say, 1/30, but you would need to choose a smaller aperture to keep the photo from becoming overexposed. If you wanted her movement frozen, a shutter speed of 1/125 to 1/200 would suffice.)

4. **Consider ISO.**

 Because you're indoors, even with the slower shutter speed and open aperture you chose, your image would still be slightly underexposed. So bump up your ISO from 100 to 200, and now your exposure is perfect. Voilà!

Becoming familiar with camera settings

In addition to exposure (see the preceding section), a few other camera techniques are important to understand in order to take quality photographs. With the advance of digital technology, there are hundreds of different ways a photographer can set up his or her camera with different settings and preferences, but don't worry. In the following sections, I cover only a handful of settings that are the most important.

Making it clear: Autofocus

Having a good handle on how to focus on a subject is one of the most important things you can do. It can mean the difference between a sharp, clear photo and a missed opportunity. With DSLRs, you can focus manually or you can use autofocus. Because autofocus allows you to compose and snap a picture much faster than manual mode does, I suggest taking advantage of your autofocus system on wedding day.

Your camera has the following three autofocus modes to choose from (note that the terminology for different autofocus modes may not be the same across different brands of cameras, so I include an alternate term in parentheses):

✔ **Single shot (AF-Single):** This mode is used for stationary subjects. When you press the shutter halfway down, the camera locks its focus on the subject, and you can take the picture. This mode is great for portraits and for photographing still-life objects like jewelry, flowers, and table settings.

✔ **AI servo (AF-Continuous):** This mode is used primarily when shooting moving subjects. When you press the shutter halfway down, the camera focuses on your subject and then continues to focus on the subject as it moves until you snap the picture or release the shutter button. This mode works great for any action shots you want to take.

✔ **AI focus (AF-Automatic):** This mode is really smart: It's set to one shot, but if it senses that your subject is on the move, it switches to AI servo to focus correctly. It's a great feature to capture candids or moments like the ceremony, when your subjects will switch between moving and standing still.

After you determine your autofocus mode, you want to select your autofocus point. If you look through your viewfinder, you'll see a bunch of little empty squares. These squares are your autofocus points. When you press the shutter halfway down, the autofocus point that is currently selected flashes red. The default point is the one in the middle, but you can change it by following these steps:

1. **Look for and press the AF point selection button.**

2. **Look through your viewfinder to see your current selection lit up in red.**

3. **Spin the dial by your shutter-release button until the autofocus point you want is selected.**

4. **Press the shutter-release button halfway down to lock focus.**

5. **Press the button the rest of the way down to take the picture!**

You want to change your autofocus point based on where your main point of interest is in your photo. For example, if you decide that you want to compose your shot with your bride standing in the left side of your frame, you should move the autofocus point so that it rests on the bride's face, not on the empty space in the middle of your frame.

Casting just the right tint: White balance

White balance refers to the color of the light in your photo. Have you ever taken a picture in fluorescent light and noticed that the picture looks green? It's because each light source has a different "temperature" that makes your picture warm (yellow) or cool (blue or green). Figure 2-12 is a good example of how white balance can affect a photo. Figure 2-12a has a cool temperature, and Figure 2-12b is too warm. Figure 2-12c has the proper white balance.

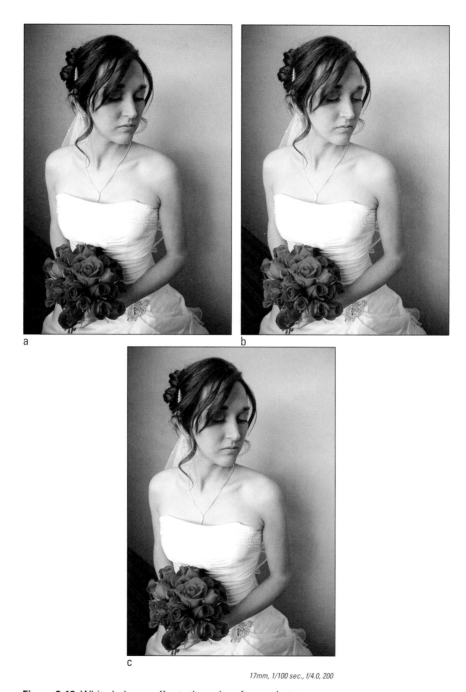

17mm, 1/100 sec., f/4.0, 200

Figure 2-12: White balance affects the color of your photos.

Your eyes are able to adjust for different colors of light, but the digital camera has a harder time adjusting on its own. The white-balance setting helps the camera to adjust the picture so that something that looks white to the human eye is also white in the photo. A DSLR usually has the following white-balance settings:

- **Auto:** The camera tries to read the light on its own and adjust each photo accordingly.

- **Sunny/Daylight:** Use in normal daylight conditions. This setting helps to cool down a photo.

- **Shade:** Shade tends to have a cooler (bluer) cast, so this setting warms up the photo.

- **Cloudy:** Light on a cloudy day also tends to be cooler, so the cloudy setting also warms up the light for you.

- **Tungsten:** This setting is helpful indoors when shooting under incandescent lighting. Tungsten light is too warm (yellow) for a photo, so this setting cools it down.

- **Fluorescent:** This setting is also used for indoor light. But unlike tungsten light, fluorescent bulbs are too cool, so this setting warms up the picture.

- **Flash:** Use this setting when your on-camera flash is on. Light from a flash is on the cool side, so this setting adds some warmth.

- **Manual:** If none of the preceding settings are capturing the light correctly, you also have the ability to set the white balance manually. You can do this by selecting Manual and then taking a test shot of a white piece of paper or a card. Your camera reads the light coming off of the white object and adjusts the white balance accordingly.

Snapping one picture or many: Drive mode

Another setting you'll want to be familiar with is your camera's Drive mode. The Drive mode determines how many pictures your camera takes and how fast. Here are the two most important Drive modes for a wedding photographer to be familiar with:

- **Single drive:** Single-drive mode is depicted on your control panel as one rectangle. In this mode, your camera takes one picture each time you press down the shutter button.

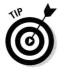

- **Continuous drive:** Continuous drive is depicted as a stack of rectangles. In this mode you can take several pictures in rapid succession by holding down the shutter release button. I personally keep my camera in this mode at all times. It is very helpful when attempting to capture expressions, real emotions, and unexpected moments, like in Figure 2-13.

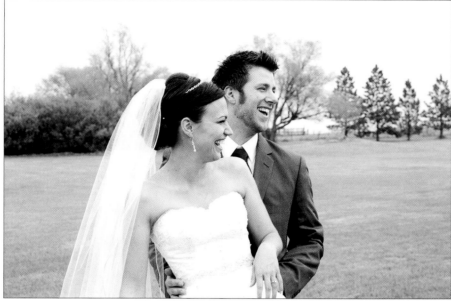

40mm, 1/320 sec., f/6.3, 100

Figure 2-13: Using the continuous drive mode allowed me to capture this image of the couple laughing between formal poses.

Taking reflected light into account: Metering

Metering describes how your camera reads reflected light and determines the correct exposure. Several metering modes are available in your camera, so here are the basics on which to use in different situations:

- ✔ **Matrix metering:** Matrix metering (also known as Evaluative metering) is when your camera measures the light from several points within the frame and combines all the information to find an average exposure. This mode is useful when your background and foreground have similar lighting.

- ✔ **Center-weighted metering:** This type of metering takes most of the light readings around the center of your frame. Center-weighted metering works really well for a portrait or still life with the subject in the center of the photograph.

- ✔ **Spot metering:** Spot metering (also known as Partial metering) takes its reading from a small point in the center of your frame. This type of metering works really well for backlit subjects, or when you want to have sharp contrast between the light and dark areas of your photo.

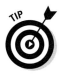

You can move your metering point to the area of your scene where you want to have the correct exposure and press the exposure lock button to seal in that exposure. Then you can recompose your shot.

Storing the photo information: File formats

When you snap a picture, your camera saves the information to your memory card. You can save your files a number of ways, but JPEG and RAW are the two most common.

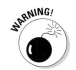

- ✔ **JPEG:** A JPEG is a compressed image file. If you have selected JPEG as your method of saving your photos, as you take each picture your camera processes and compresses the image before saving it to the card. The advantage of JPEGs is that the files are smaller and your memory card can hold a lot more of them.

 However, the downside to JPEGs is that in the compression process, some of the quality of the photo is lost, which gives less room to adjust the photos later during the editing process.

- ✔ **RAW:** A RAW file format is just what is sounds like: raw and unchanged. When you shoot in RAW, your camera does very little processing to the photo before saving it to the memory card. Because of the minimal processing, each RAW file contains a large amount of information.

 Think of RAW files as digital negatives: They need to be processed later. The benefit of RAW files is that you, not your camera, get to process the images later within your editing software. Also, because of the minimal processing, you have a lot more leeway for adjusting things like exposure and white balance while editing. So even if you happen to take a picture that's underexposed, if you shot it in RAW, chances are that your photo is still salvageable because the file has so much information to work with.

Although I absolutely love working with RAW file formats, when you choose your file format, keep two things in mind:

- • First, because RAW files contain a lot more information, they are also much larger files. Take that into consideration when choosing your memory cards because you'll need quite a bit of space to store your RAW files.

- • Second, unlike JPEGs, you can't print RAW files right away. Because they're like digital negatives, you'll have to process them and convert them to another format (such as JPEG or TIFF) before you can print. If you are unsure how to do that, no worries! Check out Chapter 11 where I cover that in more detail.

Growing Comfortable with Your Gear and Developing Your Skills

As you learn about the ins and outs of your camera and how to get the right kind of exposure in different situations, the next step is to actually apply the knowledge you've gathered and put it into practice. In this section I give you a few tips on ways to get out there and start shooting!

Practice, practice, practice

When you have armed yourself with the knowledge of exposure and camera settings (which I provide earlier in this chapter), it's time to put that knowledge into good use and master the skills of wedding photography. You've heard the saying, "Practice makes perfect," and although it may be cliché, it is certainly still true. Before you shoot your first wedding, you will want to know your camera well. You also want the ability to discern what settings and functions you need to get the best picture in every scenario, and that skill comes with practice. So go out and take some pictures. This is the fun part, after all. Here are a few ways you can practice:

- ✔ **Utilizing your family and friends:** Offer to take free pictures of your family and friends. It's a great way to ease yourself into photographing people because you won't have to worry about taking too much time to adjust your exposure and settings.

- ✔ **Shooting in a variety of lighting conditions:** On any given wedding day, you're going to encounter many situations all with different lighting. Practice shooting outside on sunny days and cloudy days and indoors with decent lighting and very low lighting.

- ✔ **Choosing white balance and metering modes:** A key to good wedding photography is learning to evaluate light and how to meter properly. Practice shooting in lighting with different "temperatures" (daylight, clouds, shade, tungsten, fluorescent) and learn to adjust your white balance accordingly, or set your own manually. Also, try selecting metering modes based on your available light. If you're shooting a portrait and the person is backlit, try using your center-weighted meter, or use your spot metering for a dramatic effect. Play around with the settings to learn exactly what effect each one has on a photo.

- ✔ **Photographing still life:** Practice shooting still-life subjects that you may encounter on a wedding day, such as shoes, clothes, food, beverages, paper goods, and flowers. Play around with apertures and selecting an autofocus point.

✔ **Capturing action:** Take pictures of moving subjects, such as people jumping and someone walking toward the camera. Experiment with different shutter speeds to capture the desired effect. Also, note which autofocus modes can consistently focus on the moving subject.

As you get out there and start taking photos, evaluate your strengths and weaknesses. Figure out the areas in which you feel most uncomfortable, and practice until they become second nature.

Apprenticing with a pro

The next step in getting yourself ready to shoot weddings is to shoot weddings! Practicing on your own feels completely different from the fast-paced feel of a wedding. But before you dive in head first, consider learning by example. One of the best ways to get experience and learn the ins and outs of weddings is to *second shoot* with a seasoned pro.

Wedding photographers are often looking for people to come along with them to a wedding to help out and to take additional pictures. This person is known as a *second shooter.* Use this to your advantage! Find established wedding photographers in your area and make yourself available. Even if you just start out by fluffing dresses and holding bouquets and only taking a few pictures here and there, you'll be able to learn a lot by watching the photographer work. Keep in mind that second shooter jobs are not always paid gigs. In this situation, the learning experience is priceless.

As you start second shooting for other photographers, pay special attention to how they navigate the wedding day: how they organize group photos, arrange the small details for still-life shots, and work around unexpected occurrences. Being in the midst of the hustle and bustle of a wedding as a second shooter is a great way to see what a typical day looks like and prepares you to get out there and start booking weddings on your own.

Attending photography workshops

Another great way to learn more about photography and ways to use your camera in different situations is to attend photography workshops. Workshops often include a question-and-answer time when you can ask an experienced pro questions and get some hands-on help. Some workshops even include a time for everyone to whip out their cameras and practice on a model couple, which can be beneficial for a beginner.

3

Understanding Lighting and Composition Techniques

In This Chapter

▶ Understanding the principles and use of lighting

▶ Composing your photos beautifully

Creating powerful images relies heavily on the mastery of lighting and compositional techniques. After I bought my first DLSR (digital single-lens reflex camera) and learned the basics of exposure, I wanted to get my feet wet and start practicing. So I picked a bright and sunny afternoon and took some pictures of a friend. Even though my pictures had the correct exposure, something didn't look quite right. She had shadows under her eyes, and the photo had a cluttered background that I hadn't noticed when I snapped the picture. I realized that in order to create images that were visually pleasing, I needed to learn how to manipulate light and to correctly compose a photograph.

The tricky part about lighting and composition is that there is no single right way of controlling light or framing a subject. Photographers use many different methods to achieve a desired effect. In this chapter I narrow down the aspects of lighting and composition that are most relevant to wedding photography and give you tips on how to use these techniques to create compelling photos.

Lighting: Making Every Hour Magic Hour

If your camera is the brain of photography, then light is the heart and soul. Lighting is one of the most important elements of photography, from setting the mood of a picture down to enabling the camera to operate. The quality of light in your photo determines whether the image lives or dies.

The tricky part about lighting is that there are very few situations during a wedding that provide you with that "magic hour" kind of light (also known as *golden hours,* which I talk about in "Using natural light") in which your subjects are illuminated by soft, even lighting. For the most part, it's up to you and your ingenuity to figure out how to shape the available light into something that will make your subjects look good.

In the following sections, I go over some basic lighting principles, outlining how to use available natural light and how to create your own light in unfavorable conditions. I also point out common situations with difficult lighting that you may face during a wedding and how to overcome those challenges.

Distinguishing hard light and soft light

Despite being surrounded by sunlight and artificial light every day, you probably rarely stop and think about how lighting from different sources affects the illumination of a subject. To turn mediocre pictures into great pictures, an understanding of the different types of light is necessary.

Light can be broken down into two categories: hard light and soft light.

- **Hard light:** Light from a source that's small in comparison to the subject casts harsh shadows and creates high contrast. The midday sun or direct flash produces this type of light, which is not flattering to the subject, especially when shooting portraits. In Figure 3-1 you can see an example of how harsh lighting affects a wedding party.

- **Soft light:** Light from a large indirect source gives your subject a smooth appearance. When light is reflected or dispersed, it wraps itself around the subject, producing fewer shadows and lower contrast. A cloudy day, a patch of shade, or a flash with an umbrella is an example of soft lighting, which is very flattering for all subjects, especially people.

 Figure 3-2 was taken at the same time of day as Figure 3-1, but we moved over into the shade. You can see in this photo how soft lighting can make a world of difference when photographing people.

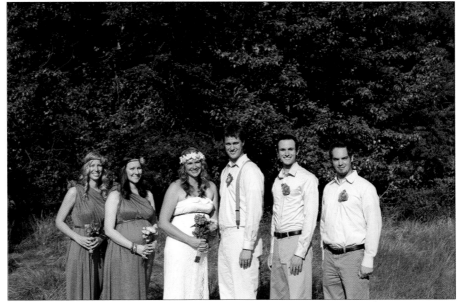

50mm, 1/640 sec., f/5.6, 100

Figure 3-1: Harsh lighting creates sharp edges and high contrast.

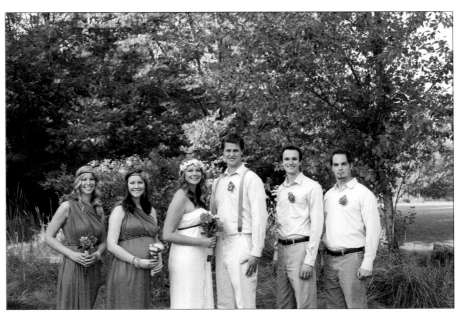

50mm, 1/125 sec., f/5.0, 100

Figure 3-2: Soft lighting evens out shadows and contrast and is very flattering to all subjects.

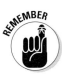

When evaluating hard and soft light, keep in mind that distance from the subject impacts how the light falls. The farther away the source, the harder the light becomes. For example, the sun is the largest source of light we have; however, because it is so far away the source is actually small to us, so the direct light from the sun creates harsh shadows. And if you place an off-camera flash with a softbox across the room from your subject, the light source is small in comparison to your subject, which results in harsh lighting. However, if you place your subject closer to the off-camera flash, the light source is now larger in comparison to the subject and provides soft, even lighting.

Using natural light

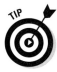

Knowing how to manipulate available light allows you to shoot anywhere at any time of day. Wedding photographers don't always have the luxury of scheduling their sessions during the *golden hours* of the day (one hour after sunrise and one hour before sunset), so if your couple wants to have their portraits taken outside at two o'clock in the afternoon, you'd best be ready.

Here are some different ways you can turn hard natural light (the kind you have on a bright sunny day) into soft light to create stunning photographs:

- **Find some shade and use it to your advantage.** Place your subjects inside the shade near the edge with the sun behind them so that the reflected light from the open sky in front of them (which acts as a giant diffuser) illuminates their faces. In Figure 3-3a, you can see how this wedding party was placed right at the edge of the shade, and Figure 3-3b shows how that placement provided soft, beautiful lighting.

- **Backlight your subjects.** This technique works well when the sun is lower in the sky, like in early morning or late afternoon. To use backlighting, place your subjects with their backs to the sun. You can use either direct sun or sunlight peeking through trees (like in Figure 3-4). Stand in front of the subjects with your camera facing the sun and meter off of your subjects to lock in the correct exposure (see Chapter 2 for more about metering).

This technique often produces lens flare or haze in your photo. Many photographers use this effect creatively, but if you don't want flare or haze, try using a lens hood to prevent too much sunlight from entering your camera.

a

b

50mm, 1/250 sec, f/5.0, 100

Figure 3-3: If you photograph in bright sunlight, place your subjects right at the edge of a patch of shade.

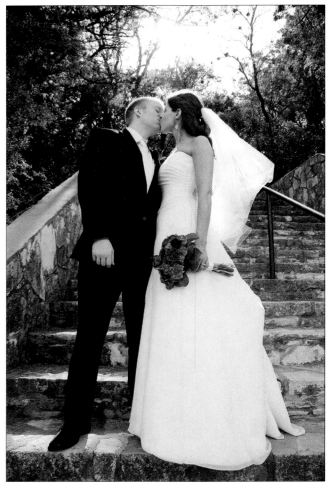

17mm, 1/500 sec., f/4.5, 125

Figure 3-4: Backlighting your subjects can shape harsh lighting into something usable.

✔ **Use natural reflectors and diffusers.** On a sunny day, you can find many objects that reflect the sunlight, such as buildings and pavement. If you position your subject toward the light reflected off something like a white wall, the subject is evenly lit. If you're indoors, windows can be used to diffuse the sunlight and softly illuminate the subject, like in Figure 3-5.

✔ **Use portable reflectors.** Portable reflectors look a lot like a sun shade for a car's windshield, and they're inexpensive and easy to transport. You can use this type of reflector to angle the sun's light toward your subject. In Figure 3-6, you can see my assistant using a reflector angled toward the bride to help lift some of the shadows.

29mm, 1/80 sec., f/2.8, 125

Figure 3-5: If you're shooting indoors, windows can diffuse harsh lighting to create perfect illumination.

50mm, 1/800 sec., f/2.8, 100

Figure 3-6: Using portable reflectors helps redirect light toward your subject to lift shadows.

You may also worry about natural light that doesn't seem bright enough, but don't shy away from shooting outside on a cloudy day. Think of clouds as a giant diffuser. An overcast sky helps to soften the direct light of the sun and provides you with a soft and even light on your subjects. Take a look at Figure 3-7. This picture was taken at about noon, which would normally be the worst time of day to shoot outdoors, but the cloud cover gave wonderful lighting for this couple.

26mm, 1/250 sec., f/5.6, 125

Figure 3-7: An overcast sky can provide a beautiful soft light at any time of day.

Creating your own light

I try to use natural light whenever I can (see the preceding section), but certain situations during a wedding just don't make it possible. If the available light is insufficient, take control and create your own. In the following sections, I briefly outline the ways you can use an on-camera and off-camera flash to create the light you need. (See Chapter 2 for details on these types of flashes.)

With an on-camera flash

An on-camera flash (also known as an external flash) is a fantastic tool for the wedding photographer. Note that when I talk about an on-camera flash, I don't mean your camera's built-in flash. An external flash is a separate piece of equipment with a rotating head that attaches to your camera via the hot shoe above the camera's viewfinder.

Using an external flash requires some practice, so before you shoot a wedding, I encourage you to explore the following techniques and develop an understanding of how to utilize this tool. Keep in mind that an external flash by itself is a hard light source (like you see in Figure 3-8a), so you should practice the following methods of dispersing the light to illuminate your subjects in the most flattering way:

✔ **Bouncing flash:** One of the best ways to softly illuminate a subject with artificial light is to bounce the light off the ceiling. The simplest way to do it is to tilt your flash up at a 75-degree angle and take the picture; the ceiling acts as a diffuser and bounces the light back down toward your subject. (For an example, check out Figure 3-8b.) You can also point your flash behind you at a 45-degree angle toward the ceiling and a wall, which pushes the light back toward your subject. If the ceiling is too high or if you want a subject to be lit from the side, consider rotating your flash 90 degrees to the side and bouncing the flash off a wall.

When bouncing flash, be aware of the color of the wall or ceiling you're using. If the wall is blue, for example, the reflected light coming off that wall has a bluish cast. White walls and ceilings work best for this technique, but you can get away with bouncing off of other neutral colors.

✔ **Using bounce cards:** Another way to disperse the light from an on-camera flash is to attach a bounce card directly to your flash. Some flash units come with a built-in card that you can pop up; otherwise you can buy one separately and attach it by using Velcro or by placing a band around the top of your flash. To use a bounce card, angle your flash straight up at a 90-degree angle and snap the picture. As the flash fires, the light shoots upward and the card reflects it back toward your subject, like you can see in Figure 3-8c.

✔ **Adding a diffuser:** A flash diffuser is an opaque device that you place over your flash. It helps disperse the light if you need to fire your flash directly at the subject.

a

b

c

Figure 3-8: Here you can see the difference in how a direct flash (a), bounced flash (b), and flash with a bounce card (c) can affect a subject.

With an off-camera flash

Many (but not all) wedding photographers integrate an off-camera flash into their lighting setup. An off-camera flash system usually includes a light stand, a powerful external flash unit, a diffuser, and a wireless flash trigger. Whether you use an off-camera flash or not is a matter of preference, but it offers these benefits:

✔ An off-camera flash can be placed off to the side of the subject and used in conjunction with the on-camera flash to even out lighting and lift shadows in a dark room.

✔ Off-camera flashes can accommodate larger diffusers than on-camera flashes can. These large diffusers, like umbrellas or softboxes, help to soften the light even further.

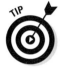

Off-camera flash is normally utilized at the reception because it can be placed in a location out of the way of guests or the wedding party (like by the DJ's speakers next to the dance floor) and can remain stationary. As events take place during the reception, you can position yourself so that your subjects are evenly illuminated from the two light sources.

Overcoming common lighting challenges

As I mention in the earlier section "Using natural light," as a wedding photographer, you need to be ready to take pictures in any kind of situation because you don't always have the luxury of scheduling photos at the perfect time of day. Though you can't anticipate every potential lighting condition, it helps to know what difficulties you may encounter ahead of time and know how to make any kind of light work in your favor. Here I outline a few common challenges wedding photographers face and give you some tips on how to overcome them:

✔ **Indoor preparation photos:** The couple usually gets ready for the wedding indoors in a hotel room or house. This can present a lighting challenge if the room is dimly lit. Consider asking your bride or groom to get ready near a large window with the shades pulled back to allow nice natural lighting, as you can see in Figure 3-9.

This technique also works well for pictures of the bride right after she has finished getting ready (refer to Figure 3-5). If the lighting from a window isn't sufficient, grab your external flash and bounce the light off the ceiling.

✔ **Outdoor portraits:** If you're doing portraits of the couple and family outside on a bright day and the sun is still high in the sky, choose a shady spot to set up the photos. Make sure that you place your subjects near the edge of the shade so that their faces are still well illuminated from the reflected sunlight. (Refer to Figure 3-3.)

✔ **Indoor portraits:** Indoor portraits can be very tricky, especially if you're photographing a large group and a smaller aperture is needed to keep everyone in focus. In this situation, you need an external on-camera flash. If the ceiling is low enough, bouncing the flash can provide an even lighting. However, if the ceiling is too high, like in a large church, you may need to fire the flash directly at your subjects. If a direct flash is necessary, make sure to put your diffuser or bounce card on the flash before taking the picture.

If the lighting indoors is very dark, a tripod and an off-camera flash system can also be helpful. The tripod offers enough stability to use a slower shutter speed, while the off-camera flash system can bounce more light on your subjects with an umbrella or softbox.

42mm, 1/50 sec., f/2.8, 200

Figure 3-9: Ask your bride to have her hair and makeup done by a large window, which can provide good lighting.

✔ **Indoor ceremony:** If a wedding has an indoor ceremony with dim lighting, use your external flash again. Like with the indoor portraits, if the ceiling is low enough, you can bounce your flash. However, if that's not an option, use your diffuser and fire your flash directly, like in Figure 3-10.

Be aware that some venues don't allow flash during the ceremony. If this is the case, you need to open the aperture as wide as you can, lower the shutter speed, and bump up the ISO in order to get the right exposure; see Chapter 2 for more details.

50mm, 1/100 sec., f/5.0, 500

Figure 3-10: When shooting an indoor ceremony, you may need to use a diffuser and fire the flash directly at your subjects.

✔ **Indoor reception:** An indoor reception can also have very low-light conditions. The nice thing about an indoor reception as opposed to the ceremony is that you can get a lot closer to your subjects to bounce the on-camera flash (Figure 3-11 is a good example), and you have the option of using the off-camera flash system. If you choose to use an off-camera flash, just make sure that you put it in a place where guests won't trip over the stand and where it can shed light on the different events of the night, like the cake cutting, dancing, and the bouquet and garter toss.

One of the most common problems for a novice when shooting with flash is the *cave effect,* where the subject is lit but the rest of the photo is very dark. One way to remedy this effect is to mix ambient (or available) light with flash. When mixing these two sources of light, remember this principle: Aperture controls flash exposure, and shutter speed controls ambient light. If you notice that the subject is well lit (meaning you've got the aperture right) but you're getting cave effect, you incorporate more of the ambient light into your photo by lowering your shutter speed. Voilà!

17mm, 1/60 sec., f/4.0, 800

Figure 3-11: Bouncing flash off the ceiling can provide the right kind of light at indoor receptions.

Composition: Using Different Techniques to Produce Stronger Images

Composition is a key element of good wedding photography. The term *composition* refers to the way you arrange and place all the elements within your frame and how they come together to create an idea. As with lighting, composition can determine the impact a photograph has on a viewer, so you need to understand how to arrange a picture to make it more visually appealing. I could write an entire book on the principles of composition, but in the following sections I just cover the basics.

The rules of composition are more like guidelines and can be broken if you feel that doing so would create a more visually compelling photo.

Trying the rule of thirds

The rule of thirds is the most widely known principle of photographic composition. To understand this concept, imagine that a tic-tac-toe grid is drawn across your viewfinder, breaking your image into thirds horizontally and

vertically. The rule of thirds proposes that you should place your primary elements in a photograph along those vertical and horizontal lines. As an example, in Figure 3-12 the bride and groom are aligned along the right vertical line, and the horizon is at the top vertical line of the photograph.

50mm, 1/250 sec., f/5.6, 125

Figure 3-12: The rule of thirds helps create a balanced and visually pleasing photograph.

Following are a few tips to keep in mind when working with the rule of thirds:

- ✔ Place the main subject or point of interest at the cross points, where the vertical and horizontal lines intersect, to make your photo more interesting.
- ✔ Align the horizon along the top third or bottom third of the frame.
- ✔ Include a second point of interest in the opposite corner to balance the photograph.

Considering your background

When my sister was getting married, she met with several photographers before choosing the one she wanted to shoot her wedding. As she looked through various portfolios, she noticed a common theme: The subjects looked great, but the background in many of the pictures was very distracting.

Choosing a good background is a key element in composition. As you arrange a photograph, you want to make sure that your background doesn't take away from your primary subject. Following are a few ways you can avoid a distracting background:

✔ Choose a simple background that has a neutral color and few objects. Photographs with a lot of clutter in the background take away the focus from your main subject.

✔ Don't place subjects directly in front of straight objects, like poles or trees; it gives the illusion that something is growing out of your subject's head, as you can see in Figure 3-13. Shift your perspective or move your subject to the side of the object to eliminate this effect.

✔ Watch for distracting or ugly things in the background that can take away from the photo, like trash cans, old beat-up cars, and street signs. Also make sure to keep an eye out for other people in the background (like guests) who aren't supposed to be in the photo.

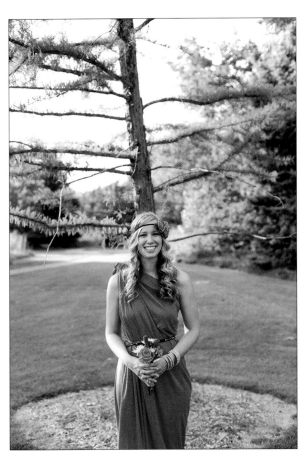

50mm, 1/125 sec., f/3.2, 100

Figure 3-13: Don't place subjects directly in front of straight objects, like trees or poles.

✔ Use a wide aperture to throw a cluttered background out of focus by decreasing your depth of field. (See Chapter 2 for more about aperture.)

A few situations during the wedding day where you want to be on the lookout for elements in the background are when the bride is getting ready (if in a cluttered room), toasts to the couple, first dances, or any other portraits that need a clear background.

Cropping in-camera

Paying attention to what's in the frame is very important in wedding photography. *In-camera cropping* refers to when you look through your viewfinder and decide exactly what you want in the photo. By cropping your photograph in-camera, you can cut out irrelevant details and place more emphasis on your subject. Though you can crop a photo during the editing process, that type of cropping can degrade the quality of your image. So it's better to take a well-composed photo from the get-go than to crop everything out in postproduction.

When cropping a photo, consider the following tips:

- **Fill the frame with your subject.** Too often, beginner photographers feel that they have to show their subject in its entirety or in its environment. Not so! Zooming in on a detail can result in a stronger image.

- **When shooting portraits, don't crop at the joints.** Cutting an image off at the wrists, elbows, knees, and ankles makes for an awkward photo (Figure 3-14a is a good example). To fix the awkward crop in Figure 3-14a, all I did was lower the angle of my camera so that the photo was cut off in-camera below the subject's joints (see Figure 3-14b).

a b

50mm, 1/400 sec., f/2.5, 125

Figure 3-14: Cropping at a person's joints makes for an awkward photo (a); including the hands looks more natural (b).

- ✔ **Determine your camera's vertical or horizontal format based on the subject's shape.** For example, if you want a picture of a wedding cake, a vertical shot fills your frame better than a horizontal shot.

Giving your subject room to move

Another compositional technique to apply to your photos is giving your subjects some breathing room. You don't want the viewer to feel claustrophobic when looking at a photo. To achieve this effect, keep the following in mind:

- ✔ If your subject is on the move, leave a space in front to give the person somewhere to go, like in Figure 3-15.

- ✔ If your subject is stationary and looking away from the camera, allow some space in the direction her eyes are pointed. For example, if you have a bride looking to her left, leave some negative space on her left in the photo so the viewer feels that she has somewhere to look toward.

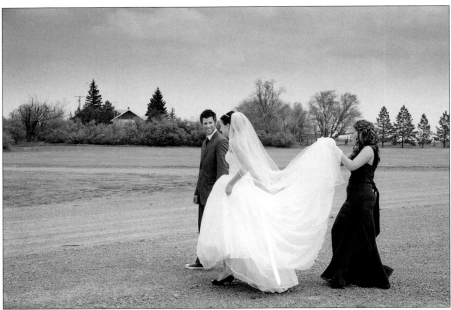

32mm, 1/640 sec., f/5.0, 100

Figure 3-15: Make sure to give your subjects somewhere to go; otherwise they may look like they're walking right out of the picture.

Guiding the viewer's eye with lines

One way to draw the viewer's eye to your primary subject is to use lines to guide them. Vertical, horizontal, diagonal, and curvy lines can each convey a different feeling to the viewer.

- ✓ **Vertical lines:** Vertical lines run up and down in a picture. These lines can convey a sense of strength, power, or the height of an object.

- ✓ **Horizontal lines:** Horizontal lines run side to side in a photograph and often make a viewer feel at peace. They also help to anchor the subject in a photo. An example would be a couple in a field with the horizon behind them. The horizon ties them to the earth, whereas a picture that crops out the horizon can give the appearance of the couple lost in negative space. Check out a photo with strong horizontal lines in Figure 3-16.

- ✓ **Diagonal lines:** Diagonal lines help to lead the viewer's eye around a photograph and to guide the eye to the main point of interest. An example of diagonal lines can be found in Figure 3-17, where the implied lines of the hallway floor draw the eyes to the back of the photo and then toward the couple's faces.

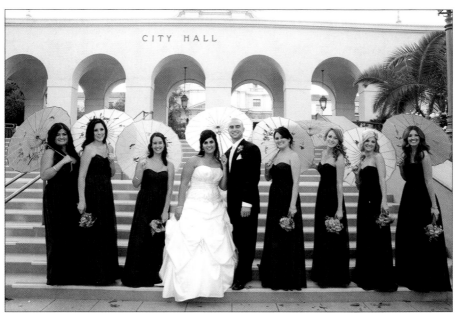

17mm, 1/40 sec., f/6.3, 200

Figure 3-16: Horizontal lines help to anchor your subjects in the photo.

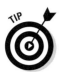

When using diagonal lines, make sure that the lines don't lead the eye straight out of the photo! They should lead to some sort of anchor that keeps the eye from leaving the picture.

✔ **Curvy lines:** Curvy lines convey a sense of beauty and elegance to the viewer and can be found in a variety of places, from the curves of a woman to a winding pathway.

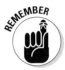

A photo can incorporate one type of line or several. For example, Figure 3-17 includes vertical, diagonal, and curvy lines, all of which lead the eye back to the bride and groom.

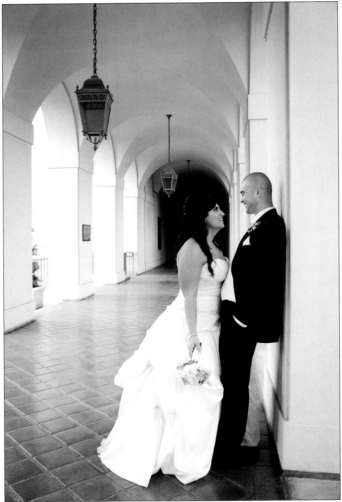

22mm, 1/50 sec., f/4.5, 320

Figure 3-17: An example of how vertical, diagonal, and curvy lines all lead your eye around the frame and back toward the main subject.

4

Capturing a Wedding's Excitement and Emotions

Weddings are some of life's most beautiful moments. As couples stand before their family and friends to express their love and make a life-long commitment, you can almost physically feel the excitement in the air. The best part about being the photographer is that you have a front-row seat to every wedding story. But you also have the responsibility of capturing the feel of the day.

Weddings are full of both motion and still moments, and you need to be able to convey the emotion of each type of setting in your photographs. This chapter covers techniques for photographing the action and excitement of a wedding day and gives you pointers for shooting the emotional, quiet moments. I also point out ways to capture both piv-otal and unexpected moments during a wedding and look into the importance of symbolism.

Fast Moves: Capturing High-Action Moments

Action photography is all about portraying the movement that is going on around you. This type of photography lends itself to capturing excitement very well because it aptly describes the essence of the moment. Though you

won't encounter situations typically considered "fast action" at a wedding, like cars racing or a soccer player doing a fantastic bicycle kick, (unless of course you photograph a couple who love extreme sports), wedding shots such as the throwing of the bouquet or the groomsmen jumping require a handle on techniques to capture motion. Read on to discover tips on how to successfully convey a sense of movement in your photos.

Preparing to shoot action

Before I dive into the variety of ways you can capture photos of movement during a wedding (see the next section), you should consider a few preliminary aspects of action photography. (Flip to Chapter 2 for more about shutter speed, aperture, ISO, continuous drive mode, memory cards, RAW format, and lenses; Chapter 3 covers the basics of composition.)

✔ **Composition:** Subject placement has a major effect on the dynamic of an action photograph. Don't stop the motion by leaving your subject nowhere to go; rather, you should always give the viewer a sense that the subject could move somewhere within the frame of the photograph.

✔ **Timing:** Action shots require a certain amount of anticipation instead of reaction. Prepare yourself to take a good photo by setting your shutter speed, aperture, and ISO ahead of time and be ready to take a picture as soon as the action takes place. If you wait to get the camera ready until the action begins, you'll probably miss the important moment.

✔ **Placement:** Placing your subjects exactly where you want them (if the shot isn't a candid) and giving them clear directions helps you capture the look you're going for.

Although shooting in continuous drive mode is very helpful, you can't fully rely on it to catch the perfect moment by just holding down the shutter-release button when you think something exciting is about to happen. Shooting too early may cause your camera to buffer during the actual moment you want to capture. Find out how to prepare for a sequence of movements and shoot right at the moment you want to capture.

✔ **Memory card rate speed:** If you take a look at your memory card, you will probably see a number followed by *x* or *MB per second.* This number refers to rate at which the card can save a picture before being ready to take the next one. The faster the card, the faster you can take the pictures. As a general rule of thumb, if you plan on shooting in RAW and taking high-resolution photos in quick succession, you should have a minimum rate speed of 20 MB/second, or 133x. (Faster speeds have higher numbers.)

✔ **Lens:** When shooting action, you want to have a fast lens on your camera, meaning one that has an aperture that can open up very wide, allowing a lot of light to hit your sensor. Because action shots require fast shutter speeds, which means that the shutter is open for a shorter amount of

time, you'll need to be able to let more light into the lens. The way to compensate for the fast shutter speed is with your aperture set wide open.

Choosing techniques for action photography

Action photography relies heavily on the use of the correct shutter speed (if you need a refresher course on shutter speed, check out Chapter 2). A faster shutter speed freezes action, whereas a slower shutter speed blurs motion.

When the time comes to capture movement on a wedding day, you can choose from one of three techniques: freezing action, blurring motion, and panning for background blur. In the following sections, I outline the three different styles and give examples of moments you can use each during a wedding day.

Freezing action

Freezing action is the technique that is used most often throughout a wedding. To determine the correct shutter speed, you need to consider how much movement will be taking place and adjust your camera accordingly. For high action moments, start at a minimum shutter speed of 1/250 and work up from there, depending on how fast your subject is moving.

If you're using a flash, be aware of the *maximum sync speed,* which refers to the highest shutter speed you can use if you want the flash to fire. The most common maximum shutter speed you can use with flash is 1/250, so be sure to take lighting into account if you think the action calls for a faster speed. As you look over the following list, note that the listed shutter speeds do not take flash into account.

The freeze action technique works well in the following wedding scenarios:

- **Portraits in motion:** Sometimes you want to give your subjects an action while shooting the portraits, like walking toward the camera, jumping in the air, or dipping the bride back for a kiss. For slower movement, like a couple walking toward you at a normal pace, a shutter speed of about 1/125 will suffice. If, however, you have people running toward the camera, you need to use a speed of 1/250 to 1/500 to freeze the action. To stop action of faster movement, like a photo of a person jumping, select a speed of at least 1/320, though pushing the shutter speed higher results in a sharper image.

- **Bouquet and garter toss:** For these photos, you should use a minimum shutter speed of 1/250 if you want the bouquet and garter to be sharp.

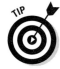

 I always try to get the bouquet/garter soon after it leaves the bride or groom's hand, like you can see in Figure 4-1. To do this, start shooting continuously as the bride or groom raises his or her arm for the throw.

50mm, 1/320 sec., f/2.0, 125

Figure 4-1: For the bouquet toss, choose a shutter speed of about 1/250 and start shooting as the bride raises her arm to throw the bouquet.

✔ **Dancing:** Many weddings include people boogying the night away on the dance floor. The shutter speed you choose depends on how fast your subjects are moving. If you're capturing the couple's first slow dance, then a speed of 1/125 or higher will work. But if one of the groomsmen starts breakdancing in the middle of the dance floor, you should bump your speed to about 1/250 or higher.

✔ **Throwing rice:** As a couple leaves the wedding, often the guests will line up and throw rice or petals at them as they run toward the car. If you want to freeze the motion of the couple, start at a speed of 1/250.

Blurring motion

Blurring motion is another technique you can use for action shots at a wedding. In contrast to freezing action, motion blur puts an emphasis on the subject's movement by showing where the action is going. In these shots, the subject is blurry and the background is crisp.

This style of photography uses a slower shutter speed, typically 1/30 or slower, and can be used creatively during a wedding. Here are two examples of how you may want to use motion blur:

- ✔ **Groom and groomsmen running:** A fun portrait of a groom and his groomsmen can be having them run toward you. In the preceding section, I mention that for running you should use 1/250 to 1/500; however, if you want to blur some of the motion, try setting your shutter speed at 1/125 or slower.

- ✔ **Dancing:** The dancing at the reception can be a really great place to take advantage of a slower shutter speed to blur motion. To show the couple's movement during the first dance, you can play around with the shutter speed throughout the duration of the dance, but 1/30 or 1/15 of a second is a good place to start to get some creative blurring (see Figure 4-2 for an example).

50mm, 1/13 sec., f/13, 100

Figure 4-2: To take advantage of blurring motion during the first dance, try slowing your shutter speed down to about 1/15.

Panning for background blur

Unlike blurring motion, which shows a blurry subject and a crisp background, panning for blur has just the opposite result: The background is blurred and the subject is frozen, as you see in Figure 4-3. This effect is accomplished by selecting a slower shutter speed and tracking your subject's movement. Panning can also be used to create unique shots during a wedding, such as an action portrait of a couple running past you or someone walking down the aisle.

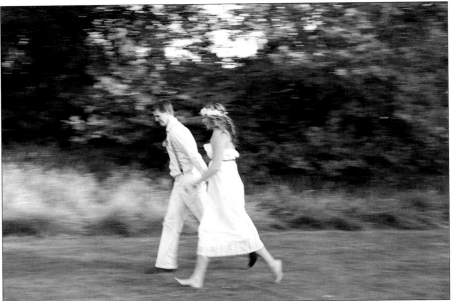

50mm, 1/40 sec., f/5.0, 100

Figure 4-3: Panning for blur can be a fun effect to use while your couple is on the move.

To pan for background blur, follow these steps:

1. **Select the center autofocus point.**

2. **Put your camera into AI Servo (or AF-Continuous) mode so that your camera's autofocus can track the movement.**

3. **Select a slower shutter speed, like 1/30 second.**

4. **Anticipate your subjects' trajectory and position yourself so that they will pass in front of you. Plant your feet firmly facing directly forward and turn your torso toward the subjects.**

5. **Frame your subjects and press the shutter-release button halfway down to focus.**

6. **As the subjects begin to move, track them continuously and release the shutter when they reach the desired point.**

7. **Continue tracking the subject after you take the picture to ensure that you have good follow-through in the photo.**

Panning can take a while to master, so make sure you practice this technique before trying it out on a wedding day.

Time for Your Close-Up: Catching Quiet Moments and Expressions

Though a wedding has a lot of fast-paced movement (as I note earlier in this chapter), it also has quiet times that present golden opportunities for some really great photos. Some of the most iconic pictures, like a portrait of the bride in her dress or a candid of the couple in an unrehearsed embrace, come from these calm moments, and a wedding photographer needs to capture them effectively.

Being able to capture expressions is a significant part of wedding photography because you want to reveal the emotions your subjects feel in that moment, not just record what they're doing. The human face is capable of communicating a great deal, and the quiet moments of a wedding give the photographer a unique opportunity to show how the subject is feeling.

Whether you capture expressions by posing a portrait or taking a candid shot, a knowledge of how to capture close-ups is very important. The following sections go over a few ways to photograph the quiet moments and create dynamic and inspired pictures.

Selecting apertures

Choosing an aperture is one of the first elements you decide when shooting the still moments. (If you don't know what an aperture is, check out Chapter 2.) Aperture is one of the factors that determine your *depth of field,* or how much of the picture is acceptably sharp. Depth of field is used to create mood by softening or hardening the foreground and background of your photo.

There isn't a hard-and-fast rule when it comes to choosing an aperture. When shooting a single subject, some photographers love to shoot with an aperture as wide open as possible to completely blur out the background, whereas others insist that f/11, with a smaller depth of field and greater overall sharpness, is the best. When deciding what to do, consider the information in the

following list, which addresses apertures f/1.2 to f/11 and how they create certain effects. Pick and choose what you want to use based on your circumstances and artistic style.

- ✔ **f/1.2 to f/2:** These widest possible apertures are best used for a single subject. They result in a very shallow depth of field, which isolates your subject from the foreground and background. They can create a very soft and dreamy look (check out Figure 4-4 for an example).

 If you're shooting a portrait, be aware that a person's face will not be entirely in focus with apertures this wide. For example, if you choose f/1.4 and you're shooting straight on, the depth of field is so narrow that only the eyes will be in focus; even the nose will be soft.

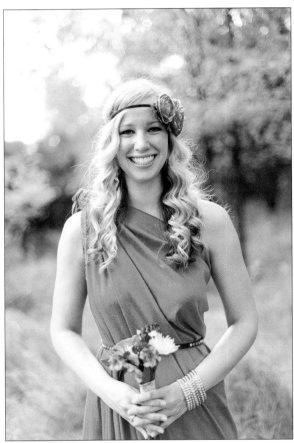

50mm, 1/200 sec., f/1.4, 100

Figure 4-4: Using a shallow depth of field helps to isolate your subject from the background, which can give a dreamy look to your photo.

- ✔ **f/2.8 to f/4:** These apertures also give you a shallow depth of field but allow more of a person's face to be in focus. For a single subject, if you start around f/2.8, most of the face is sharp, but the ears are softly focused. If you go up to f/4, you can get the entire head in focus.

 If you're photographing two people, start at a minimum of f/4 to ensure that both people are acceptably sharp in the picture.

- ✔ **f/4.5 to f/5.6:** For a single subject, f/4.5 to f/5.6 begins to add sharpness to the entire subject but also includes more of the background.

This aperture range works well for pictures of two people and small groups.

- ✔ **f/6.3 to f/8:** These apertures add increasing sharpness to a single subject as well as add in more of the foreground and background.

 This aperture range also can be used for larger-group photos with several rows of people.

- ✔ **f/9 to f/11:** A single subject photographed with this aperture range is very sharp. The foreground and background are sharp as well (see Figure 4-5).

 This range also can be used for very large group photos, such as the couple and all the wedding guests.

50mm, 1/40 sec., f/11, 800

Figure 4-5: Using a smaller aperture, like f/11, will give you a very sharp portrait, but the background will have much more detail as well.

Many photographers have different preferences for apertures, especially for single subjects. I encourage you to play around with apertures and depth of field to find what looks best to you.

Focusing on the eyes

You've probably heard the old proverb "The eyes are the window to the soul." As you photograph people on a wedding day and capture their expressions, keep in mind that the eyes are the strongest focal point of a photo of a person.

If your subject is looking at the camera, the eyes are the most crucial part of the picture to have tack sharp (highest clarity and detail possible) and well lit. The following list contains a few ways you can make eyes pop in a photograph:

- ✔ **Using single-shot mode:** If your subject is standing still, single-shot mode is very helpful when focusing on the eyes. Single-shot mode works well because when you press the shutter-release button halfway down, it locks the focus until you take the picture.

- ✔ **Taking advantage of your autofocus points:** Rather than using the center autofocus point to lock the focus and then recomposing, consider using the different autofocus points available. Move the point to the center of one of your subject's eyes. This lets your camera know that it is the most important area of the frame. (Flip to Chapter 2 for more about autofocus points.)

- ✔ **Smiling with the eyes:** If I'm shooting a portrait and I want the subject to look at me but not smile, I always tell her to "smile with the eyes" instead. I do this because without a smile on her face or in her eyes, a person can look sad, depressed, or even angry (check out Figure 4-6a). To smile with the eyes, have your subject raise her eyebrows slightly and open her eyes a little bit, like you see in Figure 4-6b. I also tell her to think about how happy she is and to communicate that to me with her eyes.

a b

50mm, 1/250 sec., f/1.6, 125

Figure 4-6: Having your subject smile with her eyes can mean the difference between a sad photo (a) and a happy photo (b).

✔ **Creating catchlights:** One of the biggest ways to make your subject's eyes come to life is to give them a little gleam with catchlights. Catchlights are reflected light in the eyes, and you can capture this effect if you're aware of the light source and make sure that enough is present to provide that reflection. When you figure out where your light is coming from, you can angle your subject toward the light to give the eyes a little oomph (see Figure 4-7).

28mm, 1/100 sec., f/2.8, 125

Figure 4-7: Position your subject toward the light to create beautiful catchlights in her eyes.

Changing your angles and framing

To prevent your pictures of the calm moments from becoming static or boring, consider switching your angles and in-camera framing to add interest to the photo.

- ✔ **Angles:** Most portraits are taken from an eye-level point of view, so changing your angle can show different details. This works especially well when shooting close-ups. Try standing up on a chair and shooting your subject from above, like in Figure 4-8, or getting down on the ground and shooting up at your subject.

- ✔ **In-camera framing:** If you find yourself getting stuck shooting in portrait mode or in landscape mode, try switching it up! Going back and forth between the two can add a lot of variety to your photos (contrast the different versions of the same shot in Figure 4-9).

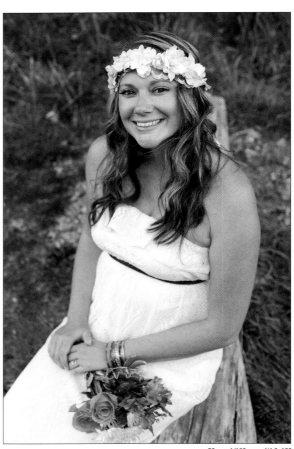

50mm, 1/160 sec., f/4.0, 100

Figure 4-8: You can add variety to your portraits by changing your angles.

Playing with lighting

Lighting can have a huge impact on your photos by creating different moods. When you combine certain types of lighting with expressions, you can create photographs that draw in a viewer. Here are a couple examples of how lighting combined with expressions can convey a mood (see Chapter 3 for more about lighting):

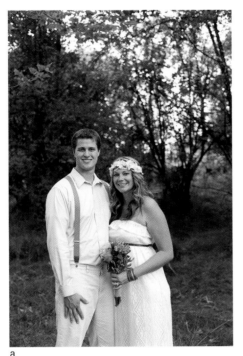

a

b

50mm, 1/100 sec., f/3.2, 125

Figure 4-9: Switching back and forth between portrait and landscape mode is another way to add variety to your photographs.

✔ **Side lighting:** When you light a subject with a neutral expression from the side, it can add a very dramatic effect to a photograph, like in Figure 4-10.

✔ **Backlighting:** Backlighting, especially in golden sunlight, can convey a sense of warmth, happiness, and romance (see Figure 4-11). Photographing a couple laughing and kissing in this kind of light strongly accentuates their emotions.

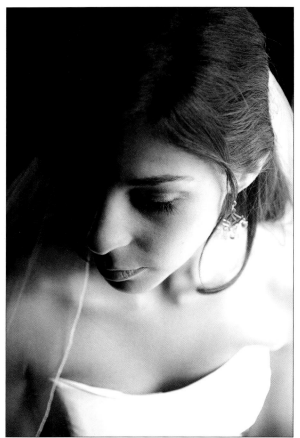

38mm, 1/50 sec., f/3.2, 160

Figure 4-10: Side lighting can have a very dramatic effect, like you can see in this bridal portrait.

Here's the Key: Depicting Pivotal Moments and Unexpected Occurrences

In every wedding, key moments are a vital part of the wedding story. Some you know to keep an eye out for, such as the moment the groom first sees the bride, but others are spontaneous. The following sections cover ways you can be ready to take pictures of the important moments of a wedding day.

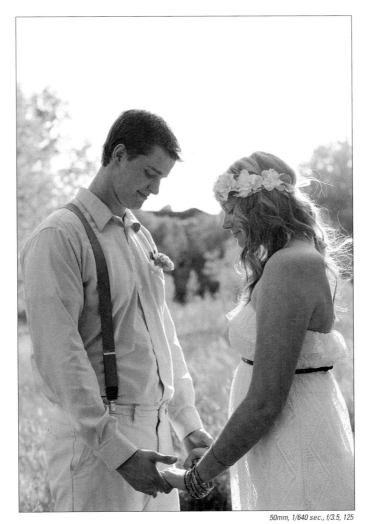

50mm, 1/640 sec., f/3.5, 125

Figure 4-11: Backlighting can add a warm and romantic feel to a photograph.

Anticipating the pivotal moments

Not all weddings are the same, but most have a lot in common. Because weddings typically have a similar flow of events (as you find out in Chapter 9), you can do the following things to make sure you successfully document the pivotal moments of the day:

✔ Always have your schedule with you at all times (to find out more about getting a schedule, see Chapter 8). If you have something to reference, you won't have to wonder what's coming next.

✔ Get your camera ready before the pivotal moments take place. If you know that the couple is about to exchange rings, for example, you should make sure that your exposure and camera settings are properly set and that you're in the right spot to capture it effectively.

✔ Use continuous drive mode to take several pictures in rapid succession. This function decreases the chance that your important moment will be marred by something minor, like a person blinking. (See Chapter 2 for more about this mode.)

Being ready for the unexpected

Even if you go into a wedding fully prepared, things are bound to happen that weren't on the schedule, like the five-year-old ring bearer busting a move on the dance floor. These moments are very important to capture, because so many things happen during any given wedding that certain details can be easily missed or forgotten. Capturing the spontaneity also helps to communicate the sense of joy and excitement of the day.

As you move through the day, always be aware of what's happening around you. Have your camera on and ready to shoot at all times to ensure you don't miss critical photo opportunities, like the photo in Figure 4-12.

Photographing unexpected moments is where shooting in RAW really comes in handy. I always recommend trying to get pictures as perfect as you can in-camera, but sometimes you just don't have time to change your settings. RAW files offer a lot of flexibility when processing in case you caught an unexpected moment but you weren't able to get your exposure just right. (Check out Chapter 2 for more about RAW format.)

The Art of Symbolism: Taking Pictures That Tell Stories

The word *symbolism* probably conjures up memories of that paper on the great American novel your high school English teacher made you write. Though symbolism in literature is a little different than in photography, understanding what it is and how it plays into your narrative is important.

Understanding symbolism in photography

Symbolism refers to the use of an object, person, action, or place to represent a deeper idea or meaning. Take wedding rings, for example, which are probably the most well-known symbol at a wedding. The rings aren't just a piece of jewelry; they represent marriage and the idea of eternal love and commitment.

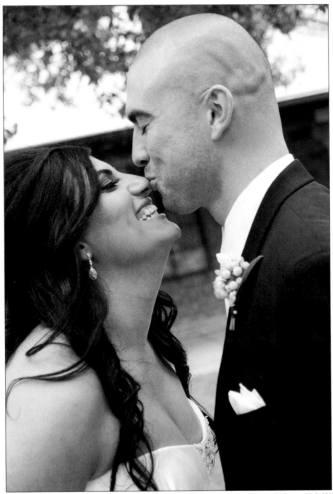

44mm, 1/200 sec., f/4.0, 200

Figure 4-12: Always having your camera ready can result in wonderfully spontaneous photos, like this groom giving his bride a kiss on the nose.

Photography is all about symbolism. Ideas, thoughts, and emotions must all be communicated to the viewer in each picture. Photographers can't rely on words to describe the message they want to tell, so they must be able to convey the story with an image. Symbolism can be either intended or incidental:

✔ **Intended symbolism:** This type of symbolism is found when a photographer purposefully uses certain visual elements to communicate a message. If the photographer arranges the wedding rings and wedding program in a photo, he's using intended symbolism. Someone looking at that image will think about a wedding based on the symbols in the picture.

✔ **Incidental symbolism:** Incidental symbolism refers to a captured image that communicates an idea that the photographer didn't necessarily plan or think about. You can see an example in Figure 4-13. The groom pulled in his bride for a kiss, and although I didn't plan the moment, the image communicates the ideas of love and passion.

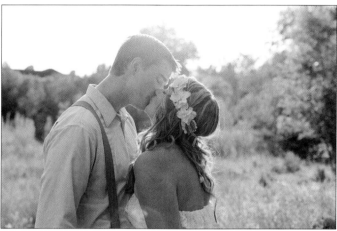

50mm, 1/640 sec., f/3.5, 125

Figure 4-13: An image of a groom kissing his bride is an example of incidental symbolism, communicating an idea the photographer didn't think about ahead of time.

Identifying the importance of symbolism

A photographer uses symbolism to tell the story of each wedding. Each image is a symbol in and of itself and should help to preserve the emotions, ideas, and events that take place. As you capture different moments on a wedding day, be thinking about what story you want to tell and what emotions you want the viewer to feel. Chapter 7 can help you figure out the scenes to shoot in order to frame a couple's wedding story.

The primary viewers you should take into account when shooting a wedding are the bride and groom. Often the wedding day is a blur of events and emotions that can be hard to remember after the craziness dies down. Your job is so important because when you give the photos back to your couple, you aren't just giving them a stack of pictures — you're giving them their memories. As memories fade, those photos should help them to relive those precious moments every time they look at them, whether it's 5, 10, or 50 years down the road. When a bride looks at a photo of her groom's face when he saw her for the first time, that photo is a symbol that will help her to remember exactly how she felt at that moment.

5

Exploring Photographic Styles

In This Chapter
▶ Discovering different types of photography
▶ Using various styles to create a complete story

*I*f you visit an art gallery and meander through the exhibits, you'll notice that various pieces are categorized by a distinct style that makes each work unique. An Impressionistic painting by Claude Monet, for example, has a much different look than a Surrealist painting by Salvador Dalí. Similarly, if you compare a black-and-white landscape photograph by Ansel Adams to a vibrantly colored landscape taken by Peter Lik, you'll see how photographic style can affect how you feel about a picture.

So what is style, exactly? *Style* can be defined as a set of characteristics and techniques that artists use to showcase their creative vision. Like any art form, style also applies to wedding photography. This chapter covers the most common styles found in wedding photography and how you can incorporate various aspects of each in a wedding to tell a complete story.

Recognizing Different Styles of Wedding Photography

Suppose that two photographers were asked to shoot the same wedding. One photographer used only a traditional style, and the other photographer took a photojournalistic approach. As the couple looked through the albums after the wedding, they'd see that although both photographers were at the same wedding, the end result was completely different.

In the following sections, I describe four styles of wedding photography: traditional, photojournalistic, fashion, and artistic. (You can mix these styles during the course of a wedding, as you find out later in this chapter.)

The style you choose to capture a wedding with has a large impact on how much control you take during a wedding and how you narrate the day. Consider the different methods available to you and determine which style (or mix of styles) best fits your artistic vision. After you choose a style, consider shooting all of your weddings with that style in mind. Doing so keeps your end product (the wedding photos) consistent and can give your work a "signature look." Knowing your style in advance is also important so that you can communicate it to your prospective clients. You want to ensure that you and the couple are on the same page and that they know exactly what style of pictures they will be receiving from you.

Traditional: Planning and posing great shots

When wedding photography first started back in the 1840s, photographers were limited by the size and bulk of their equipment. So rather than actually attending the wedding, the photographer would set an appointment with a couple, who would come and pose (sometimes not even in wedding clothes) for wedding portraits. Thus traditional wedding photography was born.

The traditional style of photography, also called the *classic style,* has been around the longest (which is probably why it's called *traditional*). This style of wedding photography relies on the photographer to formally set up and pose each shot (check out Figure 5-1 for an example). Because this style demands so much involvement from the photographer, he or she essentially becomes the wedding coordinator, and the timing and flow of events depend on whether or not the photographer is finished setting up the pictures.

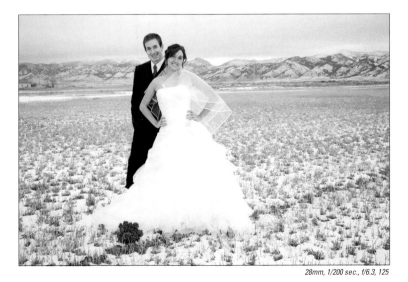

28mm, 1/200 sec., f/6.3, 125

Figure 5-1: In the traditional wedding photography style, the photographer poses the clients for each photo.

Because posing people is such an integral part of the traditional style, it requires that the photographer excel in portraiture. You must always be thinking about elements such as lighting, background, and body alignment. For example, in Figure 5-2, I carefully posed the couple to be framed by the buildings in the scene and to catch the perfect light. Traditional photography also requires that a photographer be extremely well organized in order to get all the portraits needed. For this reason, most traditional photographers work from a very detailed shot list.

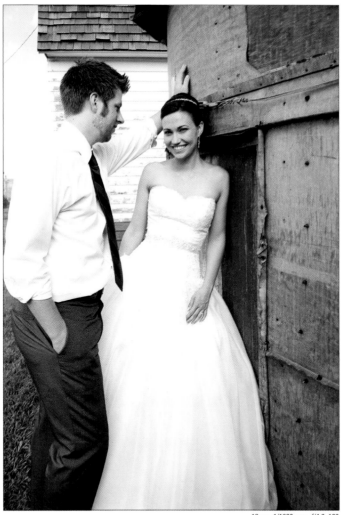

18mm, 1/1600 sec., f/4.0, 100

Figure 5-2: Posing, body alignment, background, and lighting are all things a traditional photographer must think about to craft an excellent portrait.

Traditional wedding photography offers a couple advantages:

✔ You can take beautifully polished photographs (like in Figure 5-3) because you control the situation. The lighting, background, composition, and poses are all left up to you.

✔ As the person setting the schedule for the wedding day, you can take the time you need to get specific shots.

A couple of disadvantages also come along with this style:

✔ Setting up so many poses throughout the entire wedding day can be incredibly time consuming and increases the risk of a wedding falling behind schedule.

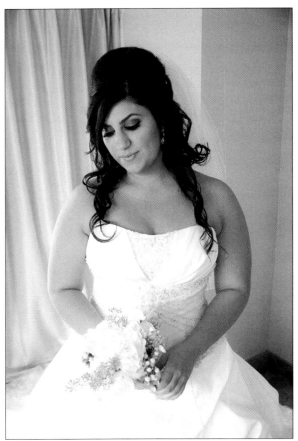

24mm, 1/80 sec., f/2.8, 125

Figure 5-3: The traditional style gives you the freedom to take control of a situation and position your subjects so that you can set up a photo exactly the way you want.

✔ Because every shot is posed and all the subjects are looking where you tell them to, you can really miss out on the real emotions and mood of a wedding day. Posed pictures don't really tell a story, other than that everyone was smiling for that second that the photo was taken.

Photojournalism: Capturing what really happened

In contrast to the traditional style of wedding photography (see the preceding section), a photojournalistic approach puts the emphasis solely on telling the story of a wedding. A purely photojournalistic photographer doesn't pose the wedding party or guests at all but remains as unobtrusive as possible

while capturing the wedding as events unfold. This style of photography focuses on the little moments that make each wedding unique, from the bride getting ready to the moment the couple departs the reception.

A photojournalist needs to be able to think and act quickly. You only get one chance to shoot certain moments at a wedding! This style demands that you be able to change exposures at a moment's notice and adjust your camera settings before subjects realize that their picture is being taken (check out Figure 5-4 for an example). It also requires that you blend in and not draw any attention to yourself.

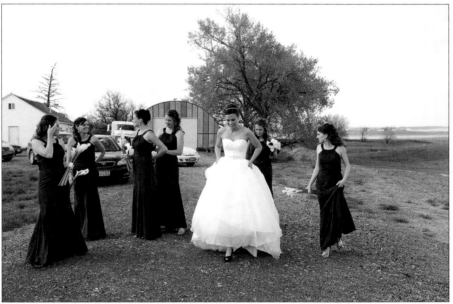

24mm, 1/200 sec., f/5.0, 100

Figure 5-4: A wedding photojournalist must be able to take pictures quickly before the subjects realize their picture is being taken.

Keep in mind that to be an effective photojournalist who tells a complete story, you need to document both the people as well as the setting and style of a wedding. Details from the bouquet (see Figure 5-5) and wedding dress down to the table settings and decorations add color to the narrative as a whole. (See Chapters 7 and 9 for the scoop on shooting the details of a wedding.)

A wedding photojournalist gets a few advantages:

- ✔ Because the photographer doesn't give any direction, the images reflect the true emotions, energy, and events of the day, like in Figure 5-6 where this bride shows her mother her wedding ring.

✔ The photographer doesn't have to worry about guiding and posing a large group of people for formal portraits.

This style also has a few disadvantages:

✔ As the quiet observer, you are at the mercy of your environment and have no control over the lighting or background.

48mm, 1/40 sec., f/4.0, 125

Figure 5-5: If you take a photojournalistic approach to a wedding, don't forget to document the details of the wedding, like this bride's purple bouquet.

✔ You may not get a well-composed quiet moment from your couple by themselves or with their families.

✔ This style can have unpredictable results.

38mm, 1/80 sec., f/4.0, 500

Figure 5-6: A photojournalistic approach to a wedding allows to you capture sweet, undirected moments.

Artistic: Getting creative

Artistic wedding photography is a style that blends either of the photojournalistic or traditional styles (or uses both) and incorporates more of the photographer's artistic vision. A few common characteristics of the artistic wedding photography style include

- Using creative lighting techniques
- Finding unique angles or points of view, like you can see in Figure 5-7
- Composing subjects and arranging details in an imaginative way (check out Figure 5-8)
- Employing editing programs to add creative coloring, textures, and filters to the image, like the vintage look you see in Figure 5-9 (Chapter 11 covers editing)

50mm, 1/60 sec., f/5.0, 200

Figure 5-7: Artistic wedding photographers often use unique angles in their photographs.

The artistic wedding photography style can't be taught. Just like you can't teach someone to have a creative vision, artistic photography must come from the heart of each photographer. It can, however, be developed as you grow as an artist and refine your vision.

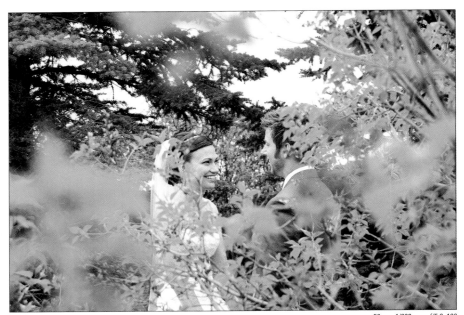

50mm, 1/200 sec., f/5.0, 100

Figure 5-8: A good example of artistic composition is this photo of the bride and groom photographed through the branches.

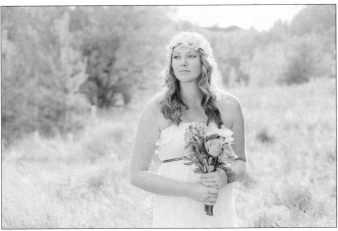

50mm, 1/640 sec., f/2.8, 100

Figure 5-9: The artistic style often relies on creative editing techniques, like this vintage approach to a wedding photo.

WARNING!

If you use the artistic style, you face two disadvantages. But if you keep these two factors in mind, using some artistic styles during a wedding can add some wonderful variety to your images.

- ✓ Certain styles can become outdated in years down the road, which can weaken your portfolio in the long run.

- ✓ You may be so involved in creating artsy photos that you lose sight of the important moments.

Fashion: Highlighting the bold and the beautiful

Fashion wedding photography puts an emphasis creating a certain mood to go along with the clothes and accessories (and the people wearing them) of a wedding in a bold and edgy manner. It utilizes careful and meticulous planning to create visually stunning images. This style looks to high fashion photography and integrates certain techniques to essentially re-create a fashion shoot during a wedding. A few aspects common to fashion wedding photography include

- ✓ Dramatic lighting

- ✓ Posing similar to what you see in magazines, like in Figure 5-10

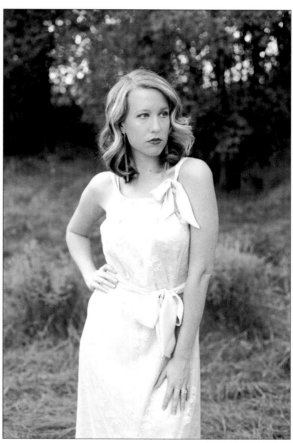

50mm, 1/160 sec., f/2.8, 320

Figure 5-10: Fashion wedding photography often incorporates poses similar to those found in magazines.

- A beautiful couple that's very comfortable in front of the camera
- High-end clothing and elaborate accessories (check out Figure 5-11 for an example)
- Unusual backgrounds or props, like the ladder in Figure 5-12

REMEMBER Like the traditional style, fashion wedding photography gives you an advantage in that you have a lot of freedom to set up each pose and setting. However, you can also miss the actual emotions and events of a wedding, and it can take up a lot of your couple's time during the day.

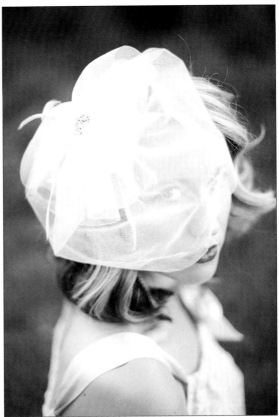

50mm, 1/640 sec., f/1.4, 320

Figure 5-11: This style of photography focuses on elaborate accessories, like this hairpiece.

Mixing and Matching Styles to Create the Story Your Newlyweds Want

Though it happens occasionally, you'll rarely come across a photographer who works exclusively with a single style. Photographers more commonly create their own hybrid of styles to suit their needs. The reasoning is simple: If you choose just one style, elements of a wedding may be left out. However, combining styles opens up possibilities and allows you to better narrate the entirety of a wedding day.

Another reason to mix and match styles is to accommodate your couple and to give them the kind of story they want. If a couple wants a photojournalistic approach to their wedding day but also wants some group shots of their families, you can use both the photojournalistic and traditional styles to create the story your couple desires. Take a look at the following examples:

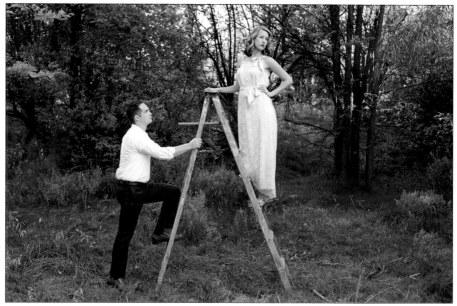

50mm, 1/160 sec., f/2.8, 320

Figure 5-12: Fashion photography also uses unusual props to pose the subjects and to create unique photographs.

✔ Figure 5-13 shows that I started this wedding with a photojournalistic approach while the bride was getting ready.

✔ Then I switched gears for the formal portraits in order to capture a few portraits of the bride and groom as well as a few with the wedding party, like in Figure 5-14.

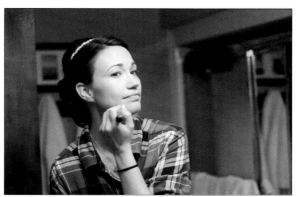

50mm, 1/160 sec., f/2.2, 1000

Figure 5-13: This wedding day began with a photojournalistic approach during the preparation photos.

✔ After the portraits were finished, I switched back to photojournalist mode and captured the image in Figure 5-15.

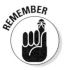

As you begin photographing weddings, I encourage you to explore the different styles and to find (or make) one that fits with your creative vision. One of the best ways to explore the different styles is to set up shoots on your own for practice. That way you can determine whether you like posing a couple,

or photographing a bride from a fashion photography point of view, or taking candid shots instead. Then you can incorporate your preferences into how you plan on shooting weddings.

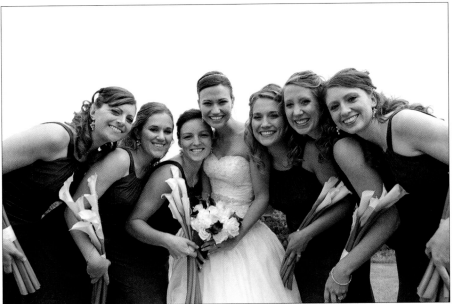

18mm, 1/500 sec., f/5.0, 200

Figure 5-14: After the wedding preparation, I switched to a traditional style during the formal portrait segment of the day.

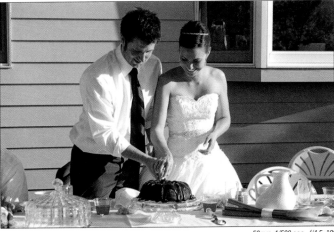

50mm, 1/500 sec., f/4.5, 100

Figure 5-15: After the formal portraits, I switched back to a photojournalistic style.

Part II
Lights, Camera, Action: Capturing the Wedding Day

The 5th Wave By Rich Tennant

"...and here's yet another photo of Marsha and me ruining a perfectly good shot of the back of Uncle Leo's head."

In this part . . .

The wedding day has arrived! After you have acquired the right tools and mastered a few genres of photography, you're ready to get down to business. In this part I walk you through the wedding day and break it down into bite-sized nuggets. If you're wondering how best to tell the story of a wedding, how to handle the formal portraits, or what specific shots you should take, you're in the right place.

6

Preparing Your Gear and Yourself

▷ Creating a to-do list to make sure you're ready

▷ Planning ahead for each segment of the wedding day

Have you ever dreamed that you've forgotten something important and you wake up in a state of panic? Like a dream where you show up to an interview in your pajamas or go to school for a test and realize you forgot to study? When I first began shooting weddings, the weeks leading up to each event were riddled with such dreams, only much worse! I'd arrive at a wedding only to find that I'd left my camera at home, or find that my memory cards were full and my batteries were almost dead. It was always such a relief to open my eyes and realize that it was just a dream.

Whether it was because of those dreams or because I'm a chronic list-maker to begin with, I started creating a detailed to-do list before each wedding to ensure that I was as prepared as possible when the day arrived. In this chapter I help you avoid showing up at your first gig with a dead battery by giving you an example of a to-do list, along with specific ways you should check your gear and mentally prepare for all the segments of a wedding day.

Making a To-Do List and Checking It Twice

I love to-do lists. I find them incredibly useful when I'm trying to organize my thoughts and when making sure that I don't forget important details. When you photograph a wedding, you have a lot of those important details (and your reputation) at stake! To avoid any of those prewedding anxiety dreams from becoming a reality, I highly recommend putting together your own list so you can make sure you have everything in order. In the following sections, I give you an example of my own to-do list of things I want to accomplish before the wedding even begins.

All clear! Cleaning your lenses properly

Keeping your camera lenses clean and free of dust is important for getting sharp pictures. After all, you spent all that dough on that tack-sharp lens, so you don't want to muddy up your shots with smudges or grime.

Before you clean your lenses, make sure you have the proper tools with you: an air blower (never use compressed air, it's too rough on your lenses), a microfiber cloth or lens tissue, a camel-hair brush, and an alcohol-based lens cleaning solution. Most lens-cleaning kits come with all of these supplies and are inexpensive and easy to find at any camera store.

To clean your lenses, follow these steps:

1. **Remove the lens cap from the front of your lens.**

2. **Use an air blower to blow away as much dust as you can.**

3. **If dust remains or there are smudges on the lens, breathe on the lens and then wipe** with a microfiber cloth or lens tissue in a gentle circular motion.

4. **Inspect the lens once again. If it's clean, move on to Step 5. If the lens still has any stubborn smudges, put one or two drops of the lens solution on your tissue or cloth and gently wipe down the lens in a circular motion.**

Note: Never place the cleaning solution directly on the lens. Doing so can damage the protective lens coating.

5. **When the lens is clean, place the lens cap back on.**

6. **Remove the cap from the back lens element and repeat Steps 2 through 5.**

Although cleaning your lenses is important, you shouldn't feel the need to clean them daily. To avoid causing any damage, only clean your lenses when they are dirty.

Making sure that your own equipment works

The most important thing to do in advance is to make sure all your equipment is in working order and ready to go. At least one or two days before the wedding, complete these tasks:

❏ Fully charge your camera batteries.

❏ Format your memory cards and make sure you have enough space across all the cards to store an entire wedding (and if you're wondering how to calculate how much space you need, check out Chapter 2).

❏ Put fresh AA batteries in both your flash and wireless trigger and pack enough spares to shoot with a flash all day if the need arises.

❏ Test your flash to make sure it is working properly.

❑ Clean your lenses. (If you need help with this task, check out the nearby sidebar "All clear! Cleaning your lenses properly.")

❑ Look over your camera's settings and make sure that the ISO, aperture, shutter speed, and format (RAW or JPEG) are where you want them to be and that all the sounds are turned off. (Flip to Chapter 2 for details on these settings.)

❑ Take a few test shots with your camera to ensure that everything works smoothly.

Picking up and testing rented gear

If you don't own a full set of wedding photography gear, consider renting equipment to go along with what you already have (as I note in Chapter 2). If you plan to use rented gear during a wedding, add the following items to your to-do list from the preceding section:

❑ If you're renting locally, pick up your rental equipment at least one day before the wedding. If you are renting from an online company, such as www.lensrentals.com or www.borrowlenses.com, I suggest putting a hold on the equipment a minimum of a month in advance and having it delivered at least two days prior to the wedding to give you a little leeway in case the package is late.

❑ Test out your rented gear to make sure it's working. The last thing you want to do is rely on a piece of gear only to find on the wedding day that something is wrong!

❑ If you are unfamiliar with the piece of equipment, such as a lens you haven't used before, take the time to set up some practice shots to figure out its capabilities and how it feels in your hands.

Packing your camera bags

After you check your gear (see the preceding two sections), you'll want to make sure that you have your camera bags packed and ready to go. Keep in mind that you want to travel as light as possible so that you have more flexibility and don't exhaust yourself, so consider taking equipment you don't plan on using out of the bags. Here is a list of gear you want to have with you:

❑ Two cameras (your main camera and a backup)

❑ Memory cards

❑ Camera batteries

❑ An assortment of lenses

❑ Lens-cleaning kit

❑ On-camera flash unit

❑ Flash diffuser or bounce card

❑ Off-camera flash system, which includes a flash unit, wireless trigger, stand, and umbrella

❑ Plenty of AA batteries

❑ A couple bottles of water so you can stay hydrated during the day

❑ A few snacks to keep your energy up throughout the wedding

❑ Your wallet

❑ Your cellphone

Creating a shot list

Another important element to include on your to-do list is putting together a complete shot list for the wedding day. I include a list of portraits in Chapter 8 and a list of the "must-have" moments in Chapter 9, but here are a few things to keep in mind as you create the list:

✔ Break the wedding down into four sections: preparation, portraits, ceremony, and reception. Outline the specific shots you want to take for each segment of the day. (I discuss these four sections in detail later in this chapter.)

✔ Be sure to include any pictures the couple asked for specifically. For example, the bride in Figure 6-1 requested a shot of the bangles she wore.

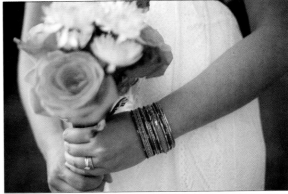

50mm, 1/500 sec., f/1.8, 125

Figure 6-1: When creating your shot list, make sure to include pictures your couple asked for specifically, like an up-close photo of special jewelry.

✔ If the couple incorporated any special details at the wedding, like handmade favors, heirlooms worn by the bride, or individual cakes for each table (see Figure 6-2), find out ahead of time and include those on the shot list so you don't forget to photograph them.

50mm, 1/50 sec., f/3.2, 100

Figure 6-2: Find out ahead of time whether the couple incorporated any special details into their wedding and make sure to get a few pictures of those details.

Knowing where you're going and what to do when you arrive

Weddings run on a very tight schedule and often require travel between several different locations. To avoid getting lost or being unaware of the timing of the wedding, consider printing off (or putting in your smartphone) the following information:

✔ Driving directions to all the separate locations

✔ The schedule of events of the entire wedding day

✔ The phone numbers of the bride, groom, and/or wedding planner in case you run into a problem or get lost

✔ The list of family names and groupings for the formal portraits (for more on the list, see Chapter 8)

Taking care of yourself

After you have your camera gear, shot list, directions, and schedules all packed, you can make sure to get yourself ready as well. You'll be bright eyed and bushy tailed the day of the wedding if you heed these tips:

✔ Fill up the gas tank in your car the day before.

✔ Charge your cellphone the night before.

✔ Have your wedding day outfit picked out and make sure that it's clean, pressed, and ready to go. For more on putting an outfit together, check out Chapter 1.

✔ Get a good amount of sleep. Shooting a wedding makes for a very long and tiring day, so you want to be well rested.

✔ Set two alarm clocks to make sure you wake up with plenty of time to get ready. I always do this just to make sure I don't sleep through one alarm and wake up in a panic and arrive late to the wedding.

✔ Eat a good breakfast. You never know when you'll have a break to grab a bite to eat, so fill up on food before you leave.

✔ Arrive at the wedding early so you have ample time to scope out the venue and get a feel for how the location and lighting will affect your photos and composition.

Getting Ready for the Four Acts of Wedding Photography

The United States Coast Guard has a motto that I think every wedding photographer should borrow. The motto is the Latin phrase *Semper Paratus,* which translates, "Always Ready." Though a wedding photographer's job doesn't deal with national security, the idea of being ready for anything is one you should carry with you at all times.

As you prepare to shoot a wedding, think through the day as a whole before you even set foot at the venue. In Chapter 1, I mention that you should be able to visualize the wedding and anticipate the aspects of the location, lighting, and other details that affect how you photograph the event. In this section, I break the wedding down into four segments — the preparation, portraits, ceremony, and reception — and go over how you can mentally prepare for these four acts of the story so you can be ready for anything.

Documenting the preparation

As you anticipate photographing the bride and groom getting ready for the wedding, be thinking about

✔ **The location, time of day, and lighting:** Take these environmental factors into consideration and begin to think about how you can best use available light. (Flip to Chapter 3 for more about lighting.)

✔ **What lenses you want to use to achieve certain effects:** Because the wedding preparation is the first thing you shoot, put your primary lens choice on your camera the night before so you're ready to shoot the moment you arrive.

✔ **How you'll shoot details:** Consider how you'll hang the bride's wedding dress (see Figure 6-3) and arrange the accessories for the detail shots as well as how you want to capture the groom's tuxedo jacket and his accessories. (See Chapter 9 for details on these shots.)

✔ **The list of specific shots:** Be familiar with the list so you don't forget anything.

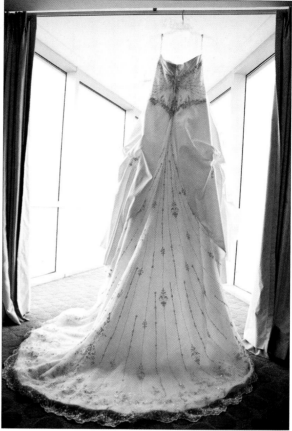

17mm, 1/50 sec., f/3.5, 200

Figure 6-3: As you get ready for the preparation photos, think about how you want to hang up the dress to take pictures.

Planning for portraits

The portrait segment of a wedding can be the most stressful for a photographer, but you can do a lot beforehand to mentally prepare yourself (check out Chapter 8 for even more portrait tips):

✔ Go over the list of family names and groupings for the formal portraits. Become familiar with the names of the most important people, like the maid of honor or the couple's parents and siblings, so you don't have to call people by saying, "Hey, you!"

✔ Check out the schedule and know exactly how much time you have to shoot each group of portraits.

✔ Scope out the location of the wedding before the actual day so that you have an idea of where you can set up the portraits and what the lighting will be like.

✔ Visualize poses that you want to use, especially for the bridal portraits, the groom's portraits, and the couple's pictures together, like you see in Figure 6-4. You can even browse through wedding blogs and magazines to find pictures that inspire your own creativity.

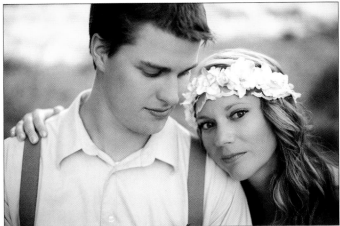

50mm, 1/250 sec., f/1.8, 100

Figure 6-4: Think about the portrait segment and plan ahead to use specific poses, like I did for this pose with this couple.

Staying on your toes at the ceremony

The ceremony has many important moments you don't want to miss. It can also be one of the most difficult segments of the day depending on the location and available light. Keep these things in mind as you anticipate shooting the ceremony:

✔ Determine how the venue and time of day affect you. For example, is the wedding outside at 2 p.m.? Or is it inside a dimly lit church where no flash is allowed? Each set of circumstances drastically changes how you capture the ceremony, and you must be prepared before it starts.

✔ Based on the venue and time of day, figure out which lenses will be most appropriate for you to capture the ceremony effectively. Also think about whether or not you need to use a flash to get the correct exposures.

✔ Think through the ceremony and note the most important photos to take, like the ring shot in Figure 6-5, and where you want to be positioned for each. (Chapter 9 notes the must-have moments to shoot during a ceremony.)

50mm, 1/640 sec., f/1.4, 320

Figure 6-5: Plan ahead for specific moments during the ceremony that you want to capture, like the ring exchange.

Arriving early at the reception

The final part of the wedding story that you want to mentally prepare for is the reception. Following are a few ways you can get ready to shoot this portion of the day:

✔ As with the ceremony (see the preceding section), consider the location and time of day and how they affect the way you shoot the reception.

✔ Anticipate your move from the ceremony to the reception, and try to get to the reception as soon as you can. You'll want to photograph lots of details there, such as the room, table settings (see Figure 6-6), food, and decorations, before the guests arrive. (See Chapter 9 for more information.)

✔ Try to plan a time during the dinner for you to quickly grab some food and perhaps a bathroom break.

✔ Look at the schedule and become familiar with the events that will take place and at approximately what time so you aren't in the middle of eating your food when suddenly the toasts begin.

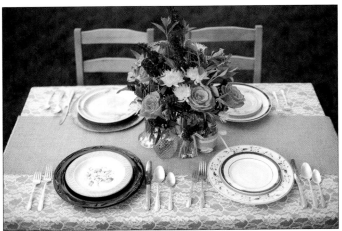

50mm, 1/160 sec., f/2.0, 250

Figure 6-6: Try to get to the reception area before guests arrive so you can grab photos of the room and tables without guests in the way.

7

Shooting Scenes to Frame the Wedding Story

*I*t's Friday night, and you've just finished watching a blockbuster film at your local theater. If you're anything like me, as soon as a movie is over, you want to talk about the movie. You discuss with your companions what you liked or didn't like, or what scenes you found funny, sad, or scary.

People use the term *scene* quite often when talking about movies or books, but unless you're a filmmaker or an English teacher, you may not know all the intricate details of what a scene actually is and how it is significant to a story. In order to tell the story of the wedding well (which should be one of your primary goals), you need to understand how a story is built, piece by piece.

In this chapter, I explore the purpose of scenes in a wedding story along with what they include. I also identify three important scenes and give you a few tips on how to photograph them.

Beginning with the Basics of Scenes

In order to tell a story, you must first understand how it's put together. The scenes are the building blocks of the day. In the following sections, I go over what scenes do and what they include.

Understanding the purpose of scenes

A *scene* is a subunit of the overall story that takes place in one setting and has a beginning, middle, and end. A scene in a photographic narrative should do the following:

- ✔ **Advance the plot:** The primary purpose of a scene is to help to move the story along.

- ✔ **Create a mood:** As you tell the story of a wedding, document the emotions of the people around you and use elements like lighting and composition to accurately portray those emotions in each photograph.

- ✔ **Forge a connection between the character and viewer:** A scene should reveal something about the people in your narrative that helps the viewer feel connected to them. Whether it's a photo of the bride with tears in her eyes as she hugs her mother or the groom laughing with his groomsmen as they help him with his tie, you want to incorporate expressions and details that help the viewer relate to the subjects.

- ✔ **Show action:** Something must happen in your scene. Stories would be very boring if all they portrayed were two people staring at each other all day! Every scene must have some sort of action that prompts change. A good example of this would be the preparation scene that I describe later in this chapter. At the beginning of the scene you see the bride in plain clothes without her hair and makeup done, but by the end of that scene you see her all made up and ready to see her husband-to-be.

Knowing what scenes include

After you're clear on the purpose of a scene, the next step is to consider what elements each scene must include to be complete. As you photograph different scenes during a wedding, make sure you ask these six questions:

- ✔ **Who?** As you take pictures, establish who the main characters are (namely, the bride and groom) by placing them as the main subject of interest in most of your photos. Be sure to convey the little things about your couple that make them unique. For example, if the bride loves to dance and is wearing ballet slippers with her dress, be sure to get a detail shot of her shoes. Or if the groom is a U.S. Marine and is wearing his uniform, get a photo of his peaked cap, like you can see in Figure 7-1. Also, make sure to include the supporting characters, like the bridesmaids, groomsmen, and families. They're important to your couple, so make sure to take plenty of photos of the bride and groom interacting with them.

- ✔ **What?** The next thing to consider is what is happening in your scene and how that fits into the overall story of the wedding. What happens when the couple sees each other for the first time during the First Look (see Chapter 9)? Or what happens when the ceremony takes place? As

you photograph each scene, be aware of the major moments taking place and make sure to capture them.

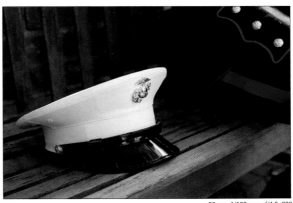

50mm, 1/100 sec., f/4.5, 200

Figure 7-1: As you establish who the characters are in your scene, make sure to show specific details about them, like this Marine's cap.

✓ **When?** Although you don't need to give specific details on time of day, you can include a reference to what time a scene is taking place. For example, if the bride is getting ready in the morning, chances are she may have laid out some pastries or muffins along with coffee for herself and the bridesmaids. Grabbing a quick photo of that spread can let the viewer know the time of day. Another more obvious example could be taking pictures of your couple in golden late-afternoon light, like in Figure 7-2, or at sunset. Lighting can tell a lot about when a scene is taking place.

✓ **Where?** Every scene needs a setting, from the location of the ceremony to the venue where the reception is taking

50mm, 1/250 sec., f/3.2, 100

Figure 7-2: The natural lighting outside can tell a viewer a lot about what time of day a scene is taking place.

place. Grab a few pictures of where your action is happening to set up the scene.

- ✔ **Why?** To have a complete scene, you need to reveal why the scene is happening. This question is probably the easiest to answer, because the white dress, veil, and tux all point to: "because they're getting married!"

- ✔ **How?** This question is an important one to consider because it covers all the unique aspects of each wedding. Though wedding schedules are generally pretty similar, the details a couple incorporates into their wedding can say a lot about them. For example, is the wedding in a church, or on horseback? Is the reception in a garden, or is it a rock-and-roll theme with an Elvis impersonator?

Seeing both the big picture and the details

When photographing different scenes during a wedding, keep in mind another important aspect of storytelling: capturing the big picture as well as all the little details.

If you open up a chapter of your favorite book, you'll notice that the author gives an overall description of the setting but then focuses on certain details that are important to the story. The same goes for wedding photography. For example, when you're shooting the reception, you need big-picture shots as well as close-ups. If you only take a picture of the room as a whole or a pulled-back shot of a table, you have a general understanding of the reception but you miss out on all the little details that really make a story come to life. Similarly, if you only focus on the details, the viewer can't see how all the pieces come together as a whole.

Figure 7-3a shows an up-close picture of a pie on a dessert table. If that was the only picture I took, you would miss out on the overall composition of how the table was arranged, like you see in Figure 7-3b.

Weddings are full of beautiful little details, so as you compose each scene in your story, make sure to include photographs of the small elements along with the overall description.

Identifying Key Scenes and How to Photograph Them

You may have to figure out what story to tell at each wedding you photograph, but fortunately you can rely on the same scenes being important almost every time. In the following sections, I discuss the three key scenes: the preparation, the ceremony, and the reception. I also go over some of the logistics of shooting each scene effectively.

a

b

Top: 50mm, 1/40 sec, f/2.8, 800

Bottom: 50mm, 1/40 sec, f/2.8, 800

Figure 7-3: Though details can help bring a story to life, seeing how all the pieces fit together is also crucial to telling a story.

The preparation

The photos of the bride and groom getting ready are the introduction to the wedding story. In this scene, the different characters are revealed and the plot begins. Following are a few reasons why this scene is so important and what your photos should accomplish:

- ✔ **Advancing the plot:** This scene lays the groundwork for the rest of the wedding story. The preparation starts to build some of the tension as the bride and groom get ready in their separate quarters.

✔ **Creating a mood:** During the preparation, the air crackles with excitement. You can show this by capturing key expressions from the bride and the groom as they get ready and interact with their friends and families.

✔ **Forging a connection between the character and viewer:** Something about preparation photos really tugs at my heartstrings. Seeing a beautiful bride being all made up and looking like a modern-day princess, or the groom looking snazzy in his tux, makes me so excited for the couple, especially if you grab a photo of each person looking straight at the camera. As you can see in Figure 7-4, the look of sheer joy in the bride's eyes communicates a lot about how she's feeling.

✔ **Showing action:** In this scene, you want to document all the little things that go into getting ready for a wedding, from the bride being laced up in her dress (see Figure 7-5) to the groom tying his shoes. Each phase should be captured, step by step, from when the preparation starts until the moment they stand ready to see their intended.

50mm, 1/60 sec., f/1.8, 500

Figure 7-4: Getting a close-up of your bride looking right at the camera can communicate a lot about her feelings.

Take a few logistics into consideration when shooting the preparation scene:

✔ **Lighting:** Lighting the preparation scene can be a bit tricky because it usually takes place indoors. If the room where they're getting ready has a large window, consider asking them to

do everything near the window so you have a good amount of natural lighting to work with. If there isn't a large window, make sure you have your flash with you. (Flip to Chapter 2 for more about flashes and other lighting equipment.)

✔ **Taking pictures of both the bride and groom:** Both the bride and groom are main characters in this story, so try to get pictures of both of them as they get ready. If they're getting ready in the same building, the logistics shouldn't be a problem. However, if your couple is getting ready in separate locations and you don't have the superpower of being in two places at once, you have the following options:

35mm, 1/50 sec., f/2.8, 400

Figure 7-5: During the preparation scene, capture all the little actions that move the story along.

- Bring along a second shooter and divvy up the preparation photos between the two of you. (See Chapter 18 for details on working with a second shooter.)

- If the two locations are fairly close together, you may be able to drive over to where the groom is getting ready, grab a few shots of him and his groomsmen, and then head over to the bride's location.

- If the two locations are too far apart, the last option you should consider is staying with the bride the whole time she's getting ready and grabbing a few pictures of the groom putting on his tux jacket when you meet up with him at the wedding venue.

✔ **Cutting out irrelevant details:** Just like a writer shouldn't put details into a story that don't add to the plot, so should a wedding photographer make sure to keep unnecessary details out of the pictures. Though you want to document what is happening on a wedding day, telling a story is part truth, part crafting the story the way you want to tell it. This includes the ability to determine what to leave out.

The room where a bride and her bridesmaids get ready can often be messy, with plastic garment bags hanging over the furniture, shoes tossed every which way, and a lot of other items strewn about the room. To capture beautiful photos of the wedding preparation scene, consider cleaning up the background of your photos before you start taking pictures. You may even ask a bridesmaid to help you tidy up before you start snapping away. This ensures that a pile of clothing or random clutter in the background won't detract from the images of your lovely bride getting her makeup done.

The ceremony

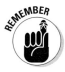

Depending on the wedding, you may include short scenes after the preparation such as the transportation to the wedding venue and the First Look. But the next primary scene that takes place is always the ceremony. This scene includes the climax of the wedding day plot: the moment the couple says "I do" and is formally introduced as husband and wife. Again, make sure to keep the following purposes in mind when shooting the ceremony:

✔ **Advancing the plot:** All the planning and preparation has built up to this moment when the couple actually ties the knot, so keep an eye out for those specific moments that move the story along, such as the bride walking down the aisle, the vows, and the kiss.

✔ **Creating a mood:** The mood of a ceremony often involves a happy sort of seriousness in what the couple is doing. Look for smiles of excitement (see Figure 7-6), tears of joy, or the moment of solemnity when the vows are said as the couple stands before their guests. You can also grab a couple quick shots of the expressions on the guests' faces, like the parents of the bride or groom while their son or daughter is saying the vows.

✔ **Forging a connection between the character and viewer:** One way to help a viewer identify with the people in your photographs is to make sure you get some up-close shots of your couple during the important moments during the ceremony. They help the viewer to know how your couple is feeling as well as a sense of what is going on. If all of your shots during a ceremony are from the back of the aisle, all your viewer will see are two people standing on a stage.

✔ **Showing action:** The ceremony scene includes many little actions that you don't want to miss, from the bride's entrance and the officiant's exhortation to the couple (see Figure 7-7) to the exchange of wedding vows and rings. Make sure to capture all those important moments.

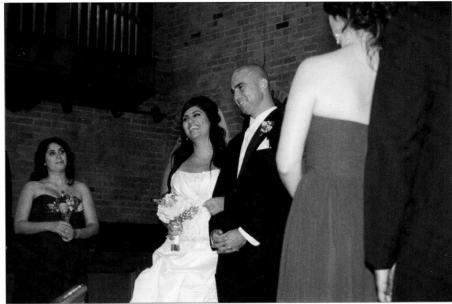

50mm, 1/100 sec., f/4.0, 1000

Figure 7-6: Capturing smiles of excitement during the ceremony can help to set the mood of your scene.

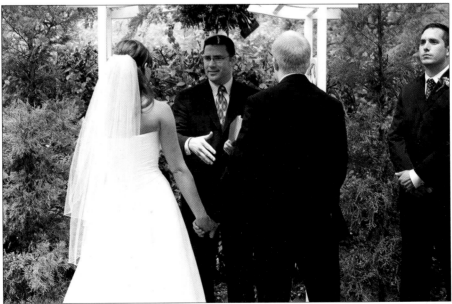

50mm, 1/400 sec., f/4.5, 250

Figure 7-7: Make sure to show all the little events during a ceremony that add to the scene, like this minister giving an exhortation to the couple.

As you get ready to shoot this scene, think through and prepare for a few logistics:

- ✔ **Capturing the setting:** In order to set the stage for the rest of the scene, I always like to get one or two photos of the ceremony site before any guests arrive (see Figure 7-8 for an example). After the preparation photos are done, consider heading straight over to where the ceremony is taking place so that you can get a few photos, uninterrupted.

- ✔ **Documenting the ceremony without being obtrusive:** Remaining inconspicuous is one of the biggest issues photographers face during this scene. Although getting all the important moments during the ceremony is crucial, it is equally important to move about quietly and not to draw any attention to yourself. Consider scoping out the ceremony site before it starts and mentally choosing different spots to stand for specific photos. Also consider using a telephoto zoom lens to help you get those tight shots of your couple without having to get too close to the stage.

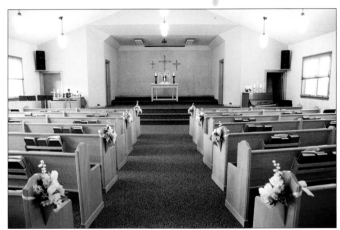

17mm, 1/100 sec., f/2.8, 1250

Figure 7-8: If possible, try to get a few shots of the ceremony site before any guests arrive. This helps to set the stage for the ceremony scene.

The reception

The reception is the final scene of the wedding, in which the story moves toward the "happily ever after" ending. As you shoot this last part of the wedding, keep the purpose of the scene in mind:

- ✔ **Advancing the plot:** The reception wraps up the plot, and the story moves in a downward arc toward the ending. Whereas the preparation photos build the story's tension, the reception is the exact opposite, releasing all the tension as your couple finally celebrates the new marriage with family and friends.

✔ **Creating a mood:** With all the feasting and dancing going on, this scene should definitely have a celebratory feel to it. You can create the mood in your photographs by focusing on all the happy faces around you, like you see in Figure 7-9.

✔ **Forging a connection between the character and viewer:** In this last scene, you want your viewer to identify with the excitement and happiness of the couple and their guests. You can help make this connection by showing candid moments like the bride hugging her father or a stolen kiss between the couple during dinner (see Figure 7-10).

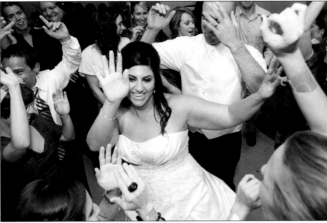

17mm, 1/60 sec., f/4.0, 800

Figure 7-9: You can set the mood for the reception by showing the happiness in the air, like this bride as she dances with her friends.

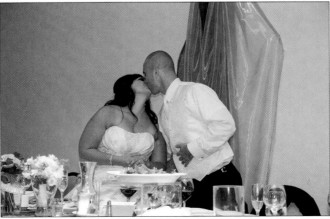

50mm, 1/50 sec., f/4.0, 800

Figure 7-10: To help the viewer identify with your couple, make sure to capture the candid moments during the reception, like this stolen kiss between the bride and groom.

✔ **Showing action:** Like the ceremony, the reception has a lot of little events, such as the cutting of the cake, toasts, garter and bouquet toss, and first dance, that help to keep the story moving. Make sure to get enough photos of each of those little moments to complete the scene.

Similar to the preparation and ceremony scenes, the reception also has a few logistical issues you'll want to think through:

✔ **Photographing the reception venue:** As soon as you're done photographing the ceremony (and the formal portraits, if they're being done after the ceremony), head straight over to the reception site so you can get pictures of the venue and tables. Getting these photos of the venue may involve talking ahead of time with the wedding coordinator to let her know to hold off guests from going inside until you've had about 15 to 20 minutes in there to capture the room, tables, and décor without guests in the way (like you see in Figure 7-11). If, however, holding off the guests isn't possible, try to find a time before the ceremony to get those detail shots.

✔ **Shooting what you want:** Like during the preparation scene, don't be afraid to cut out irrelevant details to craft the story the way you want it to be told. As you shoot different parts of the reception room, feel free to move things around, like taking the pats of butter and creamers off of a table in order to capture a clear view of the place settings. Just be sure to put everything back the way you found it!

17mm, 1/80 sec., f/2.8, 800

Figure 7-11: Arrange a time with the wedding coordinator for you to capture the reception area before guests arrive.

8

Herding Cats (Also Known as Shooting Portraits)

*O*n a perfect wedding day, the formal portraits are a breeze. You have a couple who loves being in front of the camera and works it like models. The family shows up on time (or even early) looking spick-and-span with cheery faces and children who've all had their naps. But unless the stars align or you have some crazy mojo, the portraits are going to feel a whole lot more like herding cats.

The formal portraits are, without a doubt, the most hectic part of the wedding day. As the photographer, you're tasked with sticking to a tight schedule while organizing large groups of people whose names you don't know and who may or may not show up for their pictures at the correct time. Navigating the formal portraits requires the ability to stick to an organized plan, think quickly, and keep calm in the midst of chaos.

In this chapter I cover the steps you can take before the wedding day to prepare for the formal portraits and give you a breakdown of a standard portrait shot list to ensure you get the images you need.

Taking Charge

As the wedding photographer, your job is to help the formal portraits flow as smoothly as possible. You can lay much of the groundwork in the months before the actual wedding date as you communicate with the couple. If you do your homework, you can focus on keeping the portrait sessions organized and maintaining control over the many people coming and going. In the following sections, I help you take charge of the portrait session with tips on establishing a detailed schedule, getting people where you need them, and more.

Minimizing confusion with a schedule and a list of names

When you talk with the couple before the wedding day, discuss the portraits and come up with a photography schedule and a list of the people they want to include.

Ask questions that help both you and the couple establish the order of the schedule. For example, will they see each other before the wedding (a situation known as the *First Look*)? If so, can all the formal portraits of the wedding party and family be taken before the ceremony? If they choose not to do a First Look, what portraits can you do before the ceremony to alleviate the postceremony time crunch? Is the reception at the same location as the ceremony, or is it off-site? These questions help you get a good feel of how the wedding day will run.

Let the couple know approximately how long each group of pictures takes so that they can set realistic goals. For example, here's a general schedule of the time needed for the following portraits:

- ✔ **Bride:** 30 to 40 minutes.
- ✔ **Groom:** 15 minutes.
- ✔ **Bride and bridesmaids:** 20 to 30 minutes.
- ✔ **Groom and groomsmen:** 20 to 30 minutes.
- ✔ **Bride and groom together:** 45 to 60 minutes.
- ✔ **Full bridal party:** 20 to 30 minutes.
- ✔ **Family:** 6 minutes per grouping. Depending on how many groups the couple wants, this portion may take 30 minutes to 2 hours.

This general schedule doesn't include time to travel between different locations, should the couple choose to have the pictures somewhere other than the ceremony location. Let the couple know that if they choose to take pictures at an off-site location, they need to adjust the schedule accordingly.

Ask to have the schedule, the list of names, and the location addresses a month before the wedding. This time frame gives you time to look over the schedule and make any suggestions. If changes are necessary, ask for a finalized schedule two weeks before the wedding date to ensure that you and the couple are on the same page. Make sure to bring the lists and schedule with you on the wedding day, and stick to the schedule to the best of your ability.

After I have the finalized schedule from the couple, I always ask that they send that schedule along to all the people who will be involved in the portraits. That way everyone knows exactly when and where they are supposed to be throughout the event.

Appointing a wrangler

Because you spend the portrait session in flurried picture-taking mode, having a *wrangler* who knows all the important people on the bride and groom's list is extremely helpful. The wrangler should manage the list and stage the groups while you're shooting. This setup keeps the process flowing and well organized. Ask the couple to recommend someone who isn't in the wedding party to act as the wrangler. If they don't have a recommendation, asking the wedding coordinator or your second shooter (if you have one) to assist you is another option. (For more on using a second shooter, flip to Chapter 18.)

Staying flexible

On the wedding day, some things are beyond your control. The father of the bride may show up 20 minutes late, or all the groomsmen may forget to go to the second location where the wedding party shots are being taken. Even if you have a detailed list, an established schedule, and a helpful wrangler, you run a 99.99-percent chance that the formal portraits won't go exactly as planned.

To help de-stress the situation and stay in charge, keep that smile on your face, tell the couple "It's okay!", and use your problem-solving skills to get the job done. Move forward and don't let unexpected events induce a blowing-into-a-paper-bag type of panic!

Using your outside voice

For most of the wedding day, you're the quiet observer who blends into the background, but the formal portraits are the exception. Don't shy away from getting people's attention and giving them directions. Assume a commanding presence and truly take charge of the situation.

To get the attention of a large group of people, use a loud voice (but don't scream) and say things like "Can I get everyone's attention please?" or "I need

the Smith family front and center!" To give people a direction to look toward when they hear your voice, you can raise one hand in the air so they know to look at you. If you have a particularly chatty group of people who aren't paying attention to your voice, you can whistle loudly (if you're one of those lucky people who can do that) or clap your hands to get their attention first.

After you have the group's attention and begin giving them directions, continue speaking loudly enough that they can all hear you clearly and use some visual aids, like pointing your fingers or waving someone forward, as you position them.

Getting the Key Images

After you establish an organized plan for taking charge (see the previous section), you're ready to dive in to the formal portrait segment of the day. In this section, I go over essential images to take for each type of portrait a wedding presents and explain how to capture them effectively and naturally.

Keep in mind that the shot lists I give you here are just guidelines; as the artist, you have the freedom to expand it and be creative!

As you begin the formal portraits that I describe in the following sections, I encourage you to have fun. This part of the day is where you have the most interaction with your clients. Talk and laugh with the couple while you're setting up poses, and share their excitement to be joining their lives together. The portraits also allow you to show off your artistry, so let your creativity shine!

Remember depth of field when shooting portraits. You need to consider which apertures you should use to ensure that all your subjects are in focus and to create the look you want. I provide some tips in the following sections, but be sure to check out Chapter 3 for more details.

Bridal portraits

The bridal portraits are usually the first of the day, done shortly after the bride is finished getting ready. You want to use a portrait lens, such as the 50mm f/1.4 or the 85mm f/1.8. You also want to use wider apertures, f/2 to f/2.8, to create a feminine effect with a soft and dreamy look. A few key bridal shots are as follows:

- ✔ A portrait from the shoulders up
- ✔ A shot from behind of her hair and veil
- ✔ A mid-length portrait (shot from the waist or mid-thigh up; check out an example in Figure 8-1)

✔ A full-length portrait from the front and back to show off her dress

✔ A close-up of her hands holding her bouquet

Play around with different actions or angles to get these shots; you shouldn't take all the portraits straight on. For example, for the shoulders-up picture, have the bride look at you from over her shoulder or sweep her hair behind her ear. You can also stand on a chair and have her looking up at you or out in front of her. Look around for interesting elements in the area and incorporate them into poses. Does the room have a large window? Try silhouetting the bride in the backlighting as shown in Figure 8-2. Perhaps you see a vintage chair or bench nearby. Pose the bride on the chair and shoot from a couple of different angles.

When photographing the bride, take her personality into account. If she's sweet and shy, you want to use poses to accentuate that part of who she is. If she's a fashionista who loves being in front of the camera, you can try poses that are more glamorous.

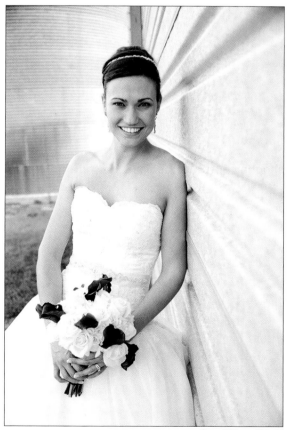

28mm, 1/320 sec., f/2.8, 100

Figure 8-1: An example of a bridal mid-length portrait.

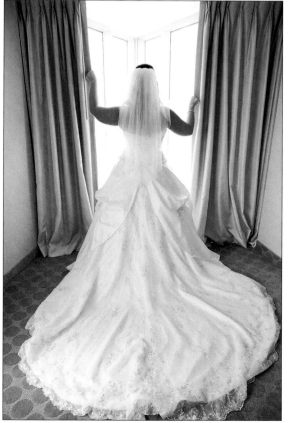

17mm, 1/80 sec., f/2.8, 125

Figure 8-2: Silhouetting the bride in the light from a large window.

Groom portraits

For the groom's portraits, you want to use a 50mm or 85mm lens, like you do for the bride's portraits (see the preceding section). Make the apertures a little narrower, say f/2.8 to f/4; doing so still gives you a blurred background but has a more masculine, less dreamy feel. Here are a few key shots for the groom:

- A portrait from the shoulders up
- A mid-length portrait
- A full-length portrait
- A close-up of the boutonniere pinned to his jacket (see Figure 8-3 for an example)

 As with the bride's portraits, look around for elements to incorporate to make your poses for the groom more interesting. Consider having the groom lean against a wall with his arms crossed or having him hold his jacket over his shoulder with his other hand in his pocket. You can also use an attractive bench or chair when you pose the groom; see Figure 8-4 for an example.

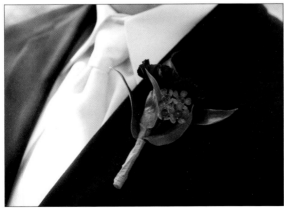

50mm, 1/50 sec., f/4.0, 100

Figure 8-3: Grab a close-up of the groom's boutonniere.

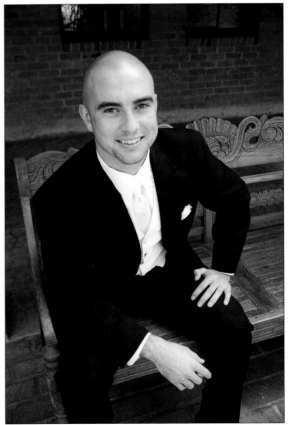

22mm, 1/100 sec., f/2.8, 125

Figure 8-4: Posing the groom on a bench or chair creates variety in your portraits.

The couple's portraits

When you shoot the couple together, you can play around with different apertures based on the desired effect. If you want both to be in focus, f/4 to f/5.6 is a good place to start. However, if you decide to stagger the couple and want only the person in the foreground to be in focus, feel free to open up the apertures a little wider. As with the bridal and groom's portraits, you can use the 50mm or 85mm portrait lens to shoot the couple's pictures. You can also use a 24mm–70mm f/2.8 if you decide you want the flexibility of a wider angle.

You can pose the bride and groom a million different ways for the couple's portraits, but I always try to get a few staples:

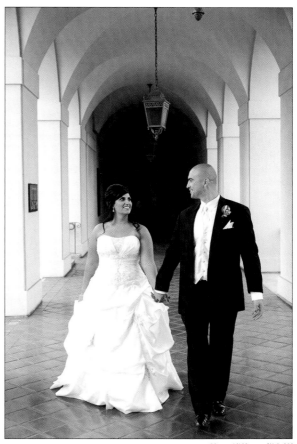

32mm, 1/100 sec., f/4.0, 800

- ✔ A close-up of the couple, both smiling at the camera.

- ✔ Standing side by side, holding hands.

- ✔ Holding hands while walking toward the camera. This pose provides some great movement in the shot, as you can see in Figure 8-5.

- ✔ Bride and groom facing each other, groom leaning in for a kiss (see Figure 8-6).

- ✔ The kiss.

Figure 8-5: Asking the couple to walk toward you allows for nice movement in your photo.

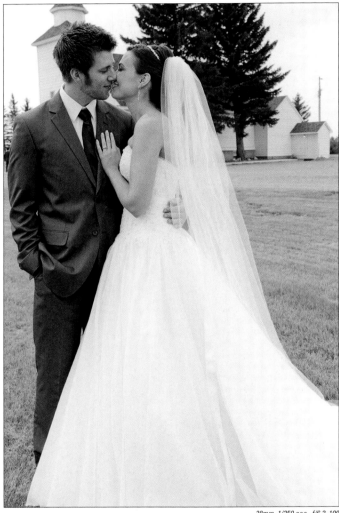

28mm, 1/250 sec., f/6.3, 100

Figure 8-6: The almost-kiss gives the viewer the sense of anticipation.

Like the bridal portraits and groom's portraits, try to look around for inter-esting elements or props, such as the piano in Figure 8-7, that you can use to add some spice and variety to your photos.

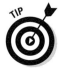

As you set up the poses, keep your camera on Continuous Shutter Mode and watch for spontaneous actions. You can get some sweet informal pictures of

the couple interacting, and you get the most natural expressions when the couple isn't paying attention to you (see for yourself in Figure 8-8).

Wedding party portraits

As you get into portraits with more people, you want to narrow your aperture more, say f/5.6 to f/8. At this point, you also want to switch lenses to a 24mm or a 24–70mm, which gives you a wider angle so you can fit all the subjects in the frame. Make sure to get the following photos:

- ✔ Bride with each individual bridesmaid
- ✔ Bride with all bridesmaids together (see Figure 8-9)
- ✔ Groom with each individual groomsman
- ✔ Groom with all groomsmen together
- ✔ Entire wedding party

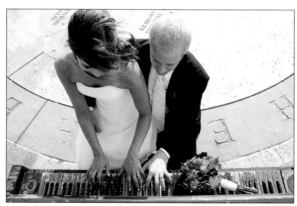

17mm, 1/400 sec., f/5.0, 125

Figure 8-7: A piano can be a fun prop for the couple's portraits.

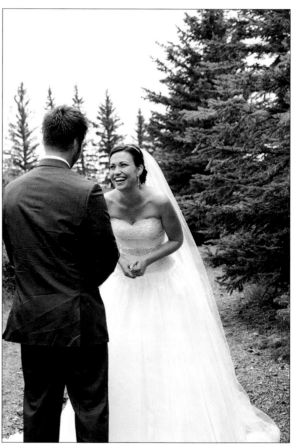

46mm, 1/200 sec, f/5.0, 100

Figure 8-8: Keep taking pictures while you're between poses.

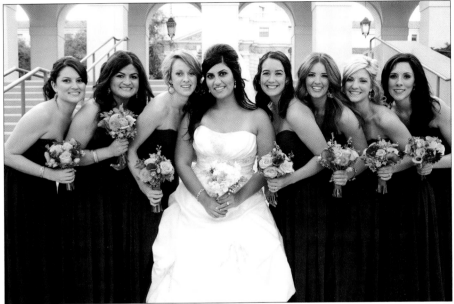

22mm, 1/60 sec, f/5.0, 200

Figure 8-9: A classic "bride and bridesmaids" portrait.

Portraits of the wedding party can be a lot of fun! This period is the time that the couple are with all their closest friends, so feed off of the energy of the group to capture the spirit of excitement and joy. For example, if you have a groom and groomsmen who are having a blast and joking around, try asking them to do a running or jumping picture, like you see in Figure 8-10. Or if the wedding party does something spontaneous, like cheering when the couple kisses (see Figure 8-11), make sure you capture those moments.

Family portraits

Of all the formal portraits, the family pictures feel the most like herding cats. In the earlier section "Minimizing confusion with a schedule and a list of names," I suggest that you ask the couple for a list of family members and specific portrait groupings; now is the time to hang on to that list like it's your lifeline.

You can use the 24mm or 24–70mm lens for the family pictures, and you should use a minimum aperture of f/5.6 and go up to f/11 based on the number of people and rows in a group. For example, if you're shooting just the bride and groom with the bride's parents, f/5.6 will suffice. However, if you're shooting the bride's extended family and have three rows of people, you want to shoot at a minimum of f/8.

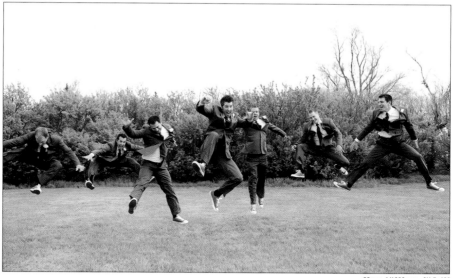

22mm, 1/1000 sec., f/4.5, 400

Figure 8-10: The jumping picture is almost always a hit with the groom and groomsmen.

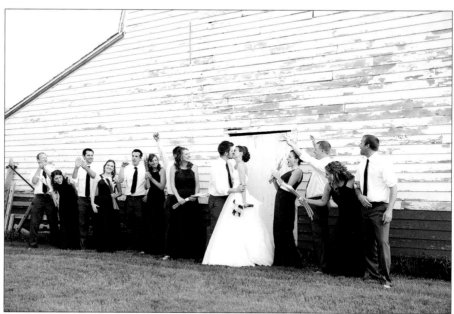

26mm, 1/200 sec, f/4.5, 100

Figure 8-11: This spontaneous cheering moment made for a great photo!

You want to consider several factors when shooting the large group portraits:

✔ **Looking for lighting:** Like all portraits, you want to find a soft light that falls evenly on all members of the group. If possible, shoot outdoors; that setting provides the best lighting. However, you may be asked to shoot indoors, in which case you may need to use a tripod, a flash, or perhaps both. If you do need a flash, make sure you use a diffuser so your subjects' faces are evenly lit and the flash illuminates everyone in the photo. Figure 8-12 shows a photo shot with a flash and diffuser.

✔ **Choosing a background:** Because the large group photos have so many subjects, choose a simple background. A background that's too noisy distracts from the subjects and makes the photo look cluttered.

✔ **Using levels to your advantage:** Look for stairs or other elements that allow you to layer people in the large group photos. Putting people on different levels helps you avoid having all the subjects standing in one long line and condenses people so you can easily fit them in the frame (as shown in Figure 8-13).

38mm, 1/80 sec., f/5.0, 500

Figure 8-12: If you're using a flash, be sure to diffuse the light.

31mm, 1/160 sec., f/5.0, 250

Figure 8-13: Using stairs in this portrait helped create pleasing dimension in the photo.

During the family photos, everyone who owns a camera seems to decide he wants a picture as well. This situation can create a big problem for two reasons. First, people get in the way of your photo; second, the subjects don't know where to look! The last thing you want is to review your family photos at home only to find that everyone is looking in a different direction. If you find yourself in this situation, be kind but firm. Ask those who are taking pictures to please wait until you're finished. You may need to ask more than once, but don't be afraid to let people know that your pictures are the priority.

The family portraits can be tense and frustrating, but don't let that show on your face. Ever. Even if you feel like pulling out your hair, take a deep breath and keep calm. The wedding day isn't about you; it's about the couple and their families.

Handling Stiffness and Stress during Portraits

Portraits are an important and time-consuming part of the wedding day, and you and the couple may have trouble relaxing. The following tips can help you reduce awkwardness or tension so that your photos capture the joy and love in a natural, beautiful way.

Guiding subjects through natural portraits

If you've ever had your picture taken, which I'm assuming you have, you've probably been in a situation where you had to hold an awkward pose for what seemed like an eternity or had to smile for so long that your cheeks started to hurt. Not only did you feel uncomfortable while getting your picture taken, but you also probably groaned when you saw the picture. Why? Because it didn't look natural!

Some of the difficulty with portraits lies in posing. How do you create a certain look in your photographs without your subjects looking stiff? Consider the following tips to getting portraits that you and your clients love:

✔ **Look to print pros.** Magazines can be a fantastic source of inspiration when you're coming up with natural poses you want to incorporate into the portrait segment of the wedding day. Not only are a plethora of wedding magazines available (which can give you ideas for everything from bridal portraits to how to arrange a wedding party), but you can also consult fashion magazines for both men and women and find natural poses that appeal to you.

✔ **"Aaaand action!"** Give your subjects something to do. For example, tell the bride to grasp the groom's lapels and pull him slowly toward her for a kiss (such as in Figure 8-14), or tell the bridal party to link arms and walk toward the camera. This strategy gives the photos movement and keeps posing from becoming stiff. Also, people often play around with the action that you give them, which results in genuine emotions that you can capture.

✔ **Try show and tell.** If you want to try a pose that's a little more complicated than "Okay, now look at me and smile," try demonstrating the pose for your subjects. People are often more willing to try a pose if they see you do it first, and it keeps them from feeling like they're doing the Hokey Pokey if they're not exactly sure what you want them to do. Showing subjects how to pose can also keep the portraits feeling more lighthearted and gives you the opportunity to further interact and build rapport with your clients.

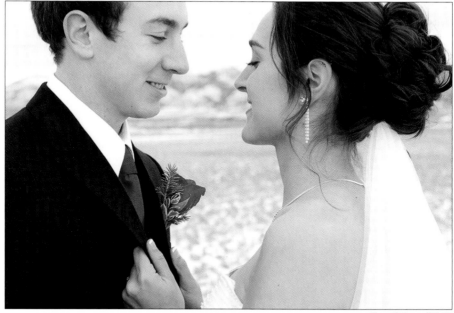

42mm, 1/200 sec., f/5.6, 125

Figure 8-14: Give your clients an action that helps them move into a pose.

✔ **Give the subjects a little R&R.** If you notice that, despite your best efforts, a pose is becoming stiff, let the subjects relax for a moment. You can tell them to do things like take a deep breath, shake out their arms, relax their face, or "swish" their knees, which prevents them from locking their legs. When they're comfortable again, reset the pose and take the picture.

✔ **Call for backup.** If the thought of memorizing so many poses is a little daunting and you're afraid you'll draw a blank, bring a pose guide or smartphone with a collection of images as a backup. Remember that people often feed off the energy of their photographer. If you're feeling stressed out about memorizing poses, that stress may translate into stiff portraits because your subjects feel uncomfortable around you. But if you're relaxed and having fun, your subjects will most likely be relaxed as well, which makes for better portraits. Having some sort of memory backup can allow a peace of mind and go a long way in letting your creative juices flow.

Staying focused

So the formal portraits are underway. You've been running around for a few hours and even helped find Grandma, who wandered away right before the family pictures. Your morning espresso has long worn off, and you're starting to feel that 6 a.m. wake-up call. This point in the wedding is where staying focused is crucial. Each wedding is a unique opportunity, and you only have the chance to do it once. Here are a few ways to keep your mind on track during the portrait session that I have found helpful:

- ✔ **Concentrate on the goal.** When you start the formal portraits, know exactly what you want to get done. Whether it's capturing people in the most creative way, sticking to the schedule, or just making sure that your exposure and composition are good in every photo, concentrate on that objective and repeat it to yourself if you find that you're distracted.

- ✔ **See the light at the end of the tunnel.** As I mention earlier in the chapter, the formal portraits are the most hectic part of the day. Keep in mind that after they're done, the rest of the wedding should be smooth sailing from there on out.

- ✔ **Cross items off your list.** I love lists. I make them all the time. Sometimes I even include something on my to-do list that I've already done, just so I can cross it off. If you have the shot list with you during the formal portraits (and you should!), crossing off what you've already done gives you a sense of accomplishment and makes what you have left to finish seem more manageable.

- ✔ **Take a break.** Even if you have only 30 seconds, take a mental break. Grab a drink of water, take a second to find your center, and get back to work.

Getting the Must-Have Moments

In This Chapter

▶ Photographing the wedding preparations

▶ Documenting the special moments of the ceremony

▶ Getting great pictures of the reception and the couple's exit

You can break any wedding day into three parts: the preparation, the ceremony, and the reception. In this chapter, I give you an organized shot list of the moments and details you don't want to miss and tips on how to capture them.

As you begin photographing weddings, one of the most important things you can do for yourself is to have a detailed shot list of things you don't want to miss. Taking a shot list with you helps to keep things organized by allowing you to check off what you've already captured and anticipating what comes next. It also gives you a point of reference if you happen to draw a blank at any time during a wedding day. The information in this chapter and the portrait list in Chapter 8 give you a complete shot list for every part of the wedding. But, as always, feel free to expand it to match your own creativity and personal taste!

Backstage Preparation: Capturing the Key Shots Before the "I Do's"

The photos of backstage preparation begin the moment you arrive on the scene. In this section I outline the important pictures to take during this time, such as the bride getting ready, the dress and details, the groom getting ready, the bouquet, invitations and wedding program, and the wedding party en route to the ceremony site.

Though tradition says that a couple shouldn't see each other before the ceremony, more and more couples are choosing to have a First Look before the ceremony so that all the formal portraits can be taken before the wedding starts. For a complete list of portraits, check out Chapter 8.

Photographing the bride before the ceremony

I love the shots of the bride getting ready. They're some of my favorite photos to take during any given wedding day. You can feel and even capture in pictures the great energy around the bride as she gets her hair and makeup done while surrounded by her closest friends. As you find out in the following sections, this segment of the wedding day also allows for a lot of creativity as you find fun ways to arrange the wedding dress, shoes, and other details.

The wedding dress

The wedding dress is one of the most important components of the wedding day. It's what every little girl dreams about wearing someday and is usually a conversation piece among the guests: "Ooooh did you see her dress? Isn't it fabulous?" Because it's such a key detail, you want to make sure you get detailed pictures of the gown.

Though you will take plenty of pictures of the bride with her dress on, grabbing a few shots of the dress by itself on the hanger can be a great way to showcase the beauty of the dress and add some variety to your photos. It also allows you to get some close-up photos of the dress's details without encroaching on the bride's personal space.

As you set up the dress for shots, make sure you handle it with extreme care. The last thing you want is to get the dress dirty before the bride even puts it on! Carefully remove the garment bag and hide any tags. Also, if you want to take the dress to a different part of the house or hotel to do some creative photos, just double-check with the bride to make sure that moving the dress is okay.

Be sure to get these must-have photos of the dress:

- ✔ A full-length shot of the front of the dress (see Figure 9-1)
- ✔ A full-length shot of the back of the dress
- ✔ A close-up shot of dress details, such as embroidery and beading

TIP

As you set up the dress shots, look around for fun places to hang the dress, such as pretty wall sconces, open doorways, wardrobes, or tall windows. Just make sure that the place you choose is well lit so that you can capture all the details of the dress.

The accessories

Though the dress is the main feature of the bride's attire, you have several other elements to consider. Look around for accessories chosen by the bride and make sure to document them in a creative manner. Take a photo of each item individually, and then feel free to group the accessories together for different photos, like in Figure 9-2. As you group the accessories together, consider limiting the number of items to around three or four to keep the photo from looking too crowded. Following are a few items to keep an eye out for:

- ✔ The veil
- ✔ The shoes
- ✔ Jewelry, such as bracelets, rings, earrings, or necklaces
- ✔ A clutch or purse
- ✔ The garter
- ✔ The perfume that the bride uses

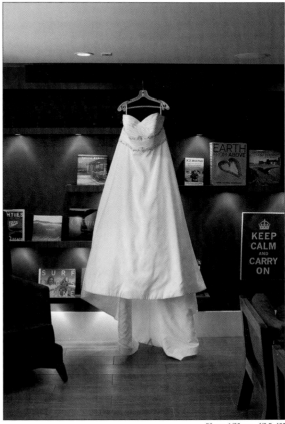

50mm, 1/60 sec., f/3.5, 400

Figure 9-1: Make sure to take a full-length picture of the wedding dress.

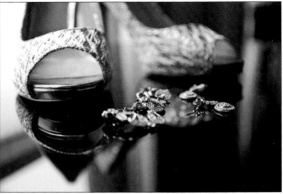

26mm, 1/80 sec., f/3.2, 200

Figure 9-2: Group the accessories together to create a unique photo.

The bride getting made up

You'll want to document moments when the bride is getting her hair and makeup done. Keep an eye out for neat photo opportunities, like when the bride is checking her hair in the mirror or when she calls her husband-to-be on her cellphone while she's sitting in the salon. Here are a few ideas for photos to take during the getting-ready time:

42mm, 1/30 sec., f/3.2, 640

Figure 9-3: Take a picture of the bride from the front as her hair is being styled.

- **The bride's hair:** Grab some shots of her face (see Figure 9-3 for an example) and some from behind her as her hair is being styled. Also make sure to get a picture of her hair after it's completed, from the side and from the back.

- **The bride's makeup:** Take pictures of her putting on her makeup (or having it done by the makeup artist). Also, make sure to take a photo of her face after her makeup is finished.

- **The bride's emotions:** While the bride is getting ready, take some candid photos to document her feelings and expressions as she prepares to be wed.

The bride getting into her dress

The big moment of the getting-ready photos is when the bride gets into her wedding dress. Usually she has some help from her maid of honor or mother, so make sure to include photos of those key people while the bride puts on the dress. Make sure to include:

- The bride stepping into the dress or having it put over her head.

- The dress being laced or zipped up. Get a close-up shot of the laces or zipper as a nice detail (see Figure 9-4) and a pulled-back shot of the whole scene. You can also use a chair or a stepladder to grab a great shot from above the scene as well.

✔ The bride with her mom or maid of honor after her dress is on.

✔ The bride putting on the garter, shoes, and jewelry (Figure 9-5 is a good example).

Note that your bride may not want to have you in the room while she is getting dressed, so consider asking her preference in advance. If she doesn't want pictures of her getting dressed, simply step out of the room and ask that a bridesmaid let you know when it's safe to come back in. I also recommend asking the bride to wait to do the last laces on the dress until you come back in the room so that you can grab a picture of the finishing touches of the dress.

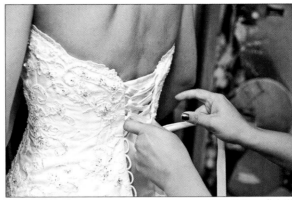
38mm, 1/125 sec., f/4.0, 400

Figure 9-4: As the bride is getting into her dress, grab an up-close shot of the laces.

50mm, 1/50 sec., f/2.8, 400

Figure 9-5: A bride putting on her jewelry can be a nice moment to capture.

The bride interacting with her bridesmaids

Though the bride is your primary focus during the getting-ready shots, don't forget about the bridesmaids. Keep an eye out for:

✔ The bridesmaids doing their hair and makeup

✔ Moments when all the girls are laughing and talking

✔ Popping the bubbly and toasting the bride, if the bride and bridesmaids are going to enjoy some pre-wedding champagne

✔ Opening the bridesmaid gifts, along with a couple pictures of the gift itself (if the bride gives her bridesmaids a gift on the day of the wedding)

The bridal portraits

After the bride is finished getting ready, you can start her bridal portraits. I talk about this portrait segment in more detail in Chapter 8, but just as a reminder, here are the absolute must-have shots to take:

- A portrait from the shoulders up
- A shot from behind of the bride's hair and veil
- A mid-length portrait (shot from mid-thigh or the waist up)
- Full-length portraits from the front and back
- A close-up of the bride's hands holding her bouquet

Getting a peek at the groom before the ceremony

Like the bride and her bridesmaids, the groom and his groomsmen also present photographic opportunities while they're getting ready for the wedding. In this section I outline the groom's accessories to photograph, a few moments while he and his groomsmen are getting ready that you should document, and a short portrait list.

The groom's tuxedo and accessories

While the groom probably doesn't have as many accessories as the bride, there are a few details to keep in mind:

- Tuxedo jacket
- Tie
- Cuff links
- Shoes

Like with the bride's dress, when you are taking pictures of the groom's tuxedo jacket, look around for interesting places to hang it up, such as a neat lighting fixture or an ornate door.

The groom getting ready

As the groom is getting ready, try to document these moments:

- Putting on and tying his tie (see Figure 9-6)
- Putting on cuff links
- Putting on the jacket
- Tying his shoes

The groom interacting with his groomsmen

As with the bride's getting-ready photos, even though your main focus is the groom, make sure to take some pictures of the groomsmen while they are all getting ready:

- ✔ Grab some candids of the guys talking and laughing

- ✔ If the groom gives the groomsmen their gifts on the wedding day, take some pictures as the grooms-men open the gifts, along with a close-up of the gift itself

The groom's portraits

If you head over to Chapter 8, you find a detailed shot list for the groom's portraits. However, in every wedding you'll want to make sure to take several types of portraits of the groom, so here is a quick list:

40mm, 1/40 sec., f/2.8, 1000

Figure 9-6: A getting-ready photo of the groom as he is about to put on his tie.

- ✔ A portrait from the shoulders up

- ✔ A close-up of the boutonniere pinned to his jacket

- ✔ Mid-length portrait

- ✔ Full-length portrait

Capturing the First Look

The *First Look* is a private moment when the bride and groom see each other before the wedding ceremony. Usually, the groom has his back to the door where the bride will enter. She then walks up behind him and taps him on the shoulder, signaling him to turn around and see his bride for the first time.

When you're photographing this moment, grab your 70–200mm lens (if you have one) and be prepared to do some sprinting!

✔ Get shots from in front of the groom as his bride walks up to him.

✔ As the bride walks up, stand in front of the groom and take one picture with him in focus (see Figure 9-7) and another with the bride as the focus as she approaches.

25mm, 1/320 sec., f/2.8, 200

Figure 9-7: You can see the anticipation on this groom's face as his bride approaches.

- Then sprint around and grab a few pictures from behind the bride as she gets closer and taps him on the shoulder.

- Position yourself so that you can capture the look on his face when he sees her (see Figure 9-8).

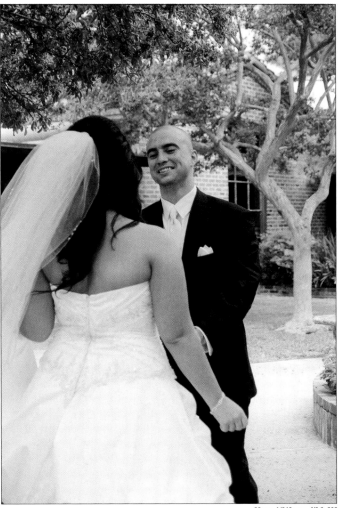

38mm, 1/640 sec., f/2.8, 200

Figure 9-8: Catch the joy on the groom's face when he sees the bride in her dress.

The First Look is my favorite part of the wedding day for several reasons:

- ✔ **You get an up-close and personal view of some of the sweetest emotions of the day.** The First Look is often filled with tears of joy from both the bride and the groom as they see each other for the first time. This moment is a prime opportunity for you to take some amazing candids as they wipe tears from each other's eyes, laugh, kiss, and just act head over heels in love.

- ✔ **It helps alleviate nerves for the couple.** In every wedding I've done, when I ask the bride or groom how he or she is feeling, the person says "I'm so nervous; I just want to see him/her!" After the couple sees each other, the wedding day takes on a more relaxed feel.

- ✔ **You can get most if not all of the formal portraits done before the ceremony.** That way, after the ceremony is over, the wedding party and family don't have to worry about sticking around for their portraits with the bride and groom. Everyone can head straight to the reception, and guests aren't kept waiting for an hour or two for the bride and groom to arrive.

When you're communicating with the bride and groom in the months before the wedding, don't be afraid to suggest a First Look and explain its benefits to the wedding day.

Though a First Look can be a very special moment to capture, some couples are very traditional and don't want to see each other until the bride walks down the aisle at the ceremony. Be aware that not all couples choose to have a First Look, and that's okay!

Taking product shots: Flowers, rings, and other things

A wedding day is made up of many small details, all carefully chosen by the bride and groom. As the photographer, you want to make sure to document these details because they are important to the overall story (see Chapter 7 for more on framing the wedding story). In this section I discuss what types of details to look for and photograph when it comes to product shots.

The flowers

Any given wedding day is likely to include a variety of floral arrangements. Consider shooting the following photos:

- ✔ The bride's bouquet (check out Figure 9-9 for an example)
- ✔ The bridesmaids' bouquets
- ✔ The groom's and groomsmen's boutonnieres
- ✔ The mother's and grandmother's corsages

You have a couple of options for setting up these shots. You can either take pictures of the different floral arrangements alone, or you can get close-ups of things like the bouquets or boutonnieres while members of the wedding party are holding or wearing them. Or you can do both! The choice is really up to you.

The rings

Another key element that you want to photograph on the wedding day is the wedding rings (this is where your macro lens will really come in handy). Be very, very careful when taking pictures of the rings! Losing the wedding rings would be disastrous, so be meticulous about handling them and knowing exactly where you put them or who you give them to after you finish.

I recommend that you take a couple pictures of the rings:

- ✔ A classic zoomed-in shot of just the couple's rings

- ✔ A creative shot of the couple's rings together with other details of their wedding day, such as the ring box, wedding program, the bride's bouquet, or on the heel of the bride's stilettos. Figure 9-10 is a good example of a creative ring shot.

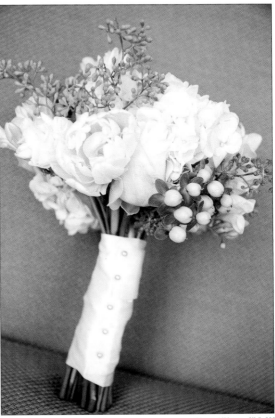

22mm, 1/80 sec., f/3.5, 200

Figure 9-9: Make sure to take a picture of the bride's bouquet.

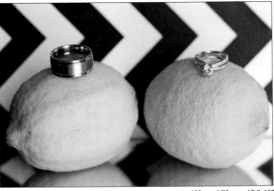

100mm, 1/80 sec., f/5.0, 160

Figure 9-10: Here is an example of a creative ring shot.

The paper goods

The wedding couple may have taken a lot of care to select just the right invitations, programs, and other paper items, so these paper goods are a detail you don't want to miss. Here are a few items to keep in mind when shooting the wedding day:

- The invitation suite, which can include the invitation, envelope, RSVP card, registry card, and driving directions

- The wedding program (check out Figure 9-11 for an example)

- The wedding vows, if the couple has written their own

- The couple's wedding-day letters to each other, if they've written any

29mm, 1/80 sec., f/5.6, 500

Figure 9-11: This wedding had very unique wedding programs; keep an eye out for photo opportunities such as this one.

Going to the chapel: The vehicle shots

If the bride and groom chose to get ready at a location separate from the ceremony site, they will use some sort of transportation to head over to the wedding. Depending on whether or not the bride and groom see each other before the ceremony, you will want to get some photos either of just the bride or of the couple together as they make their way to the ceremony. A few ideas of pictures to take are:

- The bride (or couple) as she walks out to the vehicle
- The bride (or couple) getting in the vehicle
- The bride (or couple) after she is situated inside, ready to head to the wedding

It's Showtime! Shooting the Ceremony

When the wedding preparations are done, it's go time. The ceremony is the pivotal event during the wedding day, so you want to make sure you capture all the important moments that take place. You don't get second chances with most of these shots! In this section I go over what happens during a typical ceremony and give you a list of photos you'll want to take.

Some officiants or venues have very specific rules about the use of flash during a ceremony and how close the photographer can get. It is important to ask about these kinds of stipulations in advance so that you don't have any surprises on the day of the wedding. If you have to work around rules, come prepared with an alternate plan, such as a lens with a very large aperture (in case you can't use flash) or a telephoto zoom lens (in case you can't get close to the stage).

Putting the processional in pictures

After the guests are seated and the music starts to play, get yourself ready to photograph the processional by heading up to the front of the aisle. Choose a spot at the front of the room that has a clear view of the aisle, but make sure that you're not in the way of the incoming bridal party and bride.

When the processional starts, be ready to take the following photos:

- Seating of the grandparents
- Seating of the mothers
- Mothers lighting the candles (if a unity candle is a part of the ceremony)
- Groom and officiant entrance (the groomsmen are included here as well if they don't escort the bridesmaids down the aisle)
- Bridal party entrance
- Flower girl and ring bearer as they walk down the aisle
- A candid with the bride and her father right before their entrance (if you have a second shooter with you who is able to grab this shot)
- Bride's entrance with her father (see Figure 9-12)

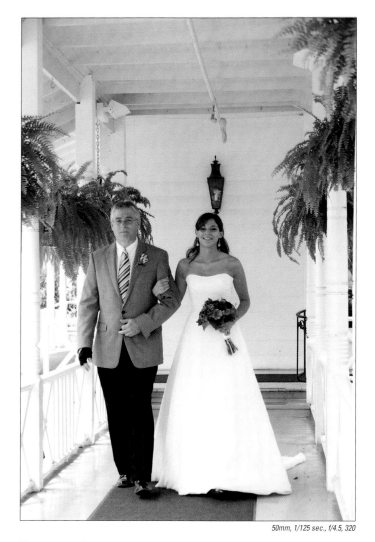

50mm, 1/125 sec., f/4.5, 320

Figure 9-12: The moment everyone has been waiting for: the entrance of the bride.

Catching key moments during the ceremony

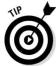

When the ceremony starts, you'll want to take several key shots (as I describe in the following sections). When you have the opportunity, consider heading to the back of the room or up on a balcony to grab a couple photos of the scene in its entirety. You can also find creative angles to spice things

up a bit, like in Figure 9-13 (taken at ground level). Then you can move up near the front again and take up-close shots and pulled-back shots of key moments all without getting too close to the stage.

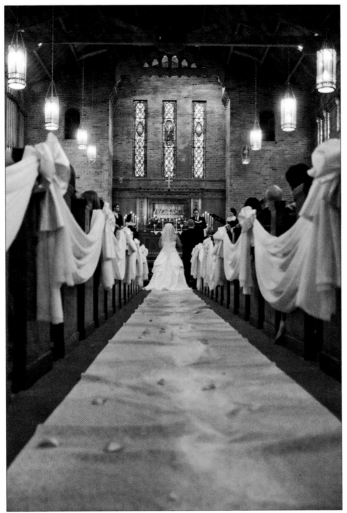

26mm, 1/50 sec., f/2.8, 1000

Figure 9-13: Taking a shot of the scene from ground level can add some creativity to your photos.

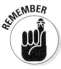

As you photograph the ceremony, always try to remain as inconspicuous as possible. The last thing you want to do is be a distraction to the guests as the bride and groom share in this momentous occasion.

Special moments leading up to the vows and ring exchange

During the first part of the ceremony, you want to make sure to document some key events that typically have a lot of significance for the couple and their families. These moments can include:

- The father of the bride hugging and kissing his daughter and giving her hand to the groom
- The bride handing off her bouquet to the maid of honor
- The couple turning to face one another and joining their hands
- A performance of special music by a friend or family member
- Lighting a unity candle or pouring sand
- Other unique moments such as a message to the couple from the officiant or a prayer with the couple, like in Figure 9-14.

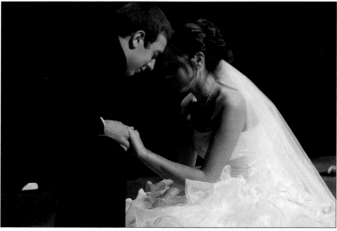

50mm, 1/30 sec., f/1.8, 800

Figure 9-14: This couple chose to have a time of prayer together during the ceremony.

The vows and ring exchange

As the wedding ceremony progresses, watch for when the vows and ring exchange take place and make sure to photograph the following moments:

- A close-up of each person saying his or her vows
- The groom putting the ring on the bride (see Figure 9-15)
- The bride putting the ring on the groom
- The reaction of the couple's parents

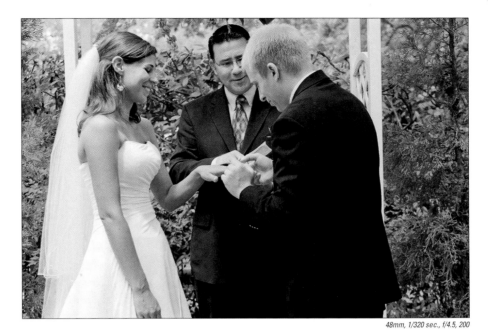

48mm, 1/320 sec., f/4.5, 200

Figure 9-15: An example shot of a groom putting the ring on his bride.

The kiss

After the vows and ring exchange take place, the ceremony starts to wind down. The officiant usually says something like, "Now, by the power vested in me by the State of [insert state name here], I now pronounce you man and wife." He then turns to the groom and says, "You may kiss your bride." These lines are your cue for the big moment of the ceremony. Have your camera ready and shoot several pictures of the following:

- ✔ The lifting of the veil (if applicable)
- ✔ The kiss (see Figure 9-16)

The introduction of the couple as Mr. and Mrs.

After the kiss, the officiant announces the couple as the newly married Mr. and Mrs. Make sure to capture these closing images:

- ✔ The couple as they turn and face the audience
- ✔ The maid of honor handing the bride her bouquet

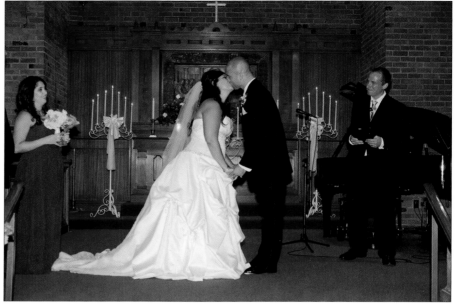

35mm, 1/100 sec., f/4.5, 500

Figure 9-16: The kiss at the altar is one of the most important moments during the ceremony.

Marking the departure

As the wedding ceremony comes to a close, the guests typically stand and cheer for the newlyweds. The happiness and enthusiasm of the guests and wedding party is an exciting part of the day to capture! Here are a few ideas on how to photograph the big departure:

- ✔ Often the bride and groom hug each set of parents before walking down the aisle. Make sure to take photos of those hugs.

- ✔ Head to the end of the aisle and take pictures as the couple walks toward you.

- ✔ Let the couple pass you, and then snap a few photos as they head outside and walk toward the limo or the reception.

- ✔ Follow the couple outside and have the couple kiss right outside the church (or other venue) as the new Mr. and Mrs. (see Figure 9-17).

- ✔ Grab some photos of congratulatory hugs from the bridal party.

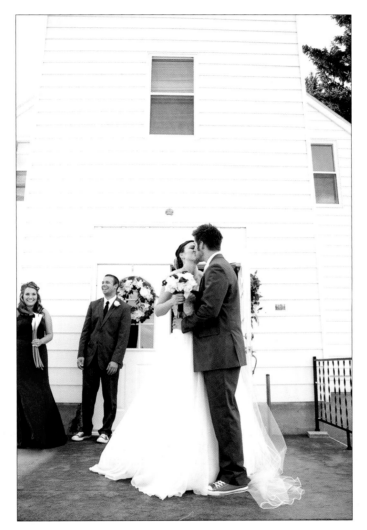

18mm, 1/1600 sec., f/2.8, 640

Figure 9-17: After the couple exits the ceremony, grab a picture of a kiss between the newlyweds.

Let's Celebrate! Staying Busy at the Reception

When you arrive at the reception, you're on the home stretch. This segment of the wedding day is often the most relaxed because the couple and their family and friends have the chance to kick back and celebrate. Though the reception can be laid back, as the wedding photographer, you still have quite a few moments and details to capture, which I go over in the following sections.

Getting the detail shots

Of all the settings on a wedding day, the reception is usually the one that is most carefully decorated. Some receptions are like eye candy for a photographer! The venue may be decorated with a lot of DIY (do-it-yourself) details, flowers, food, and other items to document, as you discover in the following sections.

If possible, try to get to the reception site before the majority of the guests do so you can snap photos of the location and decorations uninterrupted.

The location

The first thing to photograph when you arrive at the reception is the venue itself. As I discuss in Chapter 7, you should capture the big picture and the details. Consider shooting the following pictures:

- ✔ A pulled-back shot of the whole reception area
- ✔ Close-up details that make the venue unique, such as ornate doors, beautiful fountains, or interesting lighting fixtures
- ✔ A shot of the outside of the venue, if there is anything noteworthy about it, like if the reception takes place on a yacht or a large outdoor tent strung with lights

The cake

After you finish shooting the venue, look around for the cake table. The cake is one of my favorite things to photograph at a reception because it's just so pretty! When you're documenting the cake, make sure to shoot from eye level and snap the following pictures:

- A horizontal shot of the cake from the base up

- A vertical shot of the cake, (see Figure 9-18a for an example)

- Any close-up details, like flowers or the cake topper, like in Figure 9-18b

- A shot of the whole cake table

- Any details close by, such as stacked plates, cute napkins, the toasting glasses, and the cake-cutting utensils

The table settings and paper goods

Another couple of details you don't want to miss are the table settings and paper goods. A lot of time and effort from the bride and groom go into choosing centerpieces, linens, and table settings, so make sure to photograph the following items:

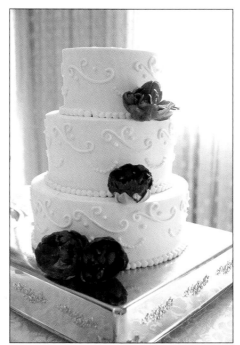

a

- A full view of a whole guest table (see Figure 9-19), and a full view of the head table

- An individual table setting, like in Figure 9-20

- The centerpiece

- The table number and name cards

- The menu cards

b

Top: 32mm, 1/80 sec., f/3.5, 1000
Bottom: 32mm, 1/100 sec., f/2.8, 800

Figure 9-18: A vertical shot of a wedding cake gives the full view. Make sure to take an up-close shot of any details on the cake, too.

50mm, 1/50 sec., f/3.2, 200

Figure 9-19: Take a photo of the table in its entirety.

The food and beverages

If one similarity links all weddings, it's that some kind of food and drink will be available. Here are a few ideas of pictures to take of the food and beverages:

20mm, 1/80 sec., f/2.8, 500

Figure 9-20: Make sure to also include an up-close shot of an individual table setting.

✔ **The appetizers:** If an hors d'oeuvres table has been set, take some pictures of the whole table and then grab a few close-up photos of individual items. If servers are passing trays of hors d'oeuvres, make sure to grab pictures of the food on the trays before the servers take them out to the guests.

✔ **The dinner:** Whether the dinner is buffet style or served, take a few photos of the food before it is eaten.

↙ **Drinks:** Some couples choose to have a signature drink at the reception, like a special sangria or cocktail. Also look around for champagne flutes for the toasts, like in Figure 9-21.

↙ **A special food table:** If a dessert bar, popcorn bar, or cupcake table is part of the reception, document it.

50mm, 1/500 sec., f/2.2, 320

Figure 9-21: The champagne glasses can make a lovely detail photo of the reception.

The wedding favors and decorations

As I mention earlier in this section, the reception typically has the majority of the decorations of a wedding day. They can be a lot of fun to photograph! Make sure to keep an eye out for the following:

↙ Decorations such as handmade signs, props, banners, floral arrangements, and framed photos

↙ Wedding favors, such as the bottles of olive oil that one couple had made from their family olive orchard for the occasion (shown in Figure 9-22)

17mm, 1/60 sec., f/5.0, 500

Figure 9-22: Make sure to look around for special favors like this and take a photo.

Introducing the newlyweds and the wedding party

After the guests have arrived at the reception, be prepared for the introduction of the newlyweds and the bridal party. You'll want to take a picture of the following scenes:

- The entrance of each member of the bridal party
- The couple as they enter (take several photos)
- Reactions from the guests as the couple enters, like people cheering and clapping

Listening to the toasts

As the meal is being eaten, or before the cutting of the cake, friends of family will probably make toasts to the happy couple. If the following events occur, be sure to take a few pictures during each:

- A speech by the maid of honor
- A speech by the best man (see Figure 9-23)
- Toasts from the parents
- The couple's reaction to the toasts

Cutting the cake

As the reception progresses, it's likely to have a moment where the couple cuts the wedding cake before it is served to the guests. Following are a few ideas of pictures:

- The couple's hands with the knife as they are about to cut the cake
- A pulled-back shot of the couple cutting the cake
- The couple feeding each other cake (see Figure 9-24)
- The cleanup, if they smash the cake, like in Figure 9-25

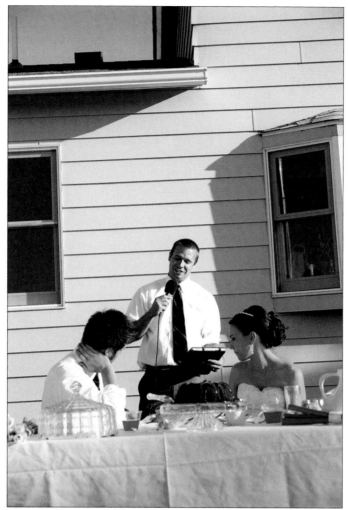

36mm, 1/500 sec., f/4.0, 100

Figure 9-23: Get a photo of the best man's speech.

50mm, 1/640 sec., f/4.5, 100

Figure 9-24: Here is an example of a bride and groom feeding each other wedding cake.

17mm, 1/50 sec., f/4.0, 800

Figure 9-25: A lot of laughter is involved if a bride and groom smash the cake in each other's faces.

Capturing the first dance

If the wedding has dancing, it is almost always kicked off with the couple's first dance. If this is the case, head over to the dance floor and take these photos:

- A shot of the groom leading his bride out to the dance floor
- A few close-ups of the couple as they dance
- A few pulled-back photos as the couple dance (see Figure 9-26)

50mm, 1/100 sec., f/4.5, 250

Figure 9-26: Capture this special moment between the bride and groom as they have their first dance.

Dancing with Mom, Dad, and guests

After the couple's first dance, several other dances usually follow that you should capture. They may include:

- The father-daughter dance
- The mother-son dance (see Figure 9-27)
- The "money dance" (also called the *honeymoon dance*) where guests give a dollar to dance with the bride or groom

And be sure to take plenty of photos of the guests dancing the night away with the couple.

50mm, 1/50 sec., f/3.2, 800

Figure 9-27: The dances with mom and dad are a really sweet moment, like the mother-son dance shown in this picture.

Tossing the garter and the bouquet

The last event during a reception is generally the bouquet and garter toss. This moment can be full of laughs as the groom takes the garter from his wife, or when the single ladies all scramble for the bouquet. Make sure to take pictures of the following moments:

✓ The bride, ready to toss the bouquet, with all the single ladies in the background (like in Figure 9-28)

✓ The bride throwing the bouquet

✓ The mad dash to catch the bouquet

✓ The bride and guest who caught the bouquet

✓ The groom getting the garter from bride

✓ The groom with garter and all the bachelors in the background

✓ The groom tossing the garter

✓ The bachelors scrambling to catch the garter

✓ The groom and man who caught garter

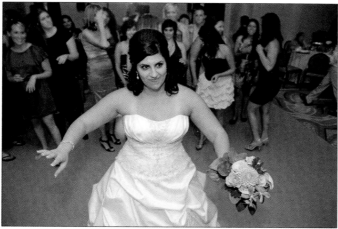

17mm, 1/60 sec., f/3.5, 800

Figure 9-28: Take a photo in front of the bride before she throws her bouquet.

Saying goodbye: The couple's departure

As the wedding comes to a close and the couple gets ready to leave and start their new life together, make sure to take these pictures:

✓ Guests lining up to say goodbye

✓ "Just married" artwork on the getaway vehicle

✔ The couple walking out and the throwing of the rice, petals, or blowing of bubbles (if this didn't occur at the ceremony venue)

✔ The couple getting into the car

✔ The couple right before they drive away, like in Figure 9-29

✔ The car as it drives away

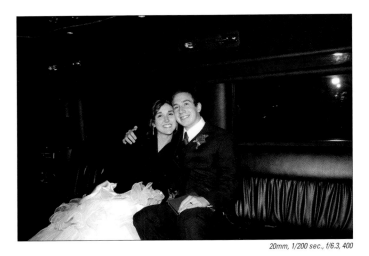

20mm, 1/200 sec., f/6.3, 400

Figure 9-29: Before you pack up your camera be sure to take a shot of the couple before they drive away.

Part III

Creating the Package for the Newlyweds: Editing and Album Design

The 5th Wave By Rich Tennant

"I can have the wedding photos printed and bound in a lovely album like this, or for something more practical, on a set of drink coasters."

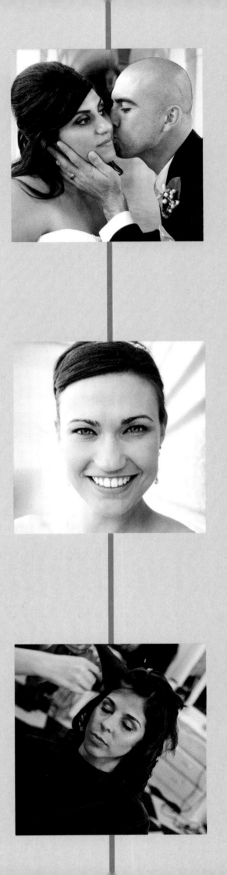

In this part . . .

You've photographed an entire wedding — congratulations! Although the hard part is over, you still have some work to do. You'll want to ensure that your photos are perfectly polished before handing them over to your newlyweds. In this part I take you through the postproduction process, beginning with how to download the images onto your computer and ending with creating a stunning wedding album for your couple to cherish. In between, I go through the editing process and give you tips on how to correct things like white balance and tone, how to crop your photos, and even how to smooth out your subject's skin! After you're finished with postproduction, you'll have some beautiful images that you can be excited and proud to hand off to your clients.

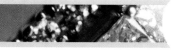

10

Back at the Studio: Getting Organized and Preparing to Edit

In This Chapter

▶ Setting up a productive workspace with the right tools

▶ Downloading your photos onto your computer and getting organized

▶ Prepping your camera for your next job

The wedding day is over. You've had a chance to catch up on some sleep, and you've finally gotten over the lingering feeling that you've been hit by a bus. Congratulations on making it through the hard part! But before you bust out the party hats and blowers, keep in mind that you still have a lot of work ahead of you. The nice thing about the postwedding work is that it can be done from your own home or studio, so if you still want to wear that party hat, that's totally cool.

As you begin to sift through all the photos you took of a wedding, you'll need a few pieces of hardware along with the knowledge of how to use your tools and work through your photos in a streamlined manner. In this chapter, I cover specific equipment you need in order to get started and go over how to create a workspace that helps you to be most productive. I also explain how to download and back up all your images and get them ready to start the editing process. Finally, I outline how to get your camera and memory cards ready for your next shoot.

Creating a Workspace That Works for You

Like any other profession, a photographer needs a place to work and the right equipment to get the job done. In the following sections, I go over each tool you need as well as specifications to look for when making your purchases. I also outline how to set up a workspace that lends itself to productivity.

Getting the right gear

With the advance of digital technology, wedding photographers these days have it much easier than those who worked with film in that you no longer have to set up a whole darkroom to process all your pictures. Instead, you can set up a "digital darkroom" with a computer, photo-editing software, a card reader, and an external hard drive.

Computer

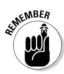

One of the most important tools of the trade for a digital photographer is a computer because it enables you to sort through, edit, and process all your images. A lot of debate takes place among photographers about whether a Mac or PC is better, or a laptop or desktop. But in the end, I believe those issues come down to a matter of preference and that you can accomplish your goals with either type, as long as the computer you choose has the right kind of hardware to handle the intensive editing programs and quantity of large files. Here are some of the basic specifications to look for when choosing a computer to handle your digital photography workflow:

- **Processor:** The processor (also known as the CPU) functions like the brain of the computer and is responsible for handling all the computer's operations. A CPU can have several cores (most often two, four, or six), which helps it work through several operations at once with ease. The more cores your computer has, the faster it can "think." As a photographer using heavy-duty editing programs, you will want multiple cores in your computer. A good place to start would be a quad processor (four cores) at a minimum speed of 2 GHz.

- **Memory:** The next specification to consider when choosing a computer is the amount of memory, or RAM, that it has. The more RAM your computer has, the faster it is. A lot of computers come with 2GB of RAM, but I recommend getting one with at least 4GB to keep your computer running smoothly while running multiple programs.

- **Hard drive:** The hard drive is where your computer stores all your files. As digital cameras get more advanced, the bigger the image files become. In order to have enough space to store all those files, I

recommend getting a hard drive with a minimum of 250GB but suggest springing for a larger one, like 500GB, if possible.

✔ **DVD burner:** If you plan on giving your clients a hard copy of their images or you want an extra place to back up your files, make sure to invest in a computer with a DVD burner.

Photo-editing software

Like everything in the photography equipment world, when it comes to photo-editing software, you have several options. However, for the sake of clarity, in this section I only refer to the programs that have become the wedding-industry standard: Adobe Lightroom and Adobe Photoshop.

✔ **Adobe Lightroom:** This database-driven program is a wonderful tool for managing a large number of files. It's incredibly easy to learn to use, and it sells for about $150. Lightroom allows you to import, sort through, and organize your photos all from within the program. It also has basic editing tools that allow you to correct and enhance white balance, color, exposure, contrast, and clarity. You can also crop and rotate images, correct lens flaws, sharpen images, and use an adjustment brush to fine-tune parts of a photo, just to name a few things! (See Chapter 11 for more detail on editing options.) On top of that, Lightroom comes with modules that allow you to create proofs, collages, and slideshows. Many photographers use Lightroom for up to 90 percent of their editing and only use Photoshop for further fine-tuning.

✔ **Adobe Photoshop:** Photoshop has been hailed as the mother of all editing programs and sells for around $700. It can do detailed image manipulation that Lightroom cannot, such as local color adjustment, removing objects from an image, creating layers, adding textures, and much more. It is an extensive program that has endless possibilities. However, the downside to using Photoshop exclusively is that it can be cumbersome to manage and keep track of the large number of photos you have for each wedding you shoot, because it doesn't use a database like Lightroom does.

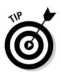

Because each program offers distinct abilities that the other does not, I recommend using both programs together. After making your basic adjustments in Lightroom, you can right-click a photo and select Edit in Photoshop to open the file. After you finish tweaking the image in Photoshop and save the file, it's stored back in Lightroom with your other images.

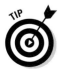

Now you may be thinking, "What if I don't want to buy two programs at once?" If purchasing both programs right away isn't in the budget, or you're brand new to photo editing, I highly recommend starting with Lightroom and working your way up to Photoshop at a later point in time.

Card reader

After you've taken all your photos of the happy newlyweds and headed back to your studio, you may be wondering how to get all those pictures from your camera to your computer. Some cameras come with a USB or FireWire cable that you can plug into your camera and computer to transfer the files. However, this method can take quite a long time if you have hundreds (or even thousands) of photos to transfer. An easier way of downloading your pictures is to use a little device called a card reader, which you can see in Figure 10-1.

Figure 10-1: You can use a card reader to transfer photos from your memory card to your computer.

Many different brands of card readers are available (most around $20 to $30) and can get the job done. Keep in mind that the most important thing to consider when buying a card reader is that you need to make sure that it's compatible with the type of memory card your camera uses. A card reader with only an SD slot cannot read a CF card, and vice versa. However, many readers have the ability to read both types of memory cards.

Flip to Chapter 2 for more about memory cards; I explain how to use a card reader to download your photos later in this chapter.

External hard drive

Though computers are wonderful things and I can't imagine doing my job without them, they can be unreliable at times. Even if you buy the best computer on the market, there's always a chance that it will fail and you will lose every bit of information you had stored. Imagine what that would be like if you were working on a wedding and didn't have your photos backed up somewhere! To prevent the gut-wrenching feeling of telling your newlyweds that you lost all their photos, consider purchasing an external hard drive to back up all your images. (I explain how to use an external hard drive in the later section "Backing up your photos.")

External hard drives are becoming more and more affordably priced, and the amount of information they store keeps rising. I purchased one for less than $100, and it holds a terabyte of information. That's a lot of pictures!

Setting up a productive work environment

You'll want to set up all your equipment in a workspace that will inspire your productivity. Your best workspace will look different than another photographer's, but while you customize your area, keep a few things in mind:

- Avoid littering your desk with clutter like trash, old dishes, papers strewn everywhere, and random knick-knacks. Clutter often leads to a disjointed thought process.

- Put your important tools in a place where you can always find them quickly. Nothing derails productivity like the need to search for an item in the depths of your desk drawers and the resulting frustration when you can't find it.

- Place decorative items or pictures in your work area that inspire your creativity.

- Remove distractions from your area, like a book you really want to read or your phone buzzing with text messages. Clear out distractions while you work and pick those things up when you take a break.

Transferring Images to Your Computer and Keeping Them Safe

Before you can start the editing process, you need to take a few steps to get the photos onto your computer and keep track of them. The following sections outline how to transfer your wedding photos from your memory card to your computer and how to back them up for safekeeping. I also go over how to organize your pictures so you can find them easily and how to import your images into Lightroom so you can start editing.

Using a card reader to download pictures

When a wedding is over, I'm always anxious to get my pictures onto my computer as soon as possible. For that short amount of time, the memory cards are the only place those important images are stored, and my brain is racing with the "what ifs": What if something breaks? What if my cameras are stolen with the cards still inside?

To minimize the chance of losing those photos, always transfer them to your computer and back them up as soon as you can. Transferring pictures from your memory card to your computer is quite easy and takes a few simple steps:

1. **Turn on your computer, create a new folder where you want your original wedding files to be stored, and name the folder appropriately (such as "Anderson Wedding").**

 Keep the new folder window open for the transfer.

2. **Plug the card reader into the USB port on your computer.**

3. **Remove the memory card from your camera (or from its case) and insert it into the card reader.**

 When your card mounts (that is, when your computer identifies the reader and the card), an icon for the card reader appears either on your desktop or under Devices (Mac) or My Computer (Windows).

4. **Double-click on the card reader's name or icon to open up the window.**

 You should now have two windows open: the card reader window and the new folder window.

5. **In the card reader window, select all the image files by pressing Command+A (on a Mac) or right-clicking a file and choosing Select All (if you're using Windows).**

 You can see what this step looks like in Figure 10-2.

Figure 10-2: To transfer photos from your memory card to your computer, select all the images on the card and drag them to the appropriate folder.

6. **Click and drag the selected files over to your new folder window.**

 A dialog box pops up telling you the estimated time for the transfer.

7. **After the photos have been transferred over to your computer, eject the card reader by right-clicking the card reader's icon and selecting Eject.**

 When you no longer see the card reader's name or icon on your computer, you can safely unplug the device from your USB port.

If you can, avoid erasing the photos from your memory card until you are finished with the editing process, just in case of an emergency. Until the photos have been downloaded, backed up, and edited, you can never be too safe.

Backing up your photos

After you transfer all your wedding photos onto your computer, the next step is to make sure those images are backed up in a separate place in case your computer malfunctions.

You can choose from two popular methods of backing up information: with an external hard drive or an online backup service.

- **External hard drive:** As I mention earlier in this chapter, external hard drives are affordably priced, easy to use, and can store a ton of information. To back up your images, all you need to do is plug the external drive into your computer (usually through a USB plug) and copy a folder of images from your computer to the drive. In fact, the steps in the process are almost exactly the same as transferring images from a card reader (see the preceding section). I usually back up the original files to the external hard drive as soon as I've transferred them from the card reader; then I back up the photos a second time after I've finished editing them.

- **Online backup service:** A second option for backing up your files is to use an online service to store all your information. Instead of using a piece of hardware, you purchase a yearly subscription to an online service, ranging from about $50 to $100 a year, which lets you store files "in the cloud," meaning on the Web. A benefit of this option over an external hard drive is that all your information is stored in a separate location, which protects you in case of fire or theft. Several online backup services are available with a couple different options. To find one that suits you, I recommend just doing an Internet search for "online backup service" and browsing through the different services available.

Though some people may use one type of backup plan or the other, I suggest using both! It is always better to beat the odds and store backups in two separate places.

Organizing photos into folders

As your photography business grows, having a system for organizing your pictures becomes more and more important so that you can find them easily. Rather than coming up with a system after a couple years of work when your folders are scattered haphazardly throughout your hard drive, start your business with a well-organized plan from the beginning to make your life a little easier.

The following are two methods of organizing your work. Keep in mind that these methods are just suggestions. The most important thing when organizing is finding a system that works best for you!

- **Organizing by category and year:** This method is particularly helpful if you shoot more than just weddings (say you also specialize in family portraits and graduate portraits). Label your root folder with a category name, like *Weddings*. Inside that folder, set up a number of separate folders labeled by year. In each of those you can store every wedding you shot that year in a separate file, labeled by the client's last name, like you can see in Figure 10-3.

- **Organizing by client name:** Another way to organize your photos is to set up an alphabetical filing system and arrange your folders by your client's last name. Label your root folder with a title, such as your business name. In that folder, make 26 folders labeled A to Z. Inside each lettered folder, place client files that correspond with the correct letter (see Figure 10-4 for an example).

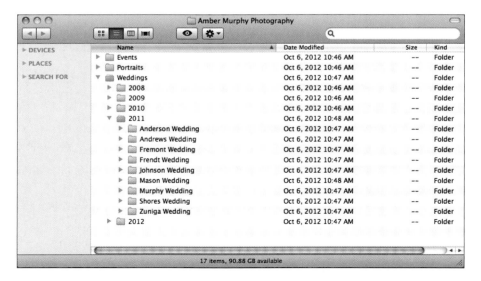

Figure 10-3: One way to organize your photos on your hard drive is to categorize them chronologically.

	Name	▲	Date Modified	Size	Kind
▼	A		Oct 6, 2012 9:59 AM	--	Folder
▶	Abbot Wedding		Oct 6, 2012 9:59 AM	--	Folder
▶	Ackman Wedding		Oct 6, 2012 9:59 AM	--	Folder
▶	Anderson Wedding		Oct 6, 2012 9:58 AM	--	Folder
▶	Andrews Wedding		Oct 6, 2012 9:58 AM	--	Folder
▶	B		Oct 6, 2012 9:57 AM	--	Folder
▶	C		Oct 6, 2012 9:57 AM	--	Folder
▶	D		Oct 6, 2012 9:57 AM	--	Folder
▶	E		Oct 6, 2012 9:57 AM	--	Folder
▶	F		Oct 6, 2012 9:57 AM	--	Folder
▶	G		Oct 6, 2012 9:57 AM	--	Folder
▶	H		Oct 6, 2012 9:58 AM	--	Folder
▶	I		Oct 6, 2012 9:58 AM	--	Folder
▶	J		Oct 6, 2012 9:58 AM	--	Folder
▶	K		Oct 6, 2012 9:58 AM	--	Folder
▶	L		Oct 6, 2012 10:36 AM	--	Folder
▶	M		Oct 6, 2012 10:37 AM	--	Folder
▶	N		Oct 6, 2012 10:37 AM	--	Folder
▶	O		Oct 6, 2012 10:37 AM	--	Folder
▶	P		Oct 6, 2012 10:37 AM	--	Folder

Amber Murphy Photography

DEVICES
PLACES
SEARCH FOR

26 items, 90.88 GB available

Figure 10-4: Another method of organization is to sort your clients alphabetically by last name.

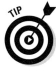

To take your organization to the next level, consider starting a folder for your clients as soon as they book you for a wedding. In each client file you can store not only their original and edited images but also their contracts, questionnaires, schedules, and important e-mails or other documents you may have saved. With this system, all your information for each client is in one easy-to-find place.

Importing photos into Lightroom

When your photos have been copied to your computer, backed up, and organized, you're ready to start editing them. I dive into editing in detail in Chapter 11, but before you can start the process, you need to import your pictures into Lightroom. Follow these steps:

1. **Open Lightroom and make sure you're in the Library module.**

 The module you're in is highlighted at the top right-hand side of your screen.

2. **Click on the Import button, found in the bottom left-hand corner of your screen.**

 Check out Figure 10-5 for a look at this starting screen.

3. **On the left-hand side of your screen under the Source pane, navigate to the location of the photos you want to import and click on the folder.**

 Your photos appear as thumbnails. Here you have the option to select Check All, which imports every image, or you can select Uncheck All and select just the photos you want to import individually.

4. **Check the top of your screen to ensure that Add is highlighted, like you see in Figure 10-6.**

 When this option is highlighted, it adds your selected photos to the Lightroom catalog without moving them from their original location. If Copy or Move is selected instead, Lightroom creates a digital copy of all your images before importing or moves them to a new location.

5. **Click on the Import button, found in the bottom-right hand corner of your screen.**

 When the photos are done importing, you're taken back to the Library module and your photos are on the screen.

Understanding the Lightroom database

Adobe Lightroom is a database at its core and has the ability to organize all the data your image files have, from the metadata to the actual image. Having all the images on your computer right at your fingertips, inside one simple program, is one of the aspects of Lightroom that makes it so easy to use. Knowing more about how the program functions can help you use Lightroom to its fullest capacity.

When you import photos into Lightroom, rather than actually moving the photos, the program creates a link to where they are stored on your hard drive. Therefore, you must keep the original files! If you move or delete a photo on your hard drive that has been imported to Lightroom, the image within the program appears with a question mark and a warning that says that the file is offline or missing. The opposite is also true: If you delete pictures from within the Folders section in Lightroom, they will also be deleted from your hard drive.

If you find the need to move the photos on your hard drive to a different location and need those images to still show up in Lightroom, the program offers the ability to locate the files. After you move the files on your hard drive, head over to the image in Lightroom, right-click the missing file, and select Locate. Then navigate to the new location of the image and click on it. When you can click Select, Lightroom updates its database. If you move an entire folder and want all the photos to be located, you can select Find nearby missing photos to find all the images at once.

Though moving or deleting files in Lightroom affects the files on your hard drive, editing does not. Lightroom is a nondestructive program, meaning that you can make edit after edit within the program without changing the original file. If you make edits and decide later (even days later) that you want to start over, all you have to do is hit the Reset button in the Develop module and your image reverts back to the way it was.

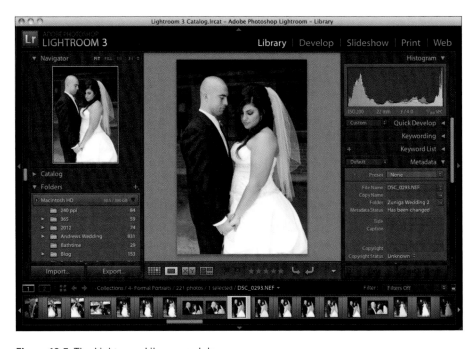

Figure 10-5: The Lightroom Library module.

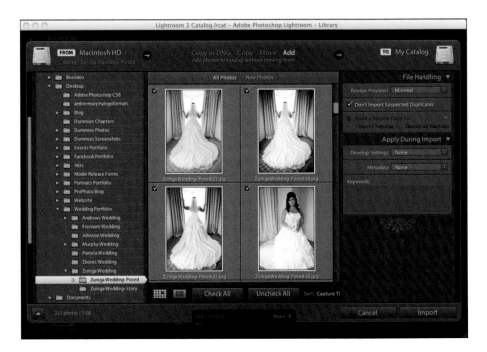

Figure 10-6: To import photos into Lightroom, use the Import Photos dialog box.

Getting Ready for the Next Shoot

Perhaps it's because I have a type A personality, but I have a lot of difficulty focusing on a task if the things around me aren't organized and put away. So I like to clean up all my wedding gear and have everything properly stowed before I sit down to start the editing process (described in Chapter 11). In the following sections, I go over a few things you should take care of after a wedding (whether you do it right away or not), like cleaning your camera, checking your settings, and formatting your memory cards.

Cleaning your camera

Even if you're very careful when switching your lenses and try to keep your camera clean, a time will come when your camera needs cleaning because of dust on the sensor. To determine whether or not your sensor needs cleaning, follow these steps:

1. **Take out your camera and set it at the smallest aperture.**

2. **Point your camera toward a plain white surface (like a piece of paper) and make sure that white is filling the entire frame.**

3. **Take a picture.**

4. **Upload the picture to your computer, review the picture on your computer, and increase the contrast of the image. Then zoom in to look for any dark spots.**

5. **If you see no blemishes in the photo, your sensor is clean. However, if the image has dark spots, your sensor is dirty and should be cleaned.**

If your sensor is dirty, you have two options: You can find a sensor-cleaning service (either locally or through the manufacturer) or you can choose to clean the camera yourself.

Your sensor is the most fragile (and expensive) part of your camera and you must be extremely careful if you choose to clean it yourself.

If you choose to clean the camera yourself, follow these steps:

1. **Choose a location that is relatively free of dust with no windows open, such as a bathroom or a kitchen.**

2. **Wipe down the outside of your camera with a soft cloth first to rid the camera of any dust.**

3. **Set your camera to cleaning mode (check your owner's manual for details on how to do this).**

 This locks the shutter open so that you have access to the sensor.

4. **Make sure your camera battery is fully charged.**

 If your camera shuts off while your cleaning tools are inside, the shutter will close and you could badly damage several parts of your camera.

5. **Carefully remove the lens from the camera and set it in a safe place.**

6. **Use a blower bulb to remove as many dust particles as you can.**

 Never use compressed air for this task. The compressed air can freeze the surface of the sensor, which can cause a lot of damage.

7. **Take a sensor swab and apply two or three drops of sensor-cleaning solution.**

 Sensor swabs are little tools with a flat edge that are designed specifically for cleaning a camera sensor. They can be found at some camera stores or online at places like www.amazon.com or www.bhphoto video.com.

8. **Place the swab at one side of the sensor and gently sweep it across the sensor.**

 Depending on the size of the swab, you may need to do this two or three times to wipe the entire sensor.

9. **Remove the swab and throw it away.**

10. **Place the lens back on your camera.**

Zeroing out your camera

Zeroing out the camera means that you put all the settings back to normal. Doing so can help you to avoid that moment of panic at your next shoot when you realize that your exposure compensation is off by a few numbers, the white balance is set to fluorescent light, and your file format is in JPEG, not RAW. Instead of being able to take pictures right away, you're forced to spend time adjusting the settings.

When you put your camera back to the average settings, make sure to check the following (see Chapter 2 for the basics on these settings):

✔ Shutter speed

✔ Aperture

> ✔ ISO
> ✔ EV exposure compensation
> ✔ White balance
> ✔ Lens and camera autofocus
> ✔ Metering mode
> ✔ File format (RAW, JPEG)
> ✔ Any other settings you may have changed

Formatting your memory cards

The final step in getting your camera ready for your next shoot involves clearing out your memory cards. This process is called *formatting*.

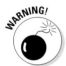

Only format a memory card when you are 100 percent sure that the images are safely stored on your computer and backed up elsewhere. When a card is formatted, those images are gone forever.

Formatting a card is different than erasing a picture, which you may do if you need more room on your card during a shoot, or if you don't like a photo you just took. Erasing only allows you to delete one picture at a time, and if you have a couple thousand pictures from a wedding, erasing the images one by one would take an eternity! Formatting, on the other hand, deletes all images from the memory card at once.

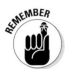

Another thing you don't want to do is to move all the image files from your memory card to the trash while the card is plugged in to the computer. Although this step deletes the images, it doesn't free up the space they took up on the card.

To format your memory card, take it out of the card reader and place it back in your camera. Then navigate to the Format Card option in your camera and erase the photos. Getting to the formatting option looks a little different with each brand of camera, but generally you can get there from your camera's menu. Consult your camera's user manual to find out how to format your memory cards correctly.

11

Editing Your Images

You may be surprised to learn a little trade secret of wedding photographers: The photos we give our clients often look much different than they did coming straight out of the camera! Although every photographer strives to capture stunning images that don't need much editing, photos straight out of the camera are like jewels waiting to be polished. Sure, you can have a photo that looks pretty nice without any editing, but processing that photo with editing software can turn it into a great image.

In this chapter, I go over the basics of the editing process, including how to weed out pictures you don't want to keep, how to organize your photos while editing, and how to tweak your photos in Adobe Lightroom. I also go over how to export your photos to your hard drive after you're finished editing.

Culling the Shoot

One of the biggest benefits of digital wedding photography as opposed to film photography is that you can take a ton of pictures without worrying about using up expensive film. You can easily weed out the unwanted photos later without having lost anything but a little bit of memory (until you format your card, as I explain in Chapter 10). This weeding out process is called *culling the shoot*.

Culling the shoot is the first thing I do with the wedding pictures after loading them onto my computer and importing them into Adobe Lightroom (Chapter 10 explains this process). During that time, I go through all of the images to decide which photos are worth editing and which are not. Generally, I have about 2,000 pictures at the start, and end up with 600 to 800, which is a much more manageable number! Because I use Adobe Lightroom for this process, I simply move my chosen images into a new collection set (which I talk more about in the next section) instead of deleting the images from my hard drive.

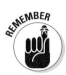

Though all photographers are unique and may judge their work based on slightly different criteria, you can use a few standards as a gauge when culling a shoot:

✓ **Exposure:** Is the image too light or too dark? If the photo is just a little light or dark, you may be able to fix it with your editing software. However, if it's too extreme on either end of the spectrum, like in Figure 11-1, the photo is probably a lost cause.

✓ **Focus:** Is your subject in focus? Even if everything else looks great but your subject is blurry, that photo is a no-go.

✓ **Subject placement:** Make sure to examine how your subject is placed within the frame. Did you cut off the photo at someone's feet? Is the subject halfway out of the frame? If cropping doesn't help with awkward subject placement, you'll want to pass on that photo.

✓ **Background:** Pay special attention to what's shown in the background of your photo. Are restroom signs or trash cans visible? Are guests photo-bombing your portrait of the bride and groom (that is, jumping into the background where they don't belong)? Are trees coming out of a groomsman's head? Keep in mind that those little details in the background can be highly distracting.

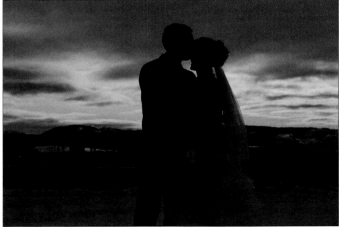

50mm, 1/2500 sec., f/5.6, 125

Figure 11-1: Toss out images that are too underexposed, like this one.

✔ **Facial expressions:** Facial expressions are a key aspect to evaluate when sorting through your wedding images. Keep an eye out for photos where your subjects are blinking or are caught in an awkward expression. Your goal is to make people look good! So even if the photo has amazing composition and lighting, if someone's smile looks weird, you should probably toss that photo.

✔ **Flattering angles:** Like with facial expressions, when considering which photos to keep, you always want to be on the lookout for photos taken at an angle that makes your subject look good. That means you should pass on photos where the angle is an up-the-nostril shot, an angle that gives the subject a double chin, an angle that makes your subjects look wider than they actually are, or any other unflattering angles.

Grouping Your Pictures into Useful Categories

During the editing process, establishing a sense of order with all your images enables you to find specific photos quickly, without having to sort through hundreds of pictures. Lightroom has a wonderful feature called Collections for just this purpose. As I mention in the previous section, as I cull a shoot and narrow down which images I want to work with, I move those select photos into what's called a *Collection Set.* After you sort through all the original shots, head over to that collection set and group the photos into specific categories. To make your own collection set and useful categories, known as *Collections,* within your set, follow these steps:

1. **Open Lightroom and click on the Library module in the upper right-hand corner of your screen.**

2. **Navigate to the Collections dropdown list on the left-hand side of your screen and click the + button that's next to the word Collections.**

 A little box opens when you click the + sign (see Figure 11-2). Select Create Collection Set.

3. **In the new Create Collection Set dialog box that opens, enter the name of your collection set in the Name field, like you see in Figure 11-3.**

4. **Choose None in the Set tab, and click Create.**

 Your new collection set appears under the Collections panel on the left-hand side of your screen.

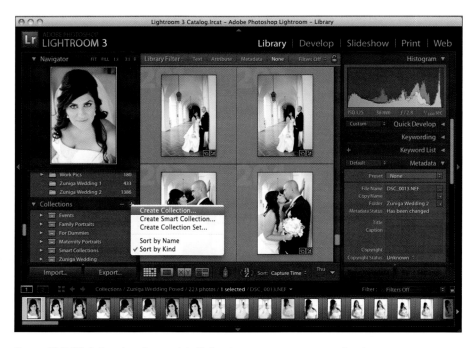

Figure 11-2: Click the plus sign next to Collections to create a new collection set.

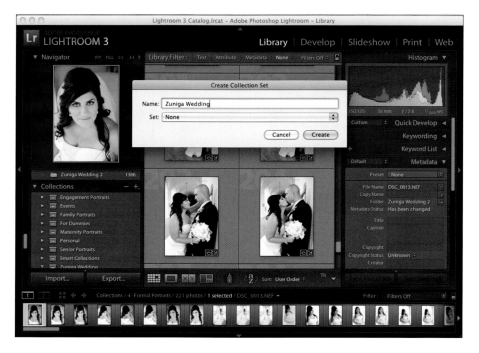

Figure 11-3: The Create Collection Set dialog box allows you to name your new collection set.

5. **To create a new folder within your collection set, right click your collection set and choose Create Collection.**

 Again, a new box opens up where you can name your new folder. Make sure that your collection set's name (such as "Zuniga Wedding" like you see in Figure 11-4) is selected under the Set tab. Click Create.

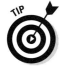

 I usually name this first folder something like "Full Wedding Story," and it's where I move my select images that I want to edit while I cull the shoot. This way I have all my best images in one place that is easy to find.

6. **To add pictures to your new collection, scroll up above the Collections panel on the left-hand side of your screen to the Folders panel and select the images you want to add.**

 You have the option to move one photo at a time or several at once by selecting the thumbnails in grid view.

7. **Click on and drag the selected images to your new collection under the Collections panel (see Figure 11-5).**

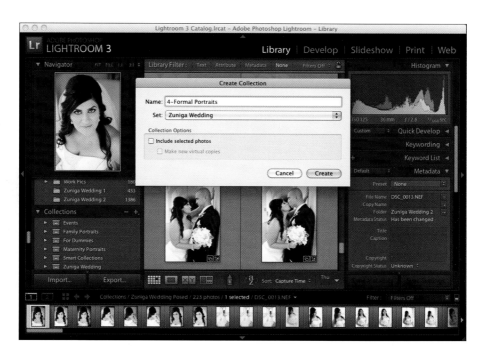

Figure 11-4: The Create Collection dialog box allows you to place a new collection in a collection set.

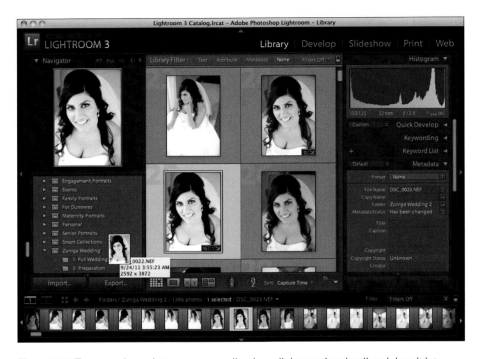

Figure 11-5: To move photos into your new collection, click on a thumbnail and drag it into your collection folder.

8. **To create additional folders within your collection set, repeat Step 5.**

 These additional folders under the main collection set are where I break down the wedding into different categories that are useful to me: Preparation, First Look, Formal Portraits, Ceremony, and Reception (see Figure 11-6).

9. **To add photos to these additional collections, head over to your "Full Wedding Story" collection and select, click, and drag your desired photos into their proper categories.**

Figure 11-6: Organizing your wedding photos into specific categories can be very helpful when looking for a specific photo.

The reason I love this system of organizing my photos is that within one collection set I have the ability to view all my best photos from a wedding or just specific images within one category.

Keep in mind that, unlike in the Folders panel, adding or removing images from a collection doesn't add, delete, or move any photos from your hard drive. It only adds or removes photos from that category or collection.

Editing and Adjusting Your Photos

After you sort through and organize all your images from a wedding, you're finally ready to start polishing your pictures. In the following sections, I outline some basic editing techniques, such as adjusting white balance and tone, boosting color, and cropping and straightening an image. (***Note:*** I always do my first round of editing right in Lightroom, so I focus on that program in the following sections. If you happen to use other editing software, keep in mind that all — or most — of the functions I talk about here can be found in other similar programs.)

After my first edits are done, if I feel that a few select pictures need a little more fine-tuning, I do my second edits within Photoshop, which I cover in Chapter 13. However, most of the time the pictures that I edit in Photoshop are only the images that will be used in a wedding album, for print, or for a post on my blog, so most of my editing happens right within Lightroom (because fine-tuning all 800 pictures from a wedding in Photoshop would take forever).

Correcting white balance

If you're new to photo editing, you may not know where to start on any particular photo. I recommend starting with white balance, which allows you to adjust the overall color of your image. The goal of adjusting white balance is to get your photo to look the way your own eyes saw the scene. Though DSLRs today are really smart, sometimes they still miss the mark when it comes to white balance. You've probably seen this problem reveal itself in images with a *color cast,* or tint, that doesn't look right. Follow these steps to correct white balance:

1. **Open Lightroom and select the photo you want to edit by double-clicking on the thumbnail of the picture or highlighting the image in the filmstrip (the row of small photos that appears at the bottom of your screen).**

2. **Click on the Develop module on the top right-hand corner of your screen.**

3. **Click on the Basic panel on the right-hand side of the screen (see Figure 11-7) and select a preset from the White Balance (WB) list.**

You can choose from several presets: As Shot, Auto, Daylight, Cloudy, Shade, Tungsten, Fluorescent, Flash, and Custom. Select the preset that coincides with the type of lighting in which you took the picture. For example, if you took the photo under a fluorescent light, select Fluorescent. Or if you'd like to adjust the white balance manually with a slider, select Custom.

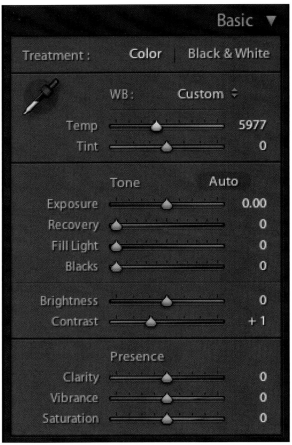

Figure 11-7: The Basic editing panel.

4. **If the color in your image still looks inaccurate, move the Temp slider until the color looks correct.**

Moving the slider to the right adds yellows and reds to your photo, making the light warmer, and moving the slider to the left adds blue to the photo, making the light cooler.

5. **If is the photo still has a color cast, you can tweak the image further by adjusting the Tint.**

Moving the slider to the right adds purple tones to the image, whereas moving the slider to the left adds greens.

Adjusting tone

Tone deals with the range of the darkest to lightest parts of your picture and is one of the most crucial elements in the photo-editing process. Tone is how you can correct exposure, recover blown-out highlights (that is, darken bright areas that are way too light), make sure your whites are white and your blacks are black, and deepen the contrast of an image. If you've ever noticed that an image looks a little gray straight out of the camera, adjusting tone is where you can fix that problem and turn a dull photo into a vibrant one. You can see the difference between an unedited picture (Figure 11-8a) and an edited picture (Figure 11-8b).

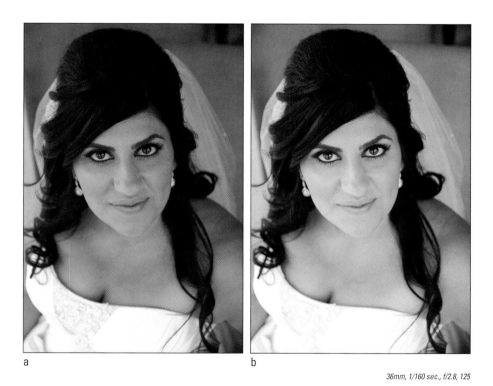

a b

36mm, 1/160 sec., f/2.8, 125

Figure 11-8: Adjusting the tone of a photo can bring life to a dull photo.

When you're ready to begin adjusting your tone, select the photo you want to adjust from the filmstrip at the bottom of your screen or double-click on the thumbnail of the photo in the grid view. Then navigate to the Develop module at the top right-hand corner of your screen and click on the Basic editing panel on the right-hand side. In that panel under Tone is a list of the following six features with a sliding bar beside it (refer to Figure 11-7):

- **Exposure:** As you may have guessed already, the Exposure bar controls the exposure, or the lightness or darkness of your photo. To brighten your image, move the slider to the right. If your image is too bright already, move the slider to the left to darken your photo.

- **Recovery:** This function allows you to darken just the lightest areas of your image that are way too bright (blown-out highlights). To recover your highlights, move the slider to the right until the image looks right to you.

- **Fill Light:** This feature is the exact opposite of recovery. It allows you to lighten the areas of your image that are way too dark (also known as *lifting shadows*).

Keep in mind that the more you push that slider to the right, the more grain that's added to the image.

- **Blacks:** This feature allows you to darken blacks. Have you ever looked at a photo of a groom in his black tux but realized that the tux looked more like a dark gray than black? The Blacks slider is what you can use to make sure blacks in a photo appear just the way they should.

- **Brightness:** The difference between the Exposure and Brightness functions is that Exposure brightens your image overall but puts an emphasis on brightening the lightest parts of the photo. Brightness, on the other hand, changes the light, medium, and dark tones equally. Most often, if you've used your Exposure, Recovery, Fill Light, and Blacks sliders already, you don't really need to use this function.

- **Contrast:** This function allows you to make your darks darker and your lights lighter, thus deepening the contrast between those values in your image. Contrast can add a lot of depth to your photo and really make it pop.

As you adjust the tone of your image, if you're unhappy with the way it looks, don't panic! If you want to start over, click on the Reset button in the bottom right-hand corner of the screen. If, however, you only want to undo your last edit, you can press Command+Z (Mac) or Control+Z (Windows) to go back one step.

On the other hand, if you edit a photo and love the way it looks and would like to apply the same edits to other photos, Lightroom has a Sync feature that allows you to do just that. The Sync feature is one of my favorite tools of this program because it saves so much time. To sync edits, select your edited photo by clicking on it and then pressing Command (Mac) or Control (Windows) and clicking on the other photos in your filmstrip that you want to adjust. When you have the images selected, click on Sync at the bottom right-hand of your screen to apply all the edits from the first photo to the rest of the chosen photos. If you apply the edits and decide that you don't like them, simply use Command+Z or Control+Z to undo the sync.

Boosting color and adjusting clarity

Color and clarity adjustments can be found under the Basic editing panel under Presence (refer to Figure 11-7). Boosting the color and clarity are often my final editing touches and can bring a lot of life to a picture (boosting the color, especially). Here I outline the different Presence controls and how to use them:

- **Clarity:** The Clarity feature makes an image sharper or softer by adding or taking away localized contrast to the mid-tones. It can be a wonderful tool to use when you have a slightly out-of-focus image, because adding some clarity can give the illusion of a sharper picture. To add clarity, move the slider to the right; to decrease clarity, move the slider to the left.

- **Vibrance:** The Vibrance feature evaluates the saturation of color in an image and only boosts the intensity of the colors that are muted. Using this tool can be especially helpful when editing photos of people, because it allows you to boost the colors around your subject while preserving the natural skin tones.

- **Saturation:** The Saturation feature treats all colors in an image equally and bumps up the intensity of all the colors if you move the slider to the right. It decreases the saturation of all colors if you move it to the left.

I used the Vibrance feature in Figure 11-9a and increased only the more muted colors; Figure 11-9b, on the other hand, used the Saturation feature, and some of its colors wound up too vibrant (like the greens and the skin tones).

If at any point during the editing process you'd like to compare your edits to your original picture, simply click on the rectangular box with two *Y*s side by side, found at the bottom left of your image. Lightroom brings up a Before and After look so you can see how your picture is progressing.

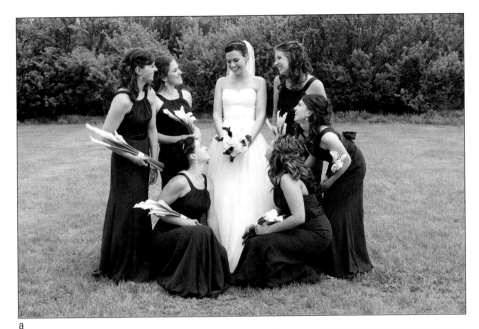

a

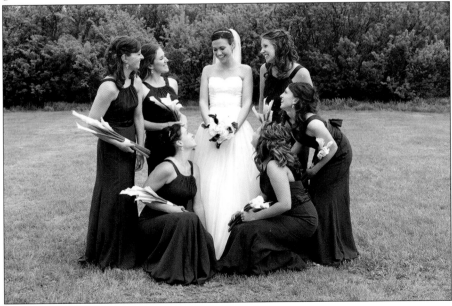

b

31mm, 1/1250 sec., f/5.0, 320

Figure 11-9: The Vibrance feature increases only the more muted colors in a photograph; Saturation treats all colors equally and can result in some colors becoming too vibrant.

Cropping and straightening images

Even if you take great care to compose your wedding pictures correctly (using the guidelines in Chapter 3 as a starting point), every once in a while you'll probably come across an image that's slightly off balance or has a bathroom sign or someone's floating arm poking its way out of the corner. In cases like these, being able to straighten and crop your pictures is a lifesaver. Thankfully, cropping and straightening is very simple and can be done in just a few steps:

1. **Open Lightroom and select the photo you want to edit by double-clicking on the thumbnail of the picture or highlighting the image in the filmstrip at the bottom of your screen.**

2. **Head over to the Develop module, which can be found at the top right-hand corner of your screen.**

3. **Click on the Crop Overlay tool (see Figure 11-10).**

 It's the tool on the far left under the Histogram. A grid and frame with adjustment handles appears over your picture.

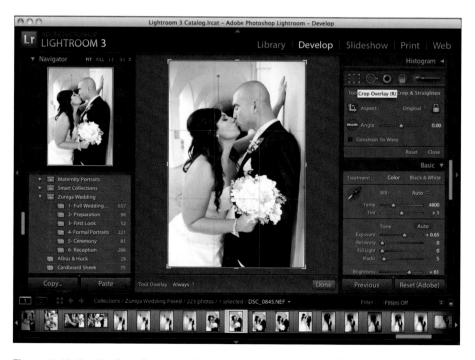

Figure 11-10: Use the Crop Overlay tool to crop and straighten your photos.

4. **Click on an adjustment handle and drag inward to crop your picture.**

If you want to keep the aspect ratio (ratio between width and height) the same, look for the padlock icon underneath Crop and Straighten and make sure that it's closed. If, however, you'd like to be able to move just one side of the crop frame at a time, click on the padlock to unlock it.

5. **If you need to straighten your image, you can click and drag the Angle slider on the right-hand side of your screen.**

A more detailed grid appears as you drag the slider to help you align the image correctly.

6. **When you're satisfied with the cropping and straightening of your image, click Done (at the bottom right under your photo) to save the changes.**

Using Lightroom Presets and Photoshop Actions

One way to speed up your workflow as you edit your images from each wedding is to use Lightroom Presets or Photoshop Actions (or both!). Actions and Presets are usually created by third-party developers and function like an add-on to your editing software. The benefit to using these add-ons is that instead of tweaking each individual detail of a photo manually to get a specific look, you can choose an action or preset programmed with all the steps and do it all with just one click. For example, if you take a look at the first photo, you can see an original wedding image. With one click I was able to give that image a vintage look (the middle photo) and then change it again into a classic black and white (the final photo).

Another benefit to using actions and presets is that you can easily give all your pictures in a wedding a consistent look throughout the editing process. Actions and presets give your photos different looks or a consistent feel to all your images and add-ons can help you sharpen eyes, smooth skin, whiten teeth, and much more.

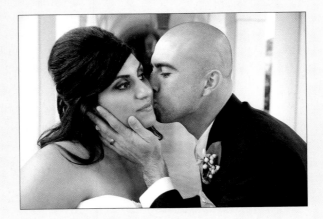

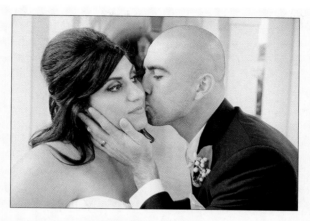

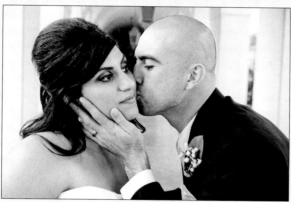

32mm, 1/100 sec., f/4.0, 800

Many different companies online offer both actions and presets, but a few stand out above the rest.

✔ **Totally Rad Actions:** This company offers both Lightroom Presets and Photoshop Actions and can be found at www.get totallyrad.com. It offers several different packages, which range in price from $45 to $99.

✔ **Kubota Image Tools:** Kubota actions and presets are lauded as some of the best image-enhancing tools on the market. The company offers a wide variety of action and preset packs, which cost about $130 to $170 and can be found at www.kubotaimage tools.com.

✔ **MCP Actions:** Found at www.mcp actions.com, this company also offers Photoshop Actions and Lightroom Presets that can take your images to the next level. The packages range from about $50 to $170 in price, depending on how many actions or presets are in the set. Each package has a set of demo videos that demonstrates how to buy, install, and use the different tools.

Saving Your Images to Your Hard Drive

After you have tweaked, molded, and polished your images to perfection, the last step in the process is to save them to your hard drive. But before you do, you need to make a few decisions first. These decisions should be based on what you plan on doing with those photos after you save them. For example, are you sending them off to a printer, or are you uploading them to your blog? In this section I go over the various elements to consider before saving your finalized photographs as well as how to actually export those photos from Lightroom to your hard drive.

Considering a few final changes

The way you save an image changes slightly based on how you'll use the photo. In the following sections, I talk about resolution, image size, file format, and watermarking — all of which are affected by whether your photos will be viewed on a computer or printed.

Choosing a file format

Before I dive into the two types of file formats you should use to save your images, you need to know why choosing a file type even matters in the first place. File types have to do with *image compression,* which can be broken down into two categories: lossless compression and lossy compression.

- *Lossless compression* refers to an image saved with all its original information, with no data lost. This type of saving results in a rather large file size to accommodate all that information.

- *Lossy compression* throws out some of the data as a file is saved, which results in a smaller file size.

Like everything else in the photography world, you have many options when it comes to choosing a type of file format in which to save your images. However, you really need be concerned with only two types as a wedding photographer: JPEG and TIFF.

- **JPEG:** A JPEG file (short for *joint photographic expert group*) falls under the *lossy compression* category. This file format is best for saving your images for the web and giving images to clients because the file size is smaller, though many online photo labs do accept 300ppi JPEGs for printing.

- **TIFF:** A TIFF file (short for *tagged image file format*) falls under the *lossless compression* category. Therefore, an image saved as a TIFF has no degradation to the file. Some professional photo labs encourage using TIFFs for printing purposes. Saving images as TIFFs is also useful if you

ever want to go back and re-edit the image. Because no degradation took place in the compressing process, all the info you need is still right there in the file.

Determining your resolution

Image resolution refers to how much detail is contained within your photo, and it's measured by *pixels per inch* (ppi). Consider two factors when determining your resolution: whether your photos will be viewed on a computer screen (see Chapter 12) or whether they will be printed (see Chapter 13).

✔ Photos viewed on a computer need only a resolution of 72ppi to be seen with perfect clarity.

✔ For the purpose of printing, always choose a high resolution of 300ppi, because that gives your photo lab the information it needs to print a high-quality photograph.

Image resolution and the way it is measured can be confusing. People often mistakenly use the term *dots per inch* (dpi) interchangeably with *pixels per inch* to describe the measurement of detail in a digital image. Dpi refers to the maximum number of dots of ink a printer can put into the space of one inch. So even though both terms relate to resolution, as the photographer, you only need to be concerned about pixels per inch. The photo lab tells the printer to print your 300ppi photo at 300dpi (or more, because printers nowadays can print at a much higher resolution).

Changing the image size

Another factor to consider before saving an image is what size you need the image to be. If you're printing the image, you don't have to worry about changing the image size, because you send the original size (without any changes) to the printer. However, if you're uploading your photos to a blog, you may need to change its measurements so that it fits within the confines of your blog space. For example, my blog allows photos in a post to be as wide as 900 pixels. Because I don't want tiny little thumbnails in my blog post or only half of the photo to show up if it's too wide, I always size my images to 900 pixels wide. (If you don't know how to change your image size, not to worry! I'll cover that in the later section "Exporting your photos."

Watermarking your images

If you plan to use your wedding images online, I strongly encourage you to watermark your photos. Any time you publish your photos on the web, there's always a chance that your images will be stolen or used without your permission. One way to protect yourself from people claiming that they took one of your photos, from downloading and printing your photos for free, or from having your photos seen without people knowing who took them is to digitally watermark your images before placing them online.

Watermarking means marking your images with your name, logo, or website address, like you see in Figure 11-11, so that viewers know that the images belong to you. To watermark or not to watermark is a topic of much debate among photographers, but I would argue that, if tastefully done, it can be a benefit!

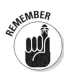

Whether you put a watermark in the corner of an image or place a semi-transparent watermark in the middle is up to you. Just keep in mind that though a watermark is useful, you don't want it to distract from your hard work.

You have two options when it comes to watermarking a photo in Lightroom. You can either create a simple copyright watermark or you can upload a logo as a PNG or JPEG file to place on your photo.

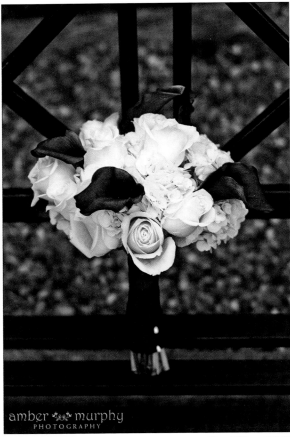

50mm, 1/400 sec., f/2.8, 100

Figure 11-11: Placing a watermark on an image lets viewers know who took the picture and can keep your image from being stolen or used without your permission.

Follow these steps to create a simple copyright watermark:

1. **Select Edit Watermarks from the Lightroom menu (on a Mac) or from the Edit menu (on a PC) at the top of your screen.**

2. **Next to Watermark Style on the right-hand side of your screen, choose the Text button.**

3. **In the text box under the photo, enter your copyright text, such as "Amber Murphy Photography," like you see in Figure 11-12.**

4. **Under the Text Options panel on the right-hand side of your screen, you can choose the font, style, alignment, and shadow options for your watermark.**

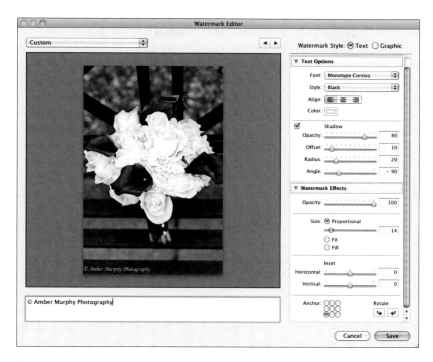

Figure 11-12: The Edit Watermark dialog box.

5. **Under the Watermark Effects panel, which is right below the Text Options panel, choose the opacity, size, inset, and anchor for your watermark.**

 These options come with sliders, so you can play around with the effects to see what you like best.

6. **Click Save.**

 A dialog box appears that asks you to name your new watermark. After you have done so, click Create. Your watermark is saved as a preset and can be added to a photo before you export it (see the next section on exporting photos).

If you already have a logo that you want to use as your watermark, follow the steps below:

1. **Select Edit Watermarks from the Lightroom menu (on a Mac) or from the Edit menu (on a PC) at the top of your screen.**

2. **Next to Watermark Style on the right-hand side of your screen, choose the Graphic button.**

 A dialog box appears that allows you to navigate to where your logo file is saved on your hard drive. Select the file and click Choose.

3. **Under the Watermark Effects panel on the right-hand side of your screen, choose the opacity, size, inset, and anchor for your new watermark.**

4. **Click Save.**

 A dialog box appears that asks you to name your new watermark. After you have done so, click Create. Your watermark is now saved as a preset and can be added to a photo before you export it (see the next section on exporting photos).

Exporting your photos

After you decide exactly how you want your photos to be used, you're ready to actually save your images. In this section I go over how to do this within Lightroom, but if you need to know how to save images from Photoshop, check out Chapter 13.

In Lightroom, the process of saving your photos is called *exporting*. As I note in Chapter 11, Lightroom is a nondestructive software that creates a link to the original file within the program. Exporting creates a brand new file using the edits you made. The process is quite simple if you follow these steps:

1. **Open Lightroom and click on the Library Module at the top right-hand corner of your screen.**

2. **Select the images you want to export.**

 To select all the images in an album or collection, select the first photo in the filmstrip at the bottom of your screen, hold down the Shift key, and click the last photo in the filmstrip to select all. You can also click a thumbnail and press Command+A on a Mac.

 If, however, you don't want to choose all the images from an album or collection, you can select the first photo you want and then hold down Control (Windows) or Command (Mac) and click your desired photos to pick which ones you want to export (check out Figure 11-13).

3. **Click the Export button found at the bottom left-hand corner of your screen.**

 A new dialog box opens that gives you a list of options for how you want to save your photos (see Figure 11-14).

4. **Under Export Location, choose Specific folder from the dropdown menu and then click Choose to browse through your folders and select the correct folder where you want your photos to be saved.**

5. **Navigate to File Naming and select how you want all your photos to be labeled.**

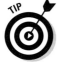

 For this option, I usually choose Custom Name - Sequence and enter the newlyweds' last name and category description into the Custom Text box (for example, Smith Wedding Preparation, Smith Wedding Formal Portraits).

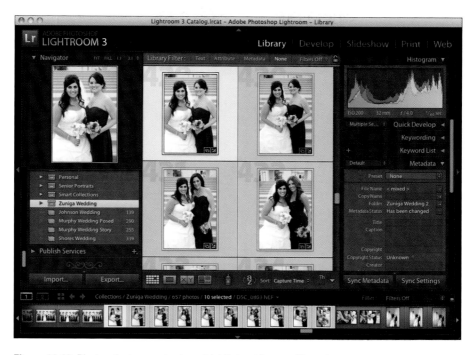

Figure 11-13: Photos that you select are highlighted in your filmstrip.

6. **Scroll down to File Settings and choose which file format you prefer by clicking on the Format box and selecting your format.**

 In this box, also make sure that Include Video Files and Limit File Size To are unchecked.

7. **Navigate to the Image Sizing section and select your size and resolution.**

 If you're saving the photos for printing, make sure that the Resize to Fit box is unchecked and that the Resolution box is set to 300 pixels per inch. If you're saving for the web, however, you can resize your image by checking the Resize to Fit box and selecting Width & Height option in the dropdown box. Then you can enter the desired dimensions into the Width and Height boxes. You should also lower the resolution to 72 pixels per inch.

8. **If you would like to sharpen your images before saving them, scroll down to Output Sharpening and check the box next to Sharpen For.**

 Here, you have a couple of options. In the left dropdown box you can select either Screen, Matte Paper, or Glossy paper based on what your photo will be used for (if you are putting your photo online, choose Screen, and if you are printing the photo, choose the option that coincides with the type of paper you'll be printing on). In the right dropdown box select Low, Standard, or High for the amount of sharpening you prefer.

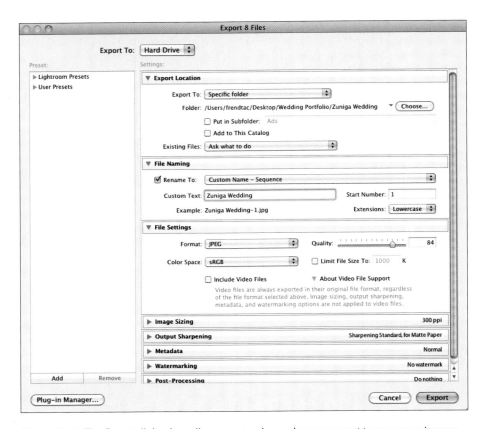

Figure 11-14: The Export dialog box allows you to choose how you want to save your images.

9. **If you want to add a watermark to your photo, open the Watermarking panel and check the box next to Watermark. Then select your desired watermark from the dropdown list.**

 For more on creating or adding a premade watermark to your photos, see "Watermarking your images" in the preceding section.

10. **Under Post-Processing, you can choose what you want to do after the images are finished exporting.**

 I usually choose the "Do Nothing" option from the dropdown box.

11. **Click on the Export button in the right-hand corner of the dialog box.**

 When the button has been clicked, the dialog box disappears and you see a status bar at the top left-hand corner of your screen. This bar shows you how far into the exporting process you are. When the photos are finished, the status bar disappears, and you're done! Now don't forget to back up your hard work.

12

Making Your Photos Available on DVD and Online

In This Chapter

▶ Considering whether to share images on DVD or online

▶ Creating a DVD of your clients' wedding images

▶ Putting wedding photos online for the world to see

*I*f you've ever seen a magician perform, you know that the most exciting part of the act is the big reveal. Photography is much the same way (without the pulling a rabbit out of the hat part, of course). All your work leads up to one big moment: when you unveil your images for the newlyweds to see.

Sharing wedding photos with my clients and their families is one of my favorite parts of the job. I love the special feeling of delivering all those precious memories and seeing the reaction as they go through the pictures of their special day. In this chapter I help you get to that moment yourself by explaining a couple of the most convenient ways to share photos from a wedding day: on DVD and online.

Examining Your Options

When it comes to sharing your photos with your clients, you have multiple options (seems like a running theme in photography, doesn't it?). In the following sections, I go over the two most popular options: sending your clients a DVD of images or sharing the photos via online galleries. Though you can certainly give your clients a DVD as well as an online gallery, most photographers only offer one option because offering both is more work. However, you're free to run your business in a way that makes sense to you, so if you want to offer both options to your clients, go for it!

The pros and cons of burning images onto a DVD

The first option you have available to you is to burn a DVD of all your client's high-resolution images and send them off in the mail. This method has a few advantages:

✔ If you send a DVD with a nice cover, you can include it as part of a branded package with a note to the couple thanking them for the opportunity to do their wedding along with a few of your business cards. This package can give you and your business a personal touch and may encourage the couple to recommend you to others. (For more info, see the later section "Creating a well-branded package to send to the couple.")

✔ A DVD with a photo release gives clients the freedom to print as many photos as they wish, wherever and whenever they like.

✔ Clients get a digital version of all their pictures for safekeeping.

Sending your clients their images on a DVD also comes with a few disadvantages that you may want to consider:

✔ You lose the ability to control the quality of prints. Your clients may not know the best places to print their photos, which means those pictures you worked so hard on may end up being printed at a local pharmacy, whose print quality probably won't represent the quality of your images.

✔ Handing over a DVD takes away from print sales. If you hope to earn some extra income by selling prints, you may not want to offer a DVD, because clients probably won't buy prints from you if they can just print them on their own.

If you really want to offer your clients a DVD but still want to control print quality, consider offering only web-sized images on the DVD. Because these images are too small to print well, you ensure that your clients will come to you to print high-resolution images. Another option you have if you choose to offer your clients a DVD is to sit down with them and show them the same picture printed at several different printers with varying quality levels. You can recommend places for good quality images and can rest assured that your clients walks away with that DVD well informed.

The pros and cons of posting images online

Another option to consider is sharing the wedding images with clients electronically through the use of online galleries. This method also comes with a few advantages and disadvantages. First, the advantages:

✔ Your clients can access their images from any computer (or even mobile device, depending on the type of gallery you choose) instead of having to carry a DVD around with them.

✔ Online galleries can provide a lot of exposure for you and your business because your clients can e-mail the link to their gallery to all of their friends and family as well as post the link on social media platforms such as Facebook and Twitter. A lot more people can view your work.

✔ Sending your clients their photos via a gallery ensures that their photos are backed up in a safe place where they can't be lost, stolen, or damaged.

✔ Browsing an online gallery can be easier than loading 800 large files from a disc onto a computer.

✔ It's less work for you! Instead of having to order a nicely printed DVD and cover, assemble a package, and make a trip to the post office, you can send your clients their images from your desk at your home or studio.

✔ Some online hosting services have options that allow clients to buy their prints straight from the gallery, which ensures that they receive quality prints, and you don't have to manage the print sales yourself.

Sharing your images online comes with two disadvantages:

✔ Some couples really want to have a hard copy of their images. This can be a make-or-break issue with some clients.

✔ A few online hosting services have a monthly membership fee of around $30 to $100, which can add up if you're not shooting a lot of weddings yet.

Burning and Sending a DVD to Your Clients

If you decide that burning and sending a DVD to your clients is how you roll, then this section is for you. Here I go over how to how to organize your photos for the DVD and give you a few things to consider when getting ready to prep, burn, and send the finished product.

Organizing the photos for the DVD

As you prepare your photos for the DVD, you want to make sure that specific images are easy for your clients to find. Imagine for a moment the newlyweds as they put the DVD into their computer. The DVD whirs and loads, and then

up pops a folder with 800 teeny tiny thumbnails. You can make the situation a lot less daunting for them.

Instead of putting all the images in one huge folder, consider dividing them into separate folders with appropriate labels. The extent to which you want to break down the pictures is up to you, but I suggest the following categories: Preparation, First Look (if they chose to have one), Formal Portraits, Ceremony, and Reception.

Deciding on the look of the DVD

When your photos are organized and ready to go, you have to consider how you want your DVD to look. Consider the following two options for presentation:

- ✔ **Creating a DVD label and DVD cover on your own:** The simplest way to present your images is by creating your own DVD label on your home printer and using a store-bought DVD case with an inserted wedding picture in the front. This option is quick and cost-effective.

- ✔ **Ordering a printed DVD and DVD cover from a photo lab:** If you'd like to take your DVD packaging up a notch, another option is to order a custom DVD cover and printed DVD from a photo lab. Having your packaging professionally printed can give your business a polished look. With this service, you have the ability to design your DVD and the cover and send the design in to the lab to be professionally printed. Then the lab sends you the finished product, and all that's left for you to do is burn the images onto the disc. This option usually costs around $35 to $45.

Several companies offer printed DVDs and DVD covers, but one of my favorites is White House Custom Color, which can be found at www.whcc.com.

Burning the DVD

Deciding how you want to present your DVD to your newlyweds aside (see the preceding section), actually burning the DVD is quite simple and can be done in just a few steps:

1. **With your computer turned on, insert the blank DVD into your disc drive.**

2. **When the DVD loads, double-click on the icon on your desktop to open up the DVD window.**

3. **Open another folder window and navigate to the folder on your hard drive where your wedding pictures are stored, and open up the root folder containing your couple's pictures.**

4. **Select the folders you wish to add to the DVD and drag them over to the DVD window.**

5. **When all the desired files are copied over to the DVD window, click Burn at the top right of your DVD window.**

 A small status bar appears showing the progress of the DVD burn.

6. **After the files are written onto the DVD, eject the DVD and place it securely into its case.**

Before I send off the DVD to my couple, I always like to double-check the disc to make sure the files were written correctly. To do this, simply insert the DVD back into your computer and open the window when the DVD loads. Browse through the files to make sure the pictures are viewable and no errors occurred in the writing process.

Creating a well-branded package to send to the couple

Although some wedding photographers choose to send their clients just a DVD of images in the mail, others love to get creative and to send their clients a well-branded package with the DVD included.

You may be asking, "What the heck is branding?" *Branding* is a buzz word that's tossed around a lot in the marketing and small business world, but the meaning is quite simple. It's the attitude, details, and personality that set your business apart from others in your field and make your business stand out in the minds of potential clients. Your brand is represented by your business name, your logo, possibly a motto for your business, and all written and online materials you use to communicate with the public. (See Chapter 16 for more information.)

Even though the couple receiving the disc already chose you, you still have the chance to go that extra mile and set yourself apart from the other photographers in your area. Here are a few ideas of things you may choose to include in your package:

- A thank-you note on your photography brand's stationary
- Some nicely wrapped goodies (such as candy or cookies)
- A little thank-you gift (like tile coasters with one of their wedding photos on it, or a mini calendar with a wedding photo for each month)
- A few of your business cards

Before you send your package off to your clients, make sure to verify the couple's address. It would be disheartening to put all that work into a beautiful wedding package, only for it to go to the wrong place! Before I send my clients' their photos, I always send them a quick text or e-mail to make sure that I have the proper address and to let them know that their photos are on the way.

Placing Your Images on the Web

If you've decided that you'd much rather share your images with your clients through the Internet, this section covers two different types of galleries available. I also cover how you can use Facebook to share wedding photos with your clients and their families.

Sending your clients' images through PASS

Every once in a while I come across an idea so brilliant it makes me wish I'd thought of it first! PASS is one such idea.

PASS is a program used for sharing your photos online and allows you to quickly upload an entire wedding and immediately share it with your clients. It comes with some unique features that allow your clients to share their photos on Facebook (while giving you photography credit on *every* image), download high-resolution pictures from their gallery (a feature you can choose to turn on or off), and even view their entire wedding gallery on their mobile device with the download of a free PASS app. It also offers benefits to you as the photographer because the program backs up all your images, and it comes without a monthly membership fee. Instead of a membership, you pay $29 or $99 per event (depending on how many years you want the gallery to be available online), which you can roll into the cost of each wedding package you offer. (See Chapter 15 for details on creating wedding packages.)

You can find PASS at www.passpremiere.com and create an account and download the program by clicking on Download & Pricing. After you have your account set up and the program on your hard drive, you're ready to share your images:

1. **Open PASS and click on the Upload tab (see Figure 12-1).**

2. **Open a separate window on your computer and navigate to the folder that contains all the images from the wedding you want to share; select the folder and drag it over to the PASS window.**

 After confirming that you want the upload to be in high resolution, your images begin to upload, and a status report about the upload window keeps track of your progress.

Figure 12-1: From the PASS home screen you can choose to Upload, Manage, or Pass your wedding images.

3. **When your photos are done uploading, click on Manage at the top of your screen to view the event.**

 Within this module, you can put the photos into categories such as Preparation, First Look, Formal Portraits, and so on, like you can see in Figure 12-2, by clicking Add Collection and then dragging your desired images into each collection.

4. **After you have finished categorizing your wedding photos, click on the Pass tab to add V.I.P.s to your gallery.**

 To add V.I.P.s, who are the people to whom you give special permission to do things like view private collections or download all the images, you can enter each person by name and e-mail address (see Figure 12-3 for an example) or you can log into Facebook and click on each person's profile picture.

5. **When you have finished adding your V.I.P. members, you can edit how much of your gallery you want the rest of the public to be able to see; click on the Privacy tab at the bottom right of your screen to view your options.**

Figure 12-2: Within the PASS Manage tab you can organize your photos in specific categories.

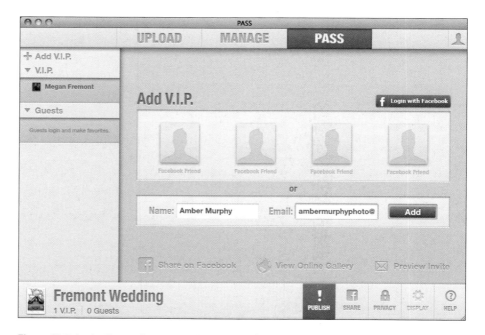

Figure 12-3: In the Pass tab you can give special permission to certain people to view private collections or download images from the gallery.

When you click on the Privacy tab, a little box pops up that lists each of the collections in that gallery. Next to each collection are two check boxes in a Show column and a Download column, like you can see in Figure 12-4. Checking (or unchecking) these boxes determines which collections the public can see, and who can download the images from each collection.

6. **To share the gallery, click on the Publish tab, also located at the bottom right of your screen.**

 A dialog box appears, like you can see in Figure 12-5, with the option to publish the event for one year for $29 or the option to publish it for five years for $99.

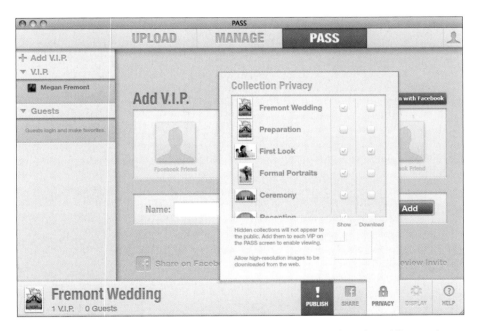

Figure 12-4: In the PASS Privacy tab you can regulate which collections the public can view.

7. **Select your preferred option and enter your payment information.**

8. **Click Publish.**

9. **After your event is published, you can share the gallery through e-mail or a Facebook post with the URL link using the Share tab at the bottom of your screen.**

If at any point in the process you need help, click on the Help tab at the bottom-right corner of your screen and a little box with the words Have A Question? will appear. If you click on Have A Question?, several little yellow icons appear onscreen (check out Figure 12-6) that take you to a video about the part of PASS in which you are working.

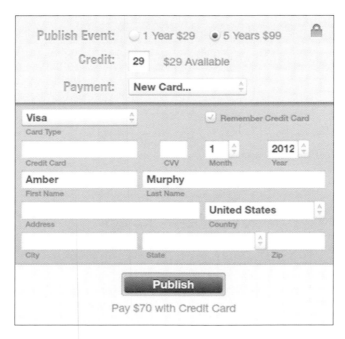

Figure 12-5: PASS allows you to pay per event you publish instead of requiring a monthly membership fee.

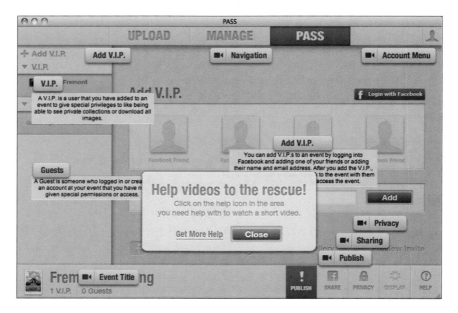

Figure 12-6: If you need help at any point while using PASS, clicking on Have A Question? brings up a variety of videos that demonstrate how to use the program.

Displaying images with an online hosting service

Another popular option for photographers who want to share their images with clients is to use an online hosting service. These services allow you to upload your photos, create galleries, and allow your clients to purchase prints directly from the gallery so you don't have to handle ordering and shipping prints. After you send your clients the link to their gallery, your work is done.

Several companies offer this type of service, a few of the most popular being SmugMug (www.smugmug.com), Pictage (www.pictage.com), and Zenfolio (www.zenfolio.com). As I mention in the earlier section "The pros and cons of posting images online," online hosting services usually come with a monthly membership fee, ranging from $30 to $100 depending on what features you want with your membership.

In this section I go over how to upload and manage your images with SmugMug and how to set your prices so that clients can order prints directly from their gallery. (*Note:* Though I personally use SmugMug, keep in mind that the steps are similar across other hosting services, should you choose a different one.)

Uploading your images to SmugMug

Uploading and managing images through an online hosting service is fairly simple. To post images of a wedding to SmugMug, create an account by going to www.smugmug.com and clicking on the Try Us Free button (if you want a free trial first) or the Skip Trial button (if you're already sure you want to use the service). Then simply enter your e-mail address, create a password, and enter a site name (such as the "ambermurphy" section of www.ambermurphy.smugmug.com). When you've entered your information, click on the Start My Free Trial button, or the Skip Trial and Sign Up button to finish creating your account.

After you create your account, follow these steps to upload your images:

1. **Go to www.smugmug.com and log in using your e-mail address and password.**

2. **Click on the Upload tab and select Create New Gallery.**

3. **Name your new gallery and select your preferred customizations for that gallery.**

4. **Click Save.**

 A new dialog box appears that allows you to add photos to your gallery.

5. **Navigate to where your wedding images are located on your hard drive and drag them into the upload dialog box.**

 The upload process begins, and you're shown the status of the upload as it proceeds.

6. **When your images are uploaded, click on I'm Done Uploading at the bottom right of your upload dialog box to be taken to your new gallery (check out Figure 12-7).**

7. **SmugMug offers the option to add captions or keywords to individual photos. If you would like to do so, click on the pictures you'd like to customize and click on the Add Caption or Keyword link underneath the photo.**

 A text box appears when you click on the Add Caption or Keyword link where you can enter your information. When you are finished, press Save.

8. **When you're satisfied that your gallery looks exactly how you want and you are ready to send it to your clients, click on the Share tab at the top right of your screen.**

 A dropdown list appears with several options of how to share your gallery, such as the ability to send an e-mail with the link to the gallery or to post the gallery to Facebook.

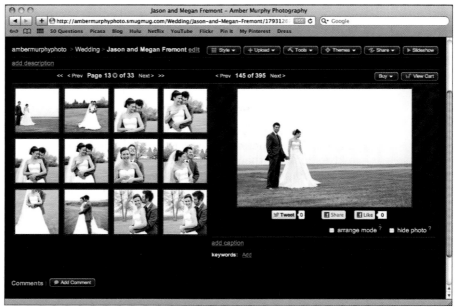

Courtesy of SmugMug Inc.

Figure 12-7: A sample SmugMug gallery.

Letting SmugMug handle print order fulfillment

If you ask most newlyweds, the last thing they want to do after getting back from their honeymoon is to sit down and order all their prints from their photographer right away. And if you ask most photographers, they'll tell you that handling print orders can be a real pain. Thankfully, a few brilliant minds came up with a solution: Let photographers set pricing on their online galleries so that the couple (along with their friends and family) can order their prints from a professional photo lab anytime they want with no deadlines.

SmugMug has this print order fulfillment feature, which is one of the main reasons I use online galleries. Follow these steps to set your own pricing:

1. **Navigate to your SmugMug home page and click on the Tools tab at the top left of your screen.**

2. **Select Account Settings from the dropdown menu.**

3. **In Account Settings, scroll down to the Business icon and click on it.**

4. **Click on Making Money and click on the Manage button next to Pricelists.**

5. **Click on Create New.**

6. **In the new dialog box (see Figure 12-8), give your pricelist a name and select which photo lab you would like your prints to come from.**

 Try to choose a name for your pricelist that makes the most sense to you. In Figure 12-8 you can see that I named my pricelist "White House Custom Color." I did so because that is the name of the photo lab I chose to order from.

7. **Select a currency.**

8. **Check the Color Correction box if you would like your printer to do so.**

 Because computers and printers use two different color models (sRGB and CMYK), sometimes the colors in a printed photograph can look a little different than the way the digital photograph looked on your screen. *Color Correction* is the process printers use to switch the color model on the digital photos that you send it so that the colors in the printed photograph look accurate.

9. **Determine how much profit you would like to make off of each photo that your clients order.**

 The default is set to 400 percent, but you can change that to whatever you like by entering a number in the box. (Check out Chapter 15 for more about pricing.)

10. **Select whether you want your prices to be rounded or not.**

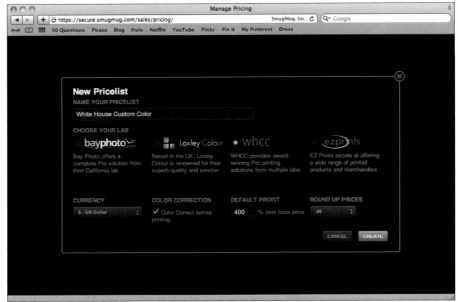

Courtesy of SmugMug Inc.

Figure 12-8: SmugMug allows you to select a photo lab, currency, color correction option, and profit margin so setting your prices is quick and painless.

11. Click on Create.

You're taken to a new window that lets you choose which products you want available for your clients to order.

12. Click on Choose Products.

A new window appears with several dropdown lists of available products. Select which products you want by checking the boxes, like you see in Figure 12-9, and then click on Done in the bottom right-hand corner.

13. If you want your pricelist to be applied to all your galleries, check the box next to Make this my default pricelist, on the right-hand side of your screen.

14. Click Apply Changes.

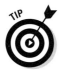

As your clients order prints, SmugMug tracks your sales history and profits. You can set up how you want to be paid in the Business section of your account under Getting Paid. To access the Business section of your account, click on Account Settings under the Tools menu. Then scroll down to the Business icon on the left-hand side of your Account Settings page. Click on the Business icon and navigate to the Getting Paid menu at the top left of your screen. Here you'll be able to set up your tax information, payment schedule, sales tax options, and fill out an electronic 1099 form.

Courtesy of SmugMug Inc.

Figure 12-9: SmugMug has an extensive product list to choose from, from the standard print sizes shown here, to gallery wrapped canvases and framed prints.

Showing off your photos on Facebook

Whether I send my clients a DVD or use an online gallery, in addition I always post images from each wedding in at least one place on the web: Facebook. It's one of the easiest ways for me to share photos from a wedding with the happy couple along with just about everyone else they know, from college buddies to grandparents (for more on utilizing Facebook and creating a business page, see Chapter 16).

One of the best parts about Facebook is that it's absolutely free and allows you to tag photos to ensure that specific people see the photos you share. If you don't have a Facebook account, I highly recommend getting one!

If you decide that you would like to use Facebook as part of your online sharing process, I do recommend that you use a business page rather than your own personal account. It gives your business name more recognition, and Facebook requires that personal pages be for personal use only. If you do business on your personal page, they retain the right to delete your profile for breaking the rules!

If you have a Facebook profile and business page set up, you're ready to start posting your pictures. Uploading an album is simple and can be done in just a few steps:

1. **Head over to www.facebook.com and log in using your e-mail address and password.**

2. **Click on your business page under Pages to navigate to your business profile.**

3. **Click on the Photo/Video link found above your status bar, and then select Create Photo Album when the option appears.**

 A new window opens that allows you to navigate to the images you want to upload.

4. **Select the photos you want in the album by hitting the Command key (Mac) or Control key (Windows) and clicking on the desired photos.**

5. **Click Open.**

 The photos begin uploading automatically in a new window. In this window you can name your album, add the date and location where the photos were taken, tag the people in each photo, and choose the quality of the images.

6. **When the photos are uploaded and you've chosen all your settings, click Post Photos to publish your album.**

13

Compiling and Designing the Wedding Album

*W*hen the party rentals have been returned, the wedding dress has been packed away, the gifts have all been opened, and the wedding day has come and gone, often the most cherished memento a couple has left is their wedding album. Usually showcased in a predominant area of the home, rather than stowed away on the computer like digital images, the wedding album is one of the best ways for a couple to show off their beautiful photos to their friends and family. It is also readily available for just the couple to peruse when they want to remember their special day.

In this chapter, I cover the process of putting together a wedding album for your clients, from selecting an album company and design program to the different methods photographers use when it comes to compiling the album. I also go over how to finetune select images in Adobe Photoshop and give you a few tips on page design.

Choosing Your Album Company and Design Program

If you've decided to include an album with your wedding packages (see Chapter 15), one of the first things you'll want to do, perhaps even before shooting a wedding, is to choose an album company to work with, along with an album design program. In the following sections, I go over the steps needed to partner with an album company and give you a list of some of the top companies out there. I also cover a few of the design programs available on the market.

Finding and registering with an album company

Just as every photographer has his own distinct style, so do the variety of album companies each come with their own set of unique qualities. As you decide which company you would like to work with, consider which products and price ranges best fit your own style and brand as a photographer. Following are some of the most well-known album companies along with their web addresses:

- **Cypress:** www.cypressalbums.com
- **Kiss:** http://kiss.us
- **Leather Craftsmen:** http://leathercraftsmen.net/joomla1
- **Asuka:** www.asukabook.com
- **White House Custom Color:** www.whcc.com
- **Renaissance:** www.renaissancealbums.com
- **Queensberry:** www.queensberry.com
- **Zookbinders:** www.zookbinders.com

Some album companies offer a choice between albums with printed pages and albums with printed photos placed on blank pages, and others offer only one type of album. See "Choosing an album style" later in this chapter to review the two options, and keep your preference in mind when selecting an album company.

When you settle on an album company that you would like to work with, the next step is to register your photography business with them. Album companies work exclusively with professional photographers and designers, so each website has a spot where you can register. Most of the time, registration entails giving them your full name, e-mail address, business name, business website,

telephone number, and year you started your business. When you submit your registration, it's sent to the album company for approval, which usually only takes a couple of days. You can begin ordering albums after you're approved.

Selecting a design program

Another aspect of album design you'll want to think about is which software best suits your needs. Before you can order an album, you'll need to create the page layouts yourself and then send them off to an album company for printing and binding. Album software allows you to easily create the album pages. A few programs out on the market are worth considering:

- ✔ **Adobe Photoshop** (www.photoshop.com): Not only can Photoshop handle all your photo-editing needs (as you find out later in this chapter), but it is also (first and foremost) a design program. Within Photoshop you can create individual page layouts manually, or you can purchase album layout templates from places like www.thealbum cafe.com. Photoshop sells for about $700.

- ✔ **FotoFusion** (http://site.lumapix.com): This program, created by LumaPix, sells for about $300 and comes with the options to use pre-made templates to create your album or to start from scratch.

- ✔ **Fundy Album Builder** (www.fundysos.com): This software also starts at about $300 and has some great features, including an auto design function, the ability to edit photos within the program, and an array of templates to use for easy page design.

- ✔ **Photojunction** (http://photojunction.com): Photojunction is a free design program that's fast and easy to use. It comes with a wide variety of templates, along with the ability to create and save your own designs. Photojunction also lets you quickly send proofs to your clients online through Queensberry Workspace (I discuss online album proofing later in this chapter).

Many of the preceding album design programs allow a user to download a free trial before making an investment. Consider taking advantage of these testing periods so you can determine which you like best before making a purchase.

Curating Images for an Album

When you've selected both your album company and design program (see the preceding section), the next thing you need to consider is how to choose the images for your wedding albums. There are three schools of thought on the issue:

✔ **Choosing all the images and designing the album on your own:** The first option you have when it comes to curating the images for your wedding albums is to choose all the images yourself. With this option, the entirety of the design is left up to you. As you go through the photos from a wedding, you select which ones you believe are the absolute best and arrange them in a pleasing manner. The benefit to this option is that you don't have to wait for input or feedback from the couple, which can make the turnaround time much faster. The only drawback to this option is that there is a possibility that you may exclude a few photos that have special significance to your couple.

✔ **Giving your clients the option to choose all the images:** Your second option is the exact opposite of the first. Here, you give your clients the edited proofs or a DVD of all their wedding photos and allow them to select every image to be included in their wedding album. The great thing about this option is that your couple gets to have the pictures that are most meaningful to them in the album. However, the drawback is that waiting on your couple to choose all their images can significantly draw out the process. (Fear not; I explain how to handle this situation in the next section.)

✔ **Predesigning the album and submitting it to the couple for revisions:** Predesigning the wedding album combines the first two options and is really, in my humble opinion, the best of both worlds. You start the process by selecting all the photos and completely designing an album. When you're finished, you submit the design along with the proofs or DVD of all their edited wedding photos to your couple for one or two revisions. When their requested revisions have been made, you send the design off to your album company to be printed and assembled. (See the later section "Creating and Finalizing the Page Design" for details on this entire process.)

The nice thing about this option is that you, as the artist, are able to create a masterfully crafted album with the best photos from the day, but the couple can also feel like they were able to have some input and ensure that you include their favorite pictures.

Consulting with the Couple

If you've decided that your policy is to allow your couple to choose the images to go into the wedding album or to make any revisions to a predesigned album (see the preceding section for more about these options), the first step in the design process is a consultation with the couple. Unfortunately, sometimes this step can be long and drawn out, because most of the time the last thing newlyweds want to do after the honeymoon is to sit down and pick out a bunch of pictures! Photographers often have to wait six months to a year after the wedding before receiving their clients' album selections.

To avoid the delay (and frustration) this scenario can cause, the communication with your couple regarding the image selection for the album should start in the months leading up to the wedding, preferably when you meet with them for the signing of the contract (see Chapter 1). That way you'll be able to explain to them in detail how the selection process will work, instead of springing the news to them in an e-mail two days after they've returned from their honeymoon. If you established some groundwork beforehand, when you do contact them after the wedding, it will simply be as a reminder that you need their image selections in order to begin the album design. Here are a few tips to consider when reaching out to your couple:

- ✔ **Give them time to relax:** After months of wedding planning and hard work, newlyweds deserve a little time off. Give them a few weeks to open all their gifts, set up the new place, and settle into married life before asking them to get back to work. If your couple has had enough of a break, they'll more than likely tackle the image selection process with more excitement.

- ✔ **Outline how many images they need to choose:** Make sure you tell your couple approximately how many pictures they need to choose for a complete album. Of course the number depends on how many pages your albums include, but generally for an album with 30 pages (also known as 15 spreads), you should have them choose about 70 to 80 photos.

- ✔ **Divide the wedding day into sections:** Most couples you photograph probably aren't album designers, so it may be helpful for you to suggest an approximate number of photos for each segment of the wedding day. This guideline ensures that the couple's album will be a complete story, not something like 80 percent portraits and 20 percent candids. The approximate number of photos to request from your clients varies depending on how many pages the album will be, but here's a general guideline:

 - 10 percent bride and groom individual portraits
 - 15 percent pictures of everyone getting ready
 - 15 percent First Look (if applicable)
 - 15 percent portraits of the couple
 - 15 percent family and wedding party portraits
 - 10 percent ceremony
 - 15 percent reception
 - 5 percent of the couple leaving the wedding

- ✔ **Remind them to select only the best photos:** The wedding album is usually proudly displayed at the newlyweds' home, so remind them that only the very best photos should be chosen.

Having a deadline for album completion can be extremely helpful to you so that you're not working on last year's client albums in the middle of the next year's busy wedding season. However, not all your clients will be good at meeting deadlines, so you may want to consider setting up an incentive for them to do so:

✔ **Past deadline fees:** Some photographers include a clause in their wedding contract stating that if a couple doesn't choose their images for the album by a set deadline, the couple will have to pay additional fees to receive their album.

✔ **Loss of input after deadline:** Another option is to state in the contract that if the couple fails to select the photos by the deadline, then you will proceed to design the album on your own without the couple's input.

Let the Second Edit Begin!

You took care of some basic image adjustments during the first round of editing (make sure to check out Chapter 11), which should happen before you show pictures to the couple or start selecting images for the album. After you or the newlyweds have chosen all the photos for the wedding album, it's time to dive into the second edit.

Note that the second edit applies only to those photos that are included in the album or are printed. The reason for limiting how many photos you edit is that even though the editing doesn't have to be extreme, it still takes quite a bit of work. Unless you'd like to spend months doing a second edit of every wedding of 800 or more photos, you'll only want to fine-tune the images that are going to be showcased.

The second round of editing involves retouching images where they need it, as well as sharpening and saving the photos for print. In the following sections, I give you step-by-step instructions on how to perfect your images in Adobe Photoshop and how to save the images at the correct resolution.

Retouching

Photoshop is known for the ability to "airbrush" photos and make an image look flawless. Unfortunately, sometimes people go overboard in their edits and make their subjects look too glowy, with eyes about to jump off the page.

As you retouch your wedding photos, it is important to remember that you don't want your edits to be obvious. The goal in this process is to tweak an image just enough that it improves the final result but keeps the natural

appearance. Compare the original portrait in Figure 13-1a to the retouched portrait in Figure 13-1b; in the retouched image I smoothed the subject's skin and sharpened her eyes, and then I lightly sharpened the entire photo to improve the overall effect while keeping the photo looking natural.

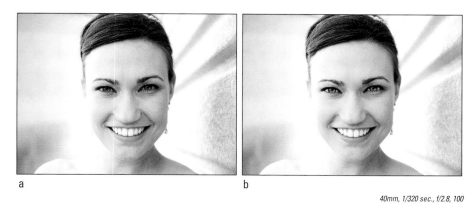

a b

40mm, 1/320 sec., f/2.8, 100

Figure 13-1: The goal of retouching is to improve the overall appearance of an image without making it too obvious.

The most common types of retouching to do on wedding photos are removing blemishes, smoothing skin, and enhancing eyes.

Removing blemishes

As too many of us know, even people who follow rigorous skincare regimens occasionally get pesky little blemishes. Fortunately, Photoshop offers an easy fix:

1. **Open the image in Photoshop and zoom in to the area with the blemish you'd like to remove.**

 To zoom in to an area in Photoshop, locate and click on the Zoom tool at the bottom of the toolbar, which is found on the left-hand side of your screen, or hit the Z key. Then click on the photo to zoom in.

2. **Find the healing tools (the icon that looks like a Band-Aid), located on the bar on the left-hand side of your screen.**

 If you are using Photoshop CS5 and newer, select the Spot Healing Brush Tool by holding down your mouse button on the healing tools icon and clicking on Spot Healing Brush from the menu that appears (see Figure 13-2). Then proceed to Step 3.

 If you're using an older version of Photoshop, select the Patch tool from the healing tools by holding down your mouse button on the healing tools icon and clicking on Patch Tool from the menu that appears.

Figure 13-2: Use the Spot Healing Brush to easily eliminate unwanted blemishes.

3. **If you're using the Spot Healing Brush Tool, resize the brush that appears as your cursor using the left or right bracket keys so that it's just a little bit larger than the blemish.**

 If you're using an older version, you can skip this step.

4. **Place your cursor brush over the blemish and click once.**

 If your cursor fits over the entire blemish, clicking once will do the job. However, if the blemish is something like a long scratch, you can click and drag your cursor over the entire mark. When you release the mouse button, the blemish disappears. Voilà!

 If you're using the Patch Tool instead of the Spot Healing Brush Tool, hold down the mouse button and draw a circle around the blemish you'd like to remove. When you release the button, a dotted circle appears around the blemish. Click on the selected blemish and drag the mark to another area that has a similar tone and is free of other blemishes. When you let go of the mouse button, the blemish disappears.

Smoothing skin

Another way to perfect a wedding image is to smooth the skin, especially if the photo is a close-up. You can smooth skin a gazillion different ways, but I prefer this quick and painless method:

1. **Open the image in Photoshop and create a duplicate layer by hitting Command+J (Mac) or Control+J (Windows).**

 A *duplicate layer* is an exact copy of your original image that lays on top of the original. Your new layer is automatically named Layer 1, but you can change the name of the layer if you wish by clicking on the Layer 1 text and typing in the new name.

2. **With your duplicate layer selected, apply a Gaussian Blur Filter by going to Filter ⇨ Blur ⇨ Gaussian Blur.**

 A dialog box pops up with the option to change the Radius amount, like you see in Figure 13-3.

3. **Move the slider until you see the skin imperfections fade and click OK.**

 Note that the entire image will blur, but that's ok! You'll fix that in a second.

4. **Apply a layer mask to your image by navigating to Layer ⇨ Layer Mask ⇨ Hide All (see Figure 13-4).**

 This step applies a mask that hides the Gaussian Blur.

Figure 13-3: Blur out skin imperfections with the Gaussian Blur Filter.

Figure 13-4: The Layer Mask feature hides the Gaussian Blur effect.

5. **Use a brush with the foreground color set to white to paint back over the skin to reveal the Gaussian Blur on the skin only, leaving the rest of the image sharp.**

Select a brush by clicking on the Brush Tool icon on the left-hand sidebar or by hitting the B key. Then navigate to the dropdown brush menu at the top left-hand side of your screen (see Figure 13-5).

Figure 13-5: The brush menu in Photoshop allows you to choose a variety of brushes.

Photoshop has a ton of different brush types to choose from, but I recommend using a Soft Round Brush (highlighted in Figure 13-5), and you can adjust the size according to your needs by using the left and right bracket keys, or moving the brush size slider.

To change the foreground color of your brush, look to the bottom of your toolbar on the left-hand side of your screen. Two little boxes partially overlap, one black and one white. The box on the top is your foreground color; the one on the bottom is your background color. To switch your foreground and background colors, click on the arrows directly above the icon, or hit the X key.

6. **If your subject's skin looks perfect, you're done! If, however, the skin looks a little too smooth, you can adjust the opacity of the layer by clicking on Opacity on the layers palette menu on the left-hand side of your screen and moving the slider to the left.**

 The opacity of a layer refers to how strong or weak an effect is on your layer.

Enhancing eyes

My favorite part of any portrait is the eyes. I love how beautiful and expressive they are, so I always make sure that they have some pop and sparkle to them in the postproduction process.

The steps for enhancing the eyes in Photoshop are very similar to those for smoothing skin (see the preceding section), except that we're sharpening instead of blurring the image. Here's how you enhance the eyes in a photograph:

1. **Open the image in Photoshop and create a duplicate layer by hitting Command+J (Mac) or Control+J (Windows).**

2. **With the duplicate layer selected, apply an Unsharp Mask Filter by going to Filter ⇨ Sharpen ⇨ Unsharp Mask.**

 A dialog box appears in which you can adjust the amount of sharpening you want with a slider bar, which you can see in Figure 13-6.

3. **Play around with the slider until the eyes look right and then click OK.**

 You need quite a bit of sharpening to make the eyes pop, but the exact amount depends on how big your file is.

4. **Apply a layer mask to your image by navigating to Layer ⇨ Layer Mask ⇨ Hide All.**

5. **Use a white brush to paint back over the eyes only, which brings out the sharpness in only that area.**

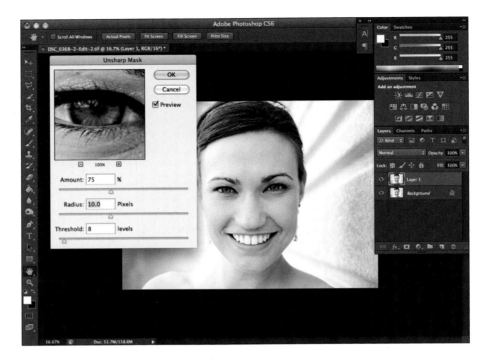

Figure 13-6: Sharpen your subject's eyes by using the Unsharp Mask Filter in Photoshop.

Sharpening images for print

Even if you have a steady hand, at times you'll have images turn out softer (that is, a bit more blurry) than you'd prefer. Thankfully, Photoshop has the ability to sharpen images and make them crisp and clear — but only to a certain degree. An overly blurry image is not fixable, even in an advanced program like Photoshop. The sharpening tools can't actually reconstruct a photo; rather they increase the contrast of the edges in a picture, making it *look* more sharp.

Like with retouching an image (see the preceding section), you want to make sure you aren't too heavy-handed with Photoshop's sharpening features. An over-sharpened image gets a *sharpening halo,* where the edges in a photo have white halos around them. You want to sharpen an image just enough to give it a crisp feel.

Follow these steps to sharpen an image in Photoshop:

1. **Open the image in Photoshop and create a duplicate layer by hitting Command+J (Mac) or Control+J (Windows).**

2. **With your duplicate layer selected, apply the High Pass Filter by going to Filter ⇨ Other ⇨ High Pass Filter.**

3. **In the dialog box, adjust the Radius until the edges of the preview look sharp enough and then click OK.**

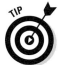

The default radius for the High Pass Filter is 10, but most images need significantly less sharpening than that. Usually around 2 or 3 suffices. As you can see in Figure 13-7, the High Pass Filter turns your image gray. Not to worry, we'll fix that in a second!

4. **Change the blending mode of your layers to Overlay by clicking the dropdown menu above your layers palette, located on the left-hand side of your screen (see Figure 13-8).**

Using the Overlay blending mode blends Layer 1 and the Background layer, giving your image a nice sharpened effect.

5. **If your image looks too sharp, adjust the opacity of the layer by sliding the Opacity bar on the layers palette to the left.**

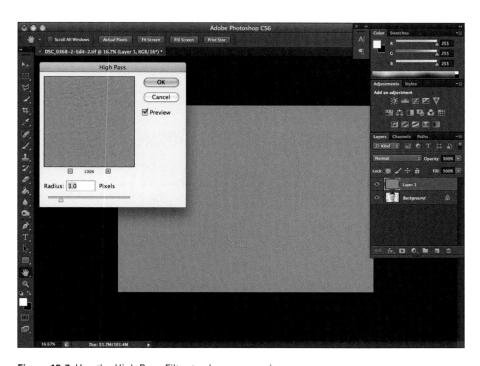

Figure 13-7: Use the High Pass Filter to sharpen your image.

Figure 13-8: The Overlay blending mode.

Saving images in Photoshop

When you're finished adjusting an image in Photoshop, you want to make sure to save it. Saving pictures in Photoshop is a little different than in Adobe Lightroom (for saving images in Lightroom, see Chapter 11), and you should take a few things into consideration before actually saving the image:

- **Preserving the original:** Instead of just hitting the Save button, which converts your original file to a new type of file, you should select Save As. Utilizing the Save As feature allows you to change the file and save it while leaving the original alone.

- **Saving as a TIFF first:** A TIFF file is a *lossless* type of file, which preserves the quality of the file and keeps all the important information. After working hard on your image in Photoshop, consider saving as a TIFF first so that you have a large file that's not degraded, just in case you want to come back to it and edit it more later on.

- **Saving as a JPEG for print or for the web:** After you've saved a TIFF file, then you can save the image as a web-ready or print-ready JPEG — or save a copy of each! A web-ready image's resolution should be set to 72ppi (pixels per inch), and a print-ready image should be saved at 300ppi.

When you're ready to save your image in Photoshop, follow these simple steps:

1. **Navigate to the Photoshop toolbar at the top of your screen and select File ➪ Save As.**

2. **In the Save As dialog box (see Figure 13-9), you can rename your file by typing in the text box.**

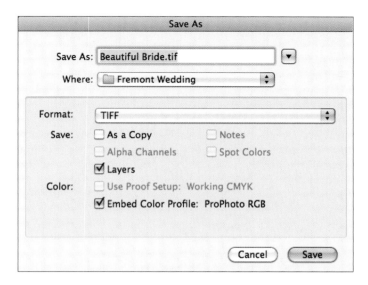

Figure 13-9: The Save As dialog box allows you to rename your file and choose how you want to save your image.

3. **Select the location of where you'd like to save your file.**

4. **Navigate to the file dropdown list and select TIFF.**

 When saving as a TIFF, you have two options:

 • **As a Copy:** Save as a copy if you want it to be a duplicate. It will add "copy" to your filename.

 • **Layers:** If you'd like to save the layers of your file so you can come back to edit them later, check this box.

5. **Click Save.**

6. **After you've saved your lossless TIFF file, you can now save the image as a JPEG if you desire. Simply repeat the Save As process and select JPEG from the dropdown menu.**

Changing color space (if you must)

Color space, also known as *color model,* is the way colors are represented as numbers. Though several different color spaces exist, the two main ones you need to be aware of as a photographer are sRGB and CMYK. Most of the time you don't need to worry about color space, but occasionally you need to be able to change this setting in Photoshop when you're preparing your files for print.

Color space starts with your digital camera and how it processes the color of the images. Digital cameras and computers generally use a sRGB color space, which stands for *standard red green blue.* However, printers use a CMYK *(cyan, magenta, yellow, black)* color space for printing images. This can sometimes result in an image having perfect colors on your computer monitor but looking different when printed.

Many professional photo labs actually convert the color profile of your images for you before they print. However, some photo labs ask you to do that for them before sending them the files. If you need to change the color space, open up the images in Photoshop and follow these steps:

1. **Navigate to the Photoshop toolbar at the top of your screen and select Edit ➪ Convert to Profile.**

2. **A dialog box opens that allows you to choose your color profile. Select Working CMYK from the dropdown menu.**

3. **Make sure that the Embed Color Profile (Mac) or the ICC Profile (Windows) box is checked.**

4. **Click OK.**

Creating and Finalizing the Page Design

After the images for the wedding album have been chosen and have gone through a final edit, you're ready to begin the actual album design. The following sections take you through the whole process, from choosing an album style to sending it off to your album company to be assembled.

Choosing an album style

The majority of wedding albums these days fall into two categories: matted albums or flush-mount albums. Here's how the two differ:

- **Matted albums:** This more traditional style of album has the photos printed individually and adhered to a pre-cut mat. The mat is then attached to the album page.

- **Flush-mount albums:** Each album page is printed as a single image so that all the photos lay flat across the entire page. It is then dry-mounted to a thick page board.

Whether you go with a matted style or a flush-mount style album, you can choose a thick, high-quality cover made from a material of your choice. Either type of album is a great option, and the choice boils down to your personal preference.

Laying out the images

Designing a wedding album may seem like a daunting task at first. As you sit before your computer with an empty album template, you may wonder where to even begin. Though putting together a complete story in a wedding album does take a good amount of time, I can give you a few tips to ease the process along.

✔ **Less is more:** Don't try to load up each page with a ton of photos, or all the images will be clamoring for attention (see Figure 13-10a) and the page can look cluttered and disorganized. Instead, choose two or three images for each page so that the viewer's eye can fully take in each image, like in Figure 13-10b.

Now that I just gave you a rule of thumb, I'll break it: Though you generally want to have just a few photos on each page, certain parts of a wedding, like reception details or wedding party photos, do lend themselves well to more images on a page (check out Figure 13-11) because these types of photos have a lot of similarities to one another and look great grouped together.

✔ **Tell a story:** One of the most important things to keep in mind as you work on the album is that you're telling the story of the entire wedding day in just a few pages. Choose images that best depict the action and emotion of each part of the wedding day, and arrange pictures chronologically. See Chapter 7 for more on the story of the day.

✔ **Don't feel the need to fill up all the empty space:** Sometimes leaving an empty space on the page can give a very calming effect (see Figure 13-12). Play around with how large or small you want each image on the album pages and don't be afraid to leave some empty space.

✔ **Use only the best images:** You know how in high school when you had to write a paper that met a minimum length requirement, and you ran out of things to say so just added a bunch of filler words to make the paper long enough? Don't carry over that technique to album design! The wedding album is a showcase of your work, so you never want to include mediocre photos just to make the album long enough. Choose only the best you have to offer and work with that.

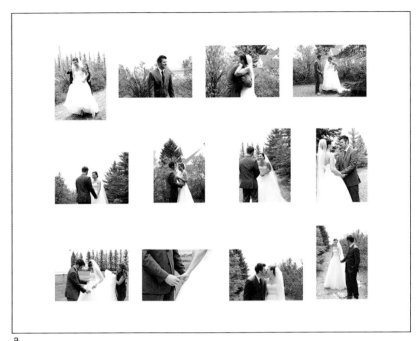

a

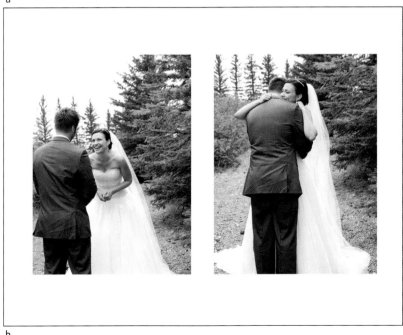

b

Figure 13-10: Instead of trying to fit too many pictures on one page, choose two or three so they receive the appropriate amount of attention.

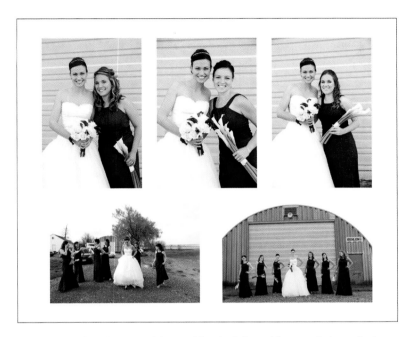

Figure 13-11: Certain parts of the wedding look fine with several photos in the spread.

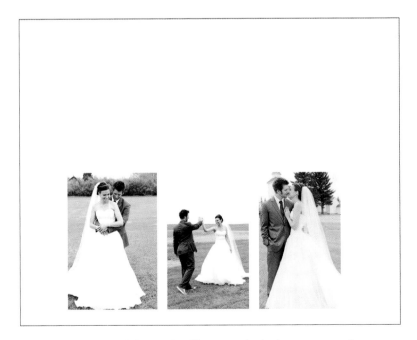

Figure 13-12: Don't feel the need to fill up every inch of space on an album page.

Showing the album proofs to the couple

If your couple is involved with the album design process (see the earlier section "Curating Images for an Album" for more about this option), show them the first draft when you have it finished so that they can make their revisions or approve what you've done. Rather than e-mail them the files and have to keep track of all their comments through a dozen different responses, consider using online album proofing.

Online album proofing makes the process quick and easy for both you and your clients. You upload your album files to the website of the proofing company you choose and create a password for that album. Then you send the link to your clients, who are then able to log in, view the album preview, make comments, and request changes. When they're finished, they submit their changes and you receive an e-mail notification. You can then make the appropriate changes and resubmit the album proofs to the couple. You may go through this process several times, depending on how many revisions you allow your couple to make.

When all edits to the album have been made, make sure you submit the proofs to your couple one last time for final approval. When the newlyweds sign off on the album, you're ready to send it off to print!

Following are a few options for online proofing:

- **Album Exposure** (www.albumexposure.com): This online option costs $15 a month, or $150 a year.

- **AlbumRev** (www.albumrev.com): Album Rev is a free site for sending album proofs to your clients.

- **Album Proofer** (www.fundysoftware.com): Album Proofer has a free account available, but you can only have two albums on the account. It also offers a paid account, which costs $15 per month or $79 every six months, that allows an unlimited number of albums.

- **Queensberry Workspace** (http://workspace.queensberry.com): Queensberry Workspace offers a range of memberships from a free proofing membership to a Pro+ membership with added benefits that costs $49 per month.

Sending the files to your album company

The next step in the process is to send your album files to your album company, who prints and binds your album. Though this process may look a little different for each album company, generally you will need to do the following:

✔ Choose your album style (I describe styles earlier in this chapter).

✔ Select a cover material and type of paper.

✔ Determine the correct size of the album along with appropriate amount of pages.

✔ Upload the images to be printed.

✔ Review the album and make sure all the images are aligned on the template correctly.

✔ Order the album by entering your payment and shipping information.

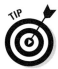

As you prepare to order the album, consider ordering one for yourself to keep. That way you'll have examples of your work on hand to show off to prospective clients. Showing off your masterfully crafted albums may even help you to upsell your wedding packages if you offer some packages with albums and some without.

If ordering an extra album is not in the budget, you may want to take a few detailed pictures of each one before sending it off to your newlyweds. Then you still have something to show new clients as an example of what your wedding albums look like.

Shipping the Finished Album to Your Newlyweds

As you near the end of the album design process, you have one more decision to make before you're finally done: how to get the album to the couple. You have two options when it comes to delivering your album masterpiece to your newlyweds.

✔ The first option is to have the album *drop shipped* to your clients, meaning the album company sends the finished product directly to your clients. The best part about this method is that you only have to pay for shipping and handling once. However, the downside is that you don't get to see the album for yourself before the client receives it.

✔ The second option is to have the album shipped to you first, and then you send it off to your clients. This choice is my personal preference, despite having to pay for shipping twice, because I like to be able to look over the album and check for any errors. If the album looks perfect, I also like to be able to send it off to my clients with a personal note of thanks for choosing my business.

Part IV
Building Your Portfolio and Business

The 5th Wave By Rich Tennant

©RICHTENNANT

"My experience as a crime scene photographer really helps me shoot at weddings. As you can see, there's plenty of evidence of a marriage being committed here."

In this part . . .

*1*f you've fallen head over heels for wedding photography and dream of quitting your day job, then this part is right up your alley. The chapters here cover all the facets you should consider as you pursue making wedding photography your full-time job. From putting together a rock-solid portfolio to establishing your business identity and covering the legal aspects, this part walks you through how to get your business started and points you toward some helpful resources online. I also give you a few tips on how to get your name out there so you can reach prospective clients and fill up your bookings calendar.

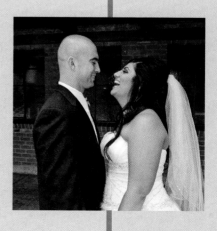

Putting Together Your Portfolio

*W*hen my husband and I were planning our wedding, one of the first things I did after we announced our engagement was to sit down at my computer and scour the Internet for a wedding photographer. On every photographer's website I found, I searched for a gallery of wedding and portrait images to see how good the photos looked. I immediately passed over some unfortunate photographers because they had very weak portfolios with images that weren't very appealing.

Establishing a solid portfolio is crucial for any photographer trying to bring in business. In this chapter, I cover the reasons you need a portfolio along with different ways you can build one before you start shooting weddings on your own. I also go over how you can put your portfolio online to be seen by potential clients.

Realizing Why You Need a Portfolio

Before I dive into how to build a *portfolio,* a collection of your photographs to show clients, it's important to understand why you need one in the first place. Here are the two main reasons why a portfolio is necessary:

✔ **Establishing credibility:** Imagine for a moment a budding young photographer named Jill. Jill desperately wants to be a wedding photographer, and upon hearing an acquaintance announce her engagement, Jill contacts the bride-to-be and offers her services as a wedding photographer.

The bride-to-be takes Jill's offer into consideration and asks Jill to see a sample of her work. Jill replies, "Oh, I'm a brand new photographer so I don't have any samples to show you yet." What do you think her chances are of being hired by the bride-to-be? Not good.

Having a good portfolio establishes credibility with people you hope to work with in the future. Though not completely out of the realm of possibility, you're not likely to find a couple who is willing to hire a photographer who has no portfolio to show his or her capabilities. A bride and groom want to feel confident that the person they hire to capture one of the most important days of their life will be able to deliver quality photographs.

✔ **Luring potential clients:** A solid portfolio can also help you lure potential clients. Stunning images grab people's attention and leave them wanting to get such good pictures of themselves and their own special day. When brides- or grooms-to-be come across your website and portfolio and like what they see, they'll want to know more about your services and availability, so your portfolio should be a tool that can prompt potential clients into action.

Gaining Knowledge and Creating Your Portfolio

The thought of building a portfolio from the ground up can be a little daunting (I remember; I've been there!). But even if you just bought your camera today and haven't taken a single picture with it yet, you can take steps toward creating an awesome portfolio and getting your wedding photography business started. In the following sections, I talk about a few different ways to acquire the kinds of pictures you need to have in order to show potential clients your capabilities.

Practicing often to develop a range of skills

Busting out that shiny new camera and taking pictures as often as you can is one of the best things you can do for yourself as a new photographer. Not only will you have something to show off, but you will become more and more comfortable behind the lens. The old saying "practice makes perfect" really applies here! The more you shoot on your own, the better you become.

Offering to photograph people for free is probably the number one way to grow your portfolio; not many people will say no to having their picture taken free of charge. When first starting out, try to photograph anyone you can, from babies and families to senior portraits and engagements. Doing so allows you to develop technical skill with the camera and feel more comfortable working with and posing people.

50mm, 1/100 sec., f/8.0, 200

Figure 14-1: Photographing your friends and family for free can lead to some great images to include in your portfolio.

You can also use some of those photos in your portfolio. I took the photo in Figure 14-1 as part of a free practice photo shoot, which eventually helped me to get paid jobs.

As you assemble your portfolio prior to shooting any weddings, be purposeful about including photos that demonstrate the range of your capabilities. Keep in mind that a skilled wedding photographer is a Jack (or Jane) of all trades and needs to be comfortable with several different genres of photography. For that reason, you'll want to take a variety of pictures that show off your skills. Consider including the following types of images:

- **Portraits:** Your portfolio should be made up predominantly of portraits, because people are the main focus of a wedding day. Including several different examples of people in a variety of environments can go a long way to communicate to a prospective couple that you can handle taking their wedding portraits.

 While shooting portraits, consider using light creatively. Whether you photograph someone backlit in golden sun or take a dramatic side-lit portrait with a flash, you'll be able to show clients that you can tackle any kind of lighting situation thrown at you on a wedding day. (Flip to Chapter 3 for more information on lighting.)

- **Photojournalism:** Including some candid photos in your portfolio is very important. A critical part of any wedding photographer's job is to capture special moments as they happen. Look for opportunities to shoot smaller events (such as parties or wedding showers) to demonstrate your ability to capture moments in a photojournalistic style.

✔ **Food, beverages, and details:** Shooting a wedding doesn't just involve people; you need to be able to accurately capture the details of the day as well. Take practice photos of wedding-type things like bouquets, shoes (see Figure 14-2), jewelry, food, and beverages. Including such photos in your portfolio lets people know that you're comfortable taking a wide variety of pictures and can be creative in arranging and capturing the details.

50mm, 1/100 sec., f/3.2, 100

Figure 14-2: Consider including pictures of details like shoes in your portfolio to demonstrate your range of skills.

Looking for mentors

When you're learning a new craft, having the wisdom and advice of someone established in the field is helpful. As you work on putting together a portfolio, seek out mentors who can help you fine-tune your skills. You can find help a couple of ways:

✔ **Attending hands-on photography workshops:** Look for wedding photographers in your area who offer hands-on workshops. Workshops can be a great way to learn some technical skills and practice with a group while getting feedback from the pro. Watching how an experienced photographer poses and photographs a model couple can be extremely helpful, and having a teacher right there when you photograph the couple allows you to ask questions and receive critiques of your photographs. An added bonus to a hands-on workshop is that not only can you walk away with a better developed skill set, but you also may get some great pictures to use in your portfolio.

✔ **Developing a one-on-one relationship with an experienced photographer:** Another great way to develop your skill and your portfolio is to find a local wedding photographer who's willing to sit down with you one on one to teach you what he or she knows. This type of mentorship

allows you to ask someone all your questions in person rather than searching for answers online. If you bring what you have of your portfolio, you can get the benefit of having someone with experience evaluate your work and offer tips on how to improve and give you "homework" for further practice.

To find a photography mentor, consider sending a polite e-mail to local photographers whose work you appreciate. Let them know that you are new to wedding photography and that you love the way that they run their businesses and would like to ask them some questions, if possible. Some wedding photographers actually offer mentoring sessions (for a fee), and you can find that information on their websites or blogs.

✔ **Reading photography blogs:** If you aren't able to find a one-on-one mentor and attending workshops isn't in the budget, photography blogs are another valuable resource that's right at your fingertips. Many established wedding photographers share their wealth of knowledge through their blogs. Check out as many blogs as you can find, and when you discover a couple photographers whose style and skill you admire, read through their photography tips and evaluate their photos. Look for how they posed the couples, what kind of lighting they chose, how they arranged details shots, and other details. Then go out and practice what you learn to further develop your portfolio.

Gaining "second shoot" experience

The best (but most difficult) way to show potential clients that you can take great wedding photos is to take great wedding photos! Make yourself available to local wedding photographers to come along and second shoot (that is, be a backup photographer for) a wedding. Second shooting (or even third shooting) can be a fantastic way for you to gain some experience and ease yourself into the world of wedding photography. Not only can you add some great pictures to your portfolio, but you also can learn a great deal by getting knee-deep into a wedding day and watching a pro work.

To make yourself available to second shoot weddings, the first thing you can do is send an e-mail to a photographer you'd like to work with, letting him know that you're interested in second shooting if the need ever arises. Make sure to include a link to your portfolio, even if it's just some sample portraits, so he knows that you can handle a camera. Another way to become familiar with established photographers is to follow them on Twitter or Facebook. Some photographers actually post on their social media pages when they are looking to hire a second shooter. Responding to their posts can result in a second shooting gig.

Make sure you talk with the professional photographer before the wedding about using the pictures you take at the wedding in your own portfolio and get a written consent. Some photographers prefer that their second shooters do not put the photos online. So rather than get yourself into a messy situation afterward, talk through all the details before the wedding. If you encounter a situation where a photographer does ask that you don't put the photos online, I highly recommend that you second shoot the wedding anyway. The experience is well worth not being able to use the photos.

Choosing Photos and Placing Your Portfolio Online

When you assemble the start of your portfolio, you want to get it online so you can begin to establish your credibility as a photographer. In the following sections, I go over a few guidelines to consider before showing off your portfolio, along with a brief overview of a few places you can display it on the Internet.

Putting your best work forward

As you sort through your photos and decide which would be best to include in your portfolio, keep in mind that your portfolio is only as strong as your weakest picture. If your portfolio remains relatively small after selecting only your best work, that's okay! You can add to it as you photograph more often. A small portfolio with only great images is much better than a large portfolio with so-so images. As you select pictures to display, consider the following factors:

- ✔ **Exposure and tone:** Is your photo bright and vibrant?
- ✔ **Composition:** Are your subjects placed within the photo in a pleasing manner? Is the photo balanced? (See Chapter 3 for pointers on composition.)
- ✔ **Facial expressions:** Do your subjects look good? Remember, making people look good is one of your most important tasks!
- ✔ **Creativity:** Do you show off your own personal creative style in the pictures? Make sure to include pictures that demonstrate your personality (see Figure 14-3 for an example).

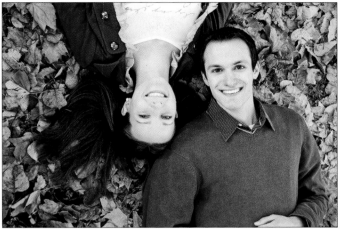

40mm, 1/100 sec., f/4.5, 250

Figure 14-3: As you put your portfolio together, make sure that the images you include are a good representation of your creativity and style.

Discovering places to put your portfolio online

When your portfolio is assembled, the next aspect to consider is how you want to show off your images. Because your images are in digital format, the best place to display them is online. Here are a couple of ideas of places online to present your portfolio:

- ✔ **Personal website:** A website lets prospective clients find you through Internet searches, and it's also a great place to refer prospective clients whom you meet in person. For more getting started with your own website, check out Chapter 16.

- ✔ **Facebook:** This free social-media platform is another great place to put your portfolio (and probably the easiest), because it lets you connect to a wide variety of people. If you need to know how to publish an album on Facebook, take a look at Chapter 12; Chapter 16 explains how to create a Facebook page for your wedding photography business.

- ✔ **Blog:** Starting a blog is another option for showcasing your portfolio. You can start showing off your work for free through websites like www.blogspot.com or www.wordpress.com. For more on setting up a blog, check out Chapter 16.

15

Crafting an Effective Business Model

In This Chapter

▶ Discovering the initial tasks required to set up a business

▶ Making it legal

▶ Figuring out your packages and pricing

So you've second shot a couple weddings (that is, worked as a backup photographer), and maybe even photographed a few on your own, and you've decided that going into wedding photography is definitely the career path you want to take. After you have made this decision, it's time to sit down and think through the logistics of actually starting a small business. For many photographers at the beginning of their careers, the thought of quitting their full-time jobs and going into business for themselves is more than a little nerve-racking!

The good news is that you don't have to quit a full-time job to get the process started. You can do a lot to get started as a photographer while still having the security of a stable job. Then when you've gotten your business established, you can figure out when you're ready to go into wedding photography full time.

In this chapter, I cover several different aspects you need to take into consideration as you start your wedding photography business, from writing a business plan and registering your business legally to creating photo packages and establishing pricing.

Setting Up Your Wedding Photography Business

The first step in setting up your wedding photography business is to think of the big picture. The nice thing about starting your own business is that you get to decide how you want things to run and what principles you bring into your workplace. Before diving into all the details, consider where you want your business to go, what success looks like to you, and how you want to get there. In this section I cover some basic guidelines to think through to get you started, including a business plan and a budget.

Writing a business plan

One of the first things you should do when starting your wedding photography business is to create a business plan. Just like you need a plan to get to your destination when you get in the car for a road trip, so should every entrepreneur have an idea of where she wants to go and a strategy of how to get there. A business plan maps out your goals and covers the logistics of how to accomplish them. You can edit it as your business grows and changes and refer to it when you feel stuck as a business owner.

Keep in mind that your business plan will — and should — look different from those of other wedding photographers. Focus on figuring out what your own vision is and what success looks like to you. Whether that means you want to shoot 10 weddings a year or 30 weddings a year, determine where you want to be and don't worry about other photographers' goals. Focus on your own and go for it!

A standard business plan usually covers the following points:

- ✔ **Executive summary:** The executive summary outlines the most important points of your entire business plan. Usually you write this section at the end, after you've addressed the details.

- ✔ **Company description:** The company description is a rundown of what your wedding photography business does, who carries out specific tasks, and what makes your business stand out from others in the market.

- ✔ **Services offered:** This section focuses on what service your business provides. Emphasize how your service is beneficial to your clients and what kind of problem you solve for them.

- **Market analysis:** The market analysis takes an in-depth look at wedding photography in your area and covers aspects such as competitor pricing, how large the current industry is, the growth rate of wedding photography in the area, and what needs and problems potential clients have that you can solve.

- **Implementation strategy:** This section covers how you plan on implementing your business plan, with specific goals outlined along with set dates for meeting those goals.

- **Marketing strategy:** Here you discuss how you plan to market your new business and get your name out there. (Check out Chapter 16 for tips.)

- **Financial plan:** This section is where you cover the accounting side of the business, such as cash flow, profit and loss, projections, and so on. (See the next section for more about financials.)

- **Funding requests:** If you'll be taking out a business loan, this section is where you outline how much you want to take out, how you plan on using those funds, and how you plan to repay the loan.

As you write out your business plan, you can use a standard template that gives you a basic outline to follow. Multiple types of templates are available on the Internet. Though you won't necessarily need to fill out every area for a wedding photography business, the templates give you a good place to start. You can find some helpful articles and templates from the Small Business Administration at www.sba.gov or from Bplans at www.bplans.com. You can also check out *Business Plans Kit For Dummies* by Steven D. Peterson, Peter E. Jaret, and Barbara Findlay Schenck (Wiley).

Choosing a location for your business

Another decision you need to make as you start your business is where you want to set up your office. The two most popular options are setting up an office at home and renting out a studio space. Both have pros and cons:

- **Home office:** The best thing about setting up an office in your own home is that you don't have to pay rent for an office space. This is a great option for wedding photographers who are just starting out and have a tight budget. I also love working from a home office because I don't have to go anywhere to get my work done. Editing wedding pictures in my pajamas? Yes please!

 The downside to a home office is that you may not feel comfortable meeting with clients at your own house. If you find yourself in a similar situation, consider conducting your consultations online via Skype or Face Time, or meet with them at your local coffee shop or café.

✔ **Rented space:** Renting a studio is another popular option for wedding photographers. The great thing about having your own studio is it provides a great place to meet with prospective and existing clients. It also gives you somewhere quiet to work, if working from home would be too distracting.

However, keep in mind that renting a studio is an extra monthly cost and could potentially be expensive.

Creating your wedding packages and establishing your pricing

Unlike some of the aspects of establishing a business, creating your wedding packages and figuring out what to charge is more open to your preference and situation. The methods different business owners use are as different as the photographers themselves. However, I can recommend a few general guidelines for creating packages and setting your prices, and I outline them in the following sections.

Deciding what kinds of packages to offer

Before you can establish your price structure, you must decide what exactly you plan on offering your clients, because what you include in your wedding packages is a factor when determining your prices. Here are a variety of common options you can pick and choose from:

✔ An engagement session

✔ A set amount of hours or full-day coverage

✔ A DVD of edited images with a photo release

✔ A DVD of proofs with the option to order prints for an additional cost

✔ A wedding album for the couple

✔ A wedding album for each set of parents

✔ A specific number of prints in certain print sizes

✔ An online gallery

✔ A second photographer to come along with you to help capture the day

As you customize your packages, adjust the prices for each based on what the package includes. You can offer a large menu of services that clients can pick and choose from, or you may want to offer a set number of packages. It's a matter of personal preference, so do what seems best for you and your business.

Setting your prices

After you decide which products and services you want to offer your clients, the next step is figuring out your price structure. Take these factors into account as you set your prices for your wedding photography services:

- ✔ **Market:** Investigate the prices of other photographers in your area. Most likely you'll want to set your prices competitively with theirs.

- ✔ **Clients:** Some photographers prefer to shoot high-end weddings only, while others don't mind shooting basic weddings. Know what kind of clientele you want to attract and use that to help determine your prices.

- ✔ **Business expenses:** Make sure to calculate your annual business expenses (such as equipment costs, insurance, monthly membership fees, advertising, taxes, and so on) along with your expenses included per wedding (equipment rentals, album and DVD costs, included prints, shipping, sales tax, parking, and other items you may need to purchase to complete the couple's wedding package).

 Let's say that you estimate that your annual business expenses total up to around $20,000 and your costs per wedding are about $1,000. If you shoot 30 weddings a year, your business expenses will be about $50,000 ($30 \times 1,000 = 30,000 + 20,000 = 50,000$).

- ✔ **Annual living costs:** Estimate your personal living expenses per year (rent or mortgage, insurance, car payments, gas, groceries, taxes, and so on).

After you estimate your annual business and living expenses, add the two together and divide that number by how many weddings you want to shoot per year. For example, if your annual business and living expenses add up to about $80,000 per year and you want to shoot 30 weddings a year, you need to make at least $2,700 per wedding ($80,000 \div 30 = 2,666.66$). Then take that number and use it as a baseline when structuring your wedding packages.

Of course, to be competitive in the market, you may need to play with the numbers and increase how many weddings you'll do or reduce how much money you need to make.

Many wedding photographers at the start of their careers feel uncomfortable with charging clients a full amount when they have very little experience shooting weddings on their own. If you find yourself in this position, there are a couple ways to ease yourself into your target price structure:

- ✔ Start by offering very basic packages that won't cost you anything and set your prices well below the market rate. As you shoot more weddings and become more confident in your abilities, slowly raise your prices to reflect those changes.

- ✔ Set your prices where you want to be eventually and offer big "new business" discounts on your services. As you gain experience, you can decrease the discounts until you are even with your pricing goal.

Creating a budget

Though financials are covered in the writing of a business plan (see the preceding section), creating a budget is so very important to a small-business owner that I believe it warrants special attention. Though passion for what you do is certainly an important part of owning your own business, whether or not a business succeeds boils down to one thing: money. Therefore, having a plan is crucial when it comes to how you will spend your funds, where you will spend them, and when.

If you're in the process of making wedding photography a full-time career, your budget will look a little different from those of photographers who plan to keep their nine-to-five jobs and do wedding photography on the side. However, the principles of budgeting are the same no matter the situation, so I encourage you to use a spreadsheet program such as Excel to make a spreadsheet with the following categories as columns:

- ✔ **Income source:** Where your income is coming from

- ✔ **Income estimate:** How much money you anticipate on making that month

- ✔ **Actual income:** How much money you actually make that month

- ✔ **Income variance:** The difference between your income estimate and your actual income

- ✔ **Expense category:** Where your money is going that month

- ✔ **Expense estimate:** How much money you anticipate spending that month, including expenses that are the same every month (such as rent, loan payments, and fixed utility bills) and variable expenses (which are costs that change from month to month, like supplies or usage-based utility bills)

- ✔ **Actual expenses:** How much you actually spend during the month

- ✔ **Expense variance:** The difference between your expense estimate and your actual expenses

- ✔ **Profit:** Your *net profit,* which is your actual income minus your actual expenses (how much you actually have left in the bank)

Figure 15-1 shows an example of this type of budget spreadsheet. Of course, you don't have to use a spreadsheet exactly like this one, but it gives you a general idea.

	A	B	C	D	E	F	G	H	I
1	Income Source	Income Estimate	Actual Income	Variance	Expense Category	Expense Estimate	Actual Expenses	Variance	Profit
2	Anderson Wedding	$ 2,500.00	$ 2,500.00	$ -	Insurance	$ 65.00	$ 65.12	$ 0.12	$ 2,434.88
3	Murphy Wedding	$ 3,000.00	$ 3,000.00	$ -	SmugMug	$ 35.00	$ 35.00	$ -	$ 2,965.00
4	Taylor Wedding	$ 2,500.00	$ 2,500.00	$ -	Web Hosting	$ 5.00	$ 5.00	$ -	$ 2,495.00
5	Watson Wedding	$ 3,000.00	$ 3,000.00	$ -	Memory cards	$ 150.00	$ 162.00	$ 12.00	$ 2,838.00
6	Print Sales	$ 500.00	$ 310.00	$ (190.00)	Parking	$ 45.00	$ 32.00	$ (13.00)	$ 278.00
7	Dawson Engagement	$ 300.00	$ 300.00	$ -	Lens rentals	$ 320.00	$ 336.00	$ 16.00	$ (36.00)
8	Smith Engagement	$ 300.00	$ 300.00	$ -	Albums	$ 2,000.00	$ 2,046.00	$ 46.00	$ (1,746.00)
9	Sawyers Engagement	$ 300.00	$ -	$ (300.00)			$ -	$ -	
10				$ -			$ -	$ -	
11				$ -			$ -	$ -	
12				$ -			$ -	$ -	
13				$ -			$ -	$ -	
14				$ -			$ -	$ -	
15				$ -			$ -	$ -	
16				$ -			$ -	$ -	
17				$ -			$ -	$ -	
18				$ -			$ -	$ -	
19				$ -			$ -	$ -	
20				$ -			$ -	$ -	
21	TOTAL	$ 12,400.00	$ 11,910.00	$ (490.00)	TOTAL	$ 2,620.00	$ 2,681.12	$ 61.12	$ 9,228.88

Figure 15-1: Using an Excel spreadsheet to keep track of your budget from month to month can be very helpful for a small-business owner.

In order to create a budget, you need to have an idea of how much money is coming in, and how much you need to spend. To do so, take a look at your calendar at the beginning of each month and total up how much you antici-pate making from each booking based on your established pricing (see the section "Creating your wedding packages and establishing your pricing"). Then write out what items you'll need to spend money on for each wedding (such as memory cards and equipment rentals), find out how much those items will cost, and add them in to your estimated expenses.

Make sure to stay on top of your budget each month to see if the numbers add up. If you have a little extra money each month, awesome! If not, you may need to trim some of your expenses to make your budget.

I recommend making a new budget tab, or separate spreadsheet, for each month. If there are any incomplete items from one month to the next, mean-ing any work or products you sold but haven't yet received the money for, or any outstanding expenses which you still need to pay for, you'll need to carry those items over to the next month. This ensures that you don't forget to cal-culate those numbers in the following month's budget. One way to make this

manageable is to create a template spreadsheet by simply saving a separate spreadsheet as "Template" and deleting everything in the spreadsheet except the columns with formulas, the titles, and the "Totals" row. Save this file wherever you keep your budget files so you don't lose it. Then, each month, you can open the template file and "Save As" with the title of whatever month for which you need a budget.

When you are in the process of starting a business from scratch, you may not have a lot of cash flow at the beginning. Though you may feel like you need to acquire all your gear and equipment up front, don't spend too much on initial startup costs without having the business and cash flow to warrant the purchases. Instead, consider finding inexpensive or even free ways of doing things at first. You can buy Adobe Lightroom for $150 instead of Photoshop for $700 and rent your camera equipment instead of making all the purchases right away. You can also create a free website or blog rather than spending money on one, and use free marketing strategies like connecting with people on Facebook rather than paying for advertising. Then, when you have business coming in and have cash on hand, you can slowly accumulate the equipment you need and consider spending more to promote yourself. Spending only what you have on hand is a great way for your business to stay in the green.

Determining what to outsource when your business is established

Another aspect of your business you should think about is what tasks you want to do yourself and what jobs you can hire out. As I mention in the previous section, you may not have the budget when you start out to consider things like hiring out work, but as your business grows, it may become an option to consider. Following are common tasks for wedding photographers to outsource:

- Photo editing (see Chapter 11)
- Wedding album design (see Chapter 13)
- Bookkeeping
- Taxes

As you figure out which tasks you may want to outsource, I encourage you to think through the following questions:

- What are your strengths and weaknesses?
- What parts of the business do you love, and what parts of it do you dread?
- Are any tasks that you're handling yourself keeping the business from growing?

Working through those questions can help you decide which tasks would be best hired out. For example, you may determine that although you don't mind designing wedding albums, you're just not very good at laying out those pages, and the process is so time-consuming for you that it's taking away from your ability to network and grow your business. You would be better off outsourcing this task, if your budget allows.

To determine if your budget allows outsourcing, take a look at your estimated income and your estimated expenses, and subtract your expenses from your income to see if you have enough money to begin hiring out projects.

Looking at Legal Matters

After you write a business plan and handle other basic tasks in setting up your wedding photography business (see the preceding section), the next step involves registering your business with the government, acquiring insurance, and protecting yourself with a contract at the beginning of every working relationship with your clients. Though this portion of establishing your business requires a lot of paperwork and may not be that exciting, it is well worth it in the end. And because you can't avoid it even if you want to, in this section I help you get through it with relative ease.

Establishing your business legally

Though small businesses don't have as many rules and regulations to follow as large corporations, you must still take steps to make your business legitimate, such as determining a tax structure, registering your name, and acquiring licenses. In the following sections, I go over the various tasks to complete in order to have a legally established business.

Deciding on a legal structure

The very first thing you need to do is to decide what kind of business entity, or structure, to be. The way you structure your business determines how you file your taxes at the end of every year. Following are the five types of business entities:

- **Sole proprietorship:** Run by an individual, sole proprietorships offer no legal distinction between the business and the business owner. Simply put, the sole proprietor is responsible for all debts and taxes of the business.

- **Partnership:** In a partnership, two or more people enter into business together and agree to share the profits and losses of the business. The partners pay the business taxes.

- **Corporation:** A corporation has many shareholders who can exchange goods for stock in the company. Corporations are taxed twice; the business and the shareholders both pay taxes.

- **S corporation:** A corporation that passes profits, losses, deductions, and credits (and all tax responsibility) through to its shareholders is called an S corporation.

- **Limited liability company (LLC):** An LLC provides liability protection to the owners, and the IRS allows LLCs to be taxed like either a partnership or corporation. State laws affect LLC structure, so check with your own state's regulations if you want to form an LLC.

After you decide which legal structure you want for your photography business, check with your state's business department for how to file any necessary forms.

If you'd like to read up on the different legal structures in more detail, the IRS website (www.irs.gov) and the U.S. Small Business Administration website (www.sba.com) have a wealth of information on the subject.

Registering your business with the IRS

The next step in the process is to register your business with the IRS for tax purposes. If you are a sole proprietor, you can use your own Social Security number when reporting your taxes. However, if you filed as any other business entity, or you don't want to use your own SSN, you can apply for an *employer identification number* (EIN), which is also known as a *federal tax ID number*. You can apply for your EIN for free on the IRS website, www.irs.gov.

Registering your business name

If you plan on doing business under a name that is different from your own, you need to register it properly as a *DBA,* which stands for "doing business as" (and is also known as an *assumed name, fictitious name,* or *trade name*). For example, if I had wanted to go into business as just *Amber Murphy,* I would not have needed to register a DBA. However, because *Amber Murphy Photography* is considered an assumed name, I needed to register it with my state.

Some states do not require businesses to register a DBA, so make sure you check your state's laws on the issue. To register your DBA, contact your county clerk's office or state government office.

Before you finalize a business name for yourself, you'll want to make sure that the name you've chosen isn't already taken, both online and offline. To see if someone is using the business name you've chosen online, do a quick web search by typing in the exact business name into your search engine browser. Then check to see if the domain name you want is available by going to a domain name registrar's website (like www.GoDaddy.com) and typing in the desired name. If you're clear to take the name online, do a final check with the search tool on the website of the U.S. Patent and Trademark Office (www.uspto.gov) to determine whether your name has already been trademarked or patented.

Acquiring a business license or permit

In order to run your business legally, many local governments require business owners to obtain a business license or permit. Whether or not you need a business license varies from city to city, so check with your city (or county) laws to establish whether you need one. To apply for a license, head over to

your city clerk's office to fill out an application. You may also have to pay an application fee and provide other requested information.

Creating a business bank account

To keep your personal and business funds separate, I recommend opening a separate bank account for your business only. After you have your EIN and DBA, you can head over to the bank of your choice and open an account. Keeping your personal and business finances separate helps you stay organized and can also make tax time a little easier.

Researching state tax laws

State tax laws vary from state to state, but generally a business owner is required to submit sales tax on any tangible goods given to a client. Therefore your photography services (like shooting a wedding or engagement session) are not taxed, but the DVD of images or the wedding album you hand over to clients is taxed. These laws vary between states, so make sure you find out your own state's laws and follow them accordingly.

Acquiring business insurance

Just as most people wouldn't think twice about getting health insurance or car insurance, so should small-business owners get a business insurance plan to protect themselves and their assets. A wedding photographer should have a couple of types of coverage, which I outline in the following sections.

 Like with any kind of insurance, there are several companies out there that offer insurance for small businesses. A popular one for photographers is Package Choice, by Hill & Usher. Their website, www.packagechoice.com, give a comprehensive overview of the policies they offer, along with the option to get a quote online. You can also search for local insurance companies online by typing "[Your city] business insurance" into your search engine browser. Consider collecting quotes from a few different companies to make sure you're getting the best price and services.

Liability insurance

The first type of coverage you want to consider is liability insurance, which covers the losses of someone other than yourself. As a wedding photographer, you want two types of liability insurance in your policy:

✓ **Errors and omissions:** This type of coverage insures the policyholder in case of an error or negligence on his or her part. This coverage can include things like making scheduling errors, losing the photos, or damaging the memory cards after finishing a job.

✔ **General liability:** A general liability policy is often required by certain venues (like golf courses, reception halls, churches, or restaurants) for vendors to have before doing a job on the premises. This type of insurance covers you in case you damage property of the client or venue, and can cover you in cases of injury, like if someone trips and falls over your light-stand cord.

Property insurance

The second type of coverage you should consider is property insurance, which covers your own losses. Again, I recommend two types of property insurance for a wedding photographer:

✔ **Camera insurance:** I shudder to think of what it would be like to lose all my camera equipment in one fell swoop! Replacing all that equipment from my own pocketbook would be absolutely painful. Thankfully, you can purchase a camera insurance policy that covers your camera, lenses, flash equipment, and other camera-related gear.

✔ **General property insurance:** Another type of property insurance to consider deals with general property, like your computer and software, important records, and rented equipment.

Writing and managing your wedding contracts

Another legal matter to take into consideration as you start your wedding photography business is creating a wedding photography contract. A contract is a written agreement to clearly present what you expect from your clients and what they can expect from you, ensuring that both parties are on the same page. The contract should cover what tasks you will accomplish on the day of the wedding and afterward as you prepare the photographs for the client. Where liability insurance is meant to protect you from things that are outside of your control (see the preceding section), the contract helps to legally protect you from potential dissatisfaction from a client that may arise out of misunderstood expectations.

As you write out your contract, make sure to cover the following points in detail:

✔ **General information:** Write out the full names of the bride and groom along with their contact information (phone number, e-mail address, and street address). Also include your name and your business name with your contact information.

✔ **A description of services provided:** Outline in detail exactly what service you will be performing and for how many hours.

✔ **Wedding-day information:** Include the wedding date, time, and location of the ceremony and reception.

✔ **Limits on photographer liability:** Make sure you spell out how the situation is to be handled if you're unable to carry out the agreement due to illness, injury, or other circumstances beyond your control. The most common policy is to return the wedding fees. Make sure to detail that after the fees are repaid, you are no longer liable.

✔ **Exclusive photographer:** Put in writing that you expect to be the sole paid photographer of the event. Having two photographers trying to capture the same photos can interrupt the flow of your work and may prevent you from getting the pictures you need to fulfill your obligations to the clients.

✔ **Agreement:** Indicate that by signing the contract, both parties (you and the couple) indicate their understanding of and agreement to everything laid out in the contract.

✔ **Photography package information:** Each wedding contract should cover what the couple is receiving with the package they chose, such as a DVD of images, a wedding album, number of prints, and online galleries. (I talk about photography packages earlier in this chapter.)

✔ **Financial agreement:** Outline in detail the charge for your services and make sure to include whether you require a deposit and what the payment schedule is to be. Also include any stipulations for cancellation or late fees. You may also want to include how you accept payment (cash, check, credit card) along with a clause that allows you to adjust the final amount due to unforeseen expenses, such as parking fees at the venue.

✔ **Photo rights:** Lay out specifically who owns the photo rights and what kinds of usage you allow for your clients. For example, do you give your clients the digital negatives, or do you just let them have the proofs and keep the printing rights yourself?

✔ **Copyright:** As soon as you take a picture, it is legally considered your property. Make sure to explain that even if you give the client permission to use and/or print the pictures for personal use, the photo rights still belong exclusively to you and that any distribution or reproduction not authorized by you is unlawful.

✔ **Model release:** Most photographers like to use images from each wedding in their portfolio or for advertising purposes, which may include posting pictures on a website, blog, Facebook, or any marketing materials (see Chapter 16 for more about these items). To do so, you must have permission to use the photos in that manner, so make sure to include a model release as part of your contract.

Because only the couple getting married signs the contract, you may also want to make a separate model release form for the other parties involved in the wedding, like bridesmaids, groomsmen, and the bride's and groom's families. Getting the signatures of all these people ensures that you have a release for everyone in your photos and can use them freely in your portfolio.

✔ **Food provided:** Indicate in the contract that a meal will be provided for you during the event.

✔ **Signatures:** The contract must be signed and dated by both parties in order to be legal. If your contract is longer than one page, have a spot at the bottom of each page for the couple to sign.

If you're not quite sure where to start when drawing up a contract, you can look at online resources that offer templates and guidelines, such as the SLR Lounge (www.slrlounge.com/photography-contract-template), Digital Photography School (http://digital-photography-school.com/sample-wedding-photography-agreement), or Pro Photo Show (www.prophotoshow.net/2008/12/09/free-wedding-portrait-contract-samples). Or you can type "sample wedding photography contract" or "wedding photography contract template" into a search engine browser to look over all the options.

Though it's not an absolute necessity, having a lawyer review your contract before you start to use it is a good idea.

Upon receiving the signed contract from the couple, make sure you file it in a place that is secure and easily accessible (like a filing cabinet in your office as well as a digital copy backed up on your computer). Hopefully you'll never have to pull it out to solve any disputes, but you should know where it is just in case that kind of situation arises.

16

Getting Your Name Out There

In This Chapter

▶ Building a brand

▶ Using social media and a personal website

▶ Getting business through referrals

▶ Connecting with vendors in your field

▶ Publishing your work

*S*tarting your own business can be incredibly rewarding, and for many photographers, stepping out on their own is a dream come true. But after they acquire their gear and establish their businesses legally, often the next question wedding photographers ask is, "How do I get my business noticed?"

Getting your name out there is probably the toughest part about getting a business started. Thankfully, with the right mixture of creativity, know-how, and perseverance, you can spread the word about your wedding photography services and begin to bring in new clients. In this chapter I tell you several tried-and-true methods for bringing attention to your business so you can pick and choose what works best for you.

Defining the Look and Feel of Your Company

Part of getting your name out there and being heard as a small business is finding an identity that sets you apart from other similar businesses. Start figuring out how you want your business to come across, or how you want to be known and recognized. For example, do you want to be known as a high-end wedding photographer? Or do you want to be known as the wedding photographer with the best prices in town? Are you known for your vintage processing? Or are you known for your classic colors and stunning black-and-white images?

After you narrow down what characteristics you want to represent your brand, you need to choose an appropriate name for the business. Though most photographers use their own name, feel free to be creative and choose something unique. However, keep in mind that your business name should be simple and easy to spell. It should also tell people what it is that you do (such as incorporating the word *photography* into the name).

Defining the look and feel of your wedding photography company also comes into play in your online presence and in your marketing materials. As you think about the look you want for your company's logo, website, and business cards, consider how they can reflect your personal characteristics and those of your business. If you're unsure of where to start, I highly recommend working with a graphic designer who can help you translate how you want to be known as a company into visuals (like a logo and color scheme) that prospective clients can identify with your brand.

After your establish your company's brand, use it consistently. Use your logo and color scheme on your website, blog, business cards, social media pages, and other marketing materials so that your company becomes easily recognizable.

Using Social Media Outlets

Because most of your marketing will take place on the Internet, one of the best ways to bring attention to your photography business is through the use of social media. You're in the business of people, after all, and what better way to connect with others online than through outlets like Facebook, Twitter, Pinterest, and blogging? Not only does social media allow you to reach a target audience, but most of the time it also doesn't cost you anything but a little invested time!

Creating a business page on Facebook

In recent years, Facebook has become such a comprehensive way of maintaining and building online relationships that I believe it's crucial for every photographer to have his or her own business page. A business page is different from a personal profile page in that instead of having a friend list, you acquire followers when people "like" your page. Your followers can see your page's status updates, but you don't see your fans' updates in your newsfeed.

Another difference between a personal and business page is that you are able to promote your business page on other users' Facebook profile pages through the use of *pay-per-click* advertising. You can establish the maximum amount you want to spend per day on advertising, and you only pay when people click on your ad for more information.

Because Facebook allows you to tag your clients in photos and share your posts on other people's pages, utilizing Facebook can garner your business page (and therefore your photography services) quite a bit of attention. To set up your own business page, follow these steps:

1. **Head over to www.facebook.com and click on Create a Page at the bottom of the screen.**

2. **Select a business category.**

 Your choices of business category are

 - Local Business or Place
 - Company, Organization, or Institution
 - Brand or Product
 - Artist, Band, or Public Figure
 - Entertainment
 - Cause or Community

 I recommend choosing Local Business or Place, Company, Organization, or Institution, or Artist, Band, or Public Figure.

3. **Select the appropriate category from the dropdown list that appears and fill in the other required information.**

 If you chose Local Business or Place, a few appropriate categories could be *Local Business* or *Professional Services*. If you chose Company, Organization, or Institution, an appropriate category would be *Company*. If you went with Artist, Band, or Public Figure, choose *Artist* from the dropdown list and type in your business name.

4. **Follow the prompts to add a photo, fill out the About section, create a unique Facebook domain name, and enable advertisements.**

 In your About section, consider adding some information about your business, such as what kind of photography you specialize in, how people can contact you, and your website information.

 If you don't have a personal account already, before you get to this step you'll be required to create one. Simply fill in the information and click Create.

5. **When you've filled out your business page information, you'll be taken to the Admin page, where you can invite friends, add photos, and begin posting pictures and status updates.**

Keep in mind that to bring attention to your photography business, you'll have to be diligent about maintaining your Facebook page. Post often, whether it's status updates, photos, or links to great photography articles that you want to share. Regular posting helps you to stay engaged with your fans and keeps your business in the forefront of their minds.

Tweeting up a storm

Businesses and individuals alike have discovered how to "tweet" what's happening in their lives in 140 characters or less. Twitter is another useful outlet for getting your name out there in a few different ways:

✔ Submitting posts about sessions or weddings you're shooting can keep your name fresh in prospective clients' minds when it comes time for them to book a photographer for their own.

✔ Posting personal tweets can help others feel like they are getting to know you, the person behind the camera. People are more likely to hire photographers they feel comfortable with or feel like they can identify with.

✔ You can post direct links to your new photos on your blog or website.

✔ You can build relationships with people by commenting on or re-tweeting their updates.

To sign up for your own Twitter account, head to www.twitter.com and enter your name, e-mail address, and password into the "New To Twitter?" box. Then add a photo and set up your profile information with some specifics about you and your photography business (location, photography business name, website info, and some personal tidbits about yourself), and tweet away!

Pinning your work on Pinterest

Pinterest is like a virtual corkboard where users can "pin" a photo to an inspiration board and the photo then acts as a link back to the original site where the photo is hosted. Other users can then "repin" a photo to their own boards. Thousands of brides are now using Pinterest to organize their inspiration for their wedding plans, from dresses and reception décor to bouquets and photography poses.

Because Pinterest is photo based, it can be a dream come true for a wedding photographer. Pinning your own work to Pinterest from your website or blog can greatly increase the amount of traffic that comes your way. Increased traffic means more exposure for you and your business, which may result in a higher booking rate.

To create your own Pinterest account, go to www.pinterest.com and click on the red Join Pinterest button at the top of your screen. After you set up your account, you can create a board with your business name on it and start pinning your own work from your blog or website for other Pinterest-ers to see. (I talk about blogs and websites later in this chapter.)

Blogging your weddings

Blogging can be another fantastic tool for the wedding photographer. Not only are blogs often more easily found than websites in search engines because of *search engine optimization,* or SEO, which I talk more about later in this chapter, but they also allow you to personalize your business. You can post your current work, tidbits about your own life, or even business or photo tips for other budding photographers.

You can choose from a couple of different free blogging platforms out there, such as Wordpress (www.wordpress.com) and Blogger (www.blogger.com). Some blogging platforms offer a little bit more customization along with a fee, such as ProPhoto Blogs (www.prophotoblogs.com) and Typepad (www.typepad.com).

If you decide to start a blog, here are a few tips for getting your blog seen:

✔ Write a little something about each session you post before you get to all the photos. This detail makes each post more personal, and even better, including *keywords* (words that people use to search for something specific) such as the name of the venue or reception hall increases the likelihood of your blog showing up in search-engine results (that's SEO for ya).

✔ Name your photos appropriately before uploading them in the post. For example, instead of just naming your photo "Smith Wedding-1," consider naming your photos something like "Smith Wedding-Boise Idaho Wedding Photographer-Hyatt Hotel Wedding-1." Again, you are using *keywords* to boost your SEO so that if a bride-to-be searches for a wedding photographer in Boise, Idaho, your images have a greater chance of appearing in her search engine browser.

✔ Post the links to your new content on other social media sites, like Facebook and Twitter, which can send new readers over to your blog.

Check out *Blogging For Dummies* by Susannah Gardner and Shane Birley (Wiley) if you want more info and tips.

Building and Marketing a Website

I've said it once and I'll say it again: Establishing a solid online presence is the number one way photographers bring in business in today's digital age. Whether you meet people through social media outlets or in person, if they're interested in your services, they'll be looking for your website so they can find out more about what you do, how you do it, and how much you charge. So having a good website is a big priority for the wedding photographer.

In the following sections, I go over a few important aspects of building and marketing a website, such as purchasing a domain name and hosting account, a few tips on web design, and how to use SEO to increase traffic to your site.

Knowing where to start

If you're anything like me, the thought of building a website was a little overwhelming. I had no experience in web design, nor did I have the budget to hire someone to do it for me. For those of you who find yourself in the same boat, the following list gives a brief overview of what you need to do to start the process:

- **Deciding to hire or not to hire:** Deciding to hire a web designer or not is really the first step in the process. If you have it in the budget to do so and would prefer not to do it yourself, then go for it! To find a web designer, do an online search for companies in your area and browse their websites to find a good match for you. If, however, you decide to build a website on your own, keep reading.

- **Finding a web-building software or online program:** The next step is to figure out how you want to go about actually building your site. Some companies, like www.godaddy.com, offer the entire package (web design, domain name, and hosting) and charge between $5 to $12 a month for the web hosting. There are also several free options, such as Webs (www.webs.com), which offer free web design and hosting. Another free option if you have a Mac is iWeb, which is included with your computer.

- **Purchasing a domain name:** A *domain name* is a part of your website's address online, like the *ambermurphyphoto* part of www.ambermurphy photo.com. Purchasing a domain name usually starts at about $10 per year. Do an online search of "domain name registrar" to find a company that sells domain names. A few popular domain name registrars are www.godaddy.com and www.name.com.

- **Setting up a hosting account:** To make your website available on the World Wide Web, you need to rent space on a server. This process is called *web hosting* and usually costs about $5 a month. Again, to find a company that you want to work with, do an online search for "web hosting." You can find hosting services at www.1and1.com, www.godaddy.com, and www.bluehost.com.

Keeping your web design simple

After you have your domain name and hosting taken care of and have settled on a method to build your site, you can get down to business. As you create your online portfolio, I urge you to keep your site simple. The main goal of your site should be to show off your wedding photography skills and make it easy for prospective clients to contact you. To keep your design simple, consider the following factors:

- **Navigate easily:** Don't get too creative with your menu bar and the way your page operates. You want to make sure that your website is easy to navigate so that prospective clients can find all the information they need quickly. I recommend including the following pages on your website: Home, About, Galleries, Pricing, Contact, and a link to your blog and social media pages.

- **Use a nondistracting background:** Because you want your website to show off your images, choose a neutral background that complements your images rather than distracts from them.

- **Showcase your best work:** Try to narrow down the number of pictures you put in your galleries. Choose to display only the best, because leaving people wanting more is better than bogging them down with far too many.

- **Make contact easy:** Make sure to include some sort of contact page, preferably with a contact form that allows interested couples to e-mail you directly from the site.

Making SEO work for you

After you build a great website, you need people to see it. The last major thing to consider is how to increase traffic to your website once it is published on the web. If you type "wedding photographer" into a search engine, you'll see that certain photographers' websites come up first. That's because they have great *search engine optimization* (SEO). The end goal with SEO is to be found by prospective clients who are searching the Internet for wedding photographers.

Though entire books have been written on the subject of SEO (like *Search Engine Optimization For Dummies* by Peter Kent, published by Wiley) and I encourage you to do your own research as to how to increase it with your own site, here are a few simple ways you can get started:

272 Part IV: Building Your Portfolio and Business

- ✔ **Keywords:** Think about what words prospective clients will be using to search for a wedding photographer, and add those words to the content of your website. For example, if you're based in Seattle, then you'll want to add keywords like "Seattle Washington wedding photographer" to your site, because that phrase is likely to be used by couples searching for a wedding photographer in your area.

- ✔ **Page titles:** Don't make your page titles too generic. Instead, add a little bit more information, such as using "Contact: Amber Murphy Photography" instead of just "Contact," to increase the SEO.

- ✔ **Description meta tags:** Meta tags tell search engines what your page is about. By adding brief descriptions like "Seattle Washington wedding and portrait photographer," you have a higher chance of coming up when Internet users type those words into the search engine.

Relying on Word of Mouth

As your start your business, think about how to get people talking about you. The more people talk about your business to their friends, family, co-workers, and acquaintances, the more the news of your services spreads to prospective clients. Wedding photographers rely heavily on word of mouth to bring in new business, so here are a few things to consider to get people talking:

- ✔ **Give existing clients amazing service:** People love a great product and great customer service, so make every effort to give your clients both. Always approach your clients with kindness and a can-do attitude, even when things don't go as planned. Be quick to respond to e-mails and other forms of communication, and deliver your couple's photos and albums on time. If you pair fantastic customer service with a beautiful array of wedding photos, chances are your clients will rave about you to their friends and recommend you to other engaged couples.

- ✔ **Create a referral program:** A referral program gives past clients an incentive to recommend you to others. The incentives can be anything from a gift card to a free print from their wedding. If you decide to use a referral program, let your clients know that they'll receive a complimentary gift if they refer a new paying client. This program keeps your name fresh in your past clients' minds.

- ✔ **Bringing up your business in conversation:** Be confident about your business and don't be afraid to tell people, "I'm a wedding photographer," even if you've only shot a few weddings! Also, if someone mentions to you that she just got engaged, don't be hesitant to ask her if she's found a photographer yet and give her your card. (Of course, you can have this conversation with grooms-to-be, too!)

Collaborating with Other Wedding Vendors

A whole team of creative people is needed to pull off a wedding. Other than a photographer, most weddings also include a cake designer, wedding planner, florist, hair stylist, makeup artist, and videographer. A great way to get your business noticed is not only to reach out to new clients but also to make friendships with other vendors in your industry. In the following sections, I go over a couple of ways to work with vendors in your area and how doing so can be mutually beneficial.

Getting to know other vendors in your area

You may be wondering how reaching out to vendors, rather than just new clients, can help you to build your business. I mention the importance of referrals in the earlier section "Relying on Word of Mouth," and working with other vendors in the industry can provide another source of referrals. For example, say you build a friendship with an established wedding planner in your area. That wedding planner books a new wedding, and the couple asks her if she knows of any good photographers. Having a good relationship with the wedding planner can result in a possible referral to your photography business.

Similarly, if you book a wedding first, couples may ask you for the names of cake designers, florists, DJs, and so on, and you can tell them about the vendors you've built relationships with. It's a win-win situation for everyone!

The following list tells you possible ways to get to know other wedding vendors:

- ✔ **Reach out online:** Get to know vendors via social media outlets like Facebook and Twitter. Let them know that you like their work, and interact with them by responding to their posts and commenting on their photos.

- ✔ **Look for networking groups in your area:** Some cities have social-networking groups for specific industries. Check out the groups in your area (you can search for "[Your city] photography networking group" or "[Your city] photography club" online) and get involved if there are any available.

- ✔ **Ask for business cards at weddings:** While you are working a wedding, pay attention to the other vendors who come and go during the wedding day. If you have time, approach the vendors, let them know that you like their work, and ask for their business cards. Often vendors will ask for yours in return, and you both now have a means of contact.

✔ **Send vendors photos of their work:** After the wedding and postproduction, consider sending the other vendors a few pictures of their handiwork from the wedding. Most vendors will really appreciate this gesture because then they can use your photos for their own portfolio.

Putting together a styled shoot

A styled shoot is just what is sounds like: a mock-wedding or engagement shoot that is styled! Styled shoots put a heavy emphasis on the details, which is why working with other wedding vendors can be so beneficial. It gives you the chance to show off your skills and is great exposure for other vendors as well. You can build friendships with other creative members of the wedding industry and showcase your creativity on your own blog or website. And it can be a lot of fun!

Here are a few steps to get you started with a styled shoot:

1. **Think of a theme for the shoot and focus your styling ideas on that theme.**

 For example, if you want to do a Great Gatsby–styled engagement shoot, think of the clothing and makeup you'd want your models to wear. Brainstorm items from the 1920s that you'd want to include as part of the shoot.

2. **Contact vendors in your area. Describe to them the idea for the shoot and ask them if they'd like to be a part of the creative process.**

 If you plan to submit the shoot for publication (see the next section), let the vendor know your intentions and where you plan to submit it. The chance of publication may give vendors an incentive to be a part of the project because having a styled shoot published gives every creative member of the team a lot of exposure, which is extremely valuable and well worth their time, cost, and effort.

3. **After the shoot, share your photos with the vendors who were involved in the process.**

 Because many of the vendors are probably not photographers themselves, giving them beautiful pictures of their work for their own business promotion is a valuable way for you to say thank you for being a part of the project.

4. **Share your photos online.**

 When the styled shoot is finished, share the photos online in places like Facebook, your website, and your blog. When you share the photos on social media outlets, make sure to give the other vendors who participated credit for their work, along with a link to their websites.

Getting Published

Publishing your work is one of the greatest ways to get your name out there because it reaches a wide target audience. Brides-to-be often peruse wedding blogs and magazines for inspiration while planning their weddings. By having your work published, you bring attention to your business from all the right people. In the following sections, I go over a couple of tips for getting your work published.

Submitting your work to wedding blogs

Wedding blogs have become increasingly popular in the last couple of years and often feature real weddings and styled shoots submitted by photographers. There are a ton of blogs out there, but here are just a few of the most popular:

- ✔ **100 Layer Cake:** www.100layercake.com/blog
- ✔ **Green Wedding Shoes:** www.greenweddingshoes.com
- ✔ **Grey Likes Weddings:** www.greylikesweddings.com
- ✔ **Once Wed:** www.oncewed.com
- ✔ **Style Me Pretty:** www.stylemepretty.com
- ✔ **The Inspired Bride:** www.inspiredbride.net

If you have a wedding or styled shoot that you think would be great for a wedding blog, consider the following tips for submitting the photos:

- ✔ Submit your work to only one blog at a time. Most blogs want exclusive content (meaning it hasn't been published anywhere else, other than perhaps your own blog), so it could be very awkward for you to have to take back a submission if your work is chosen by more than one blog editor.

- ✔ Get to know the style of the blog. If you submit a fancy church wedding to a blog that posts only bohemian and rustic-chic type weddings, your submission probably won't be accepted and you'll have wasted the editor's time.

- ✔ Become familiar with the blog editor's submission requirements. Each blog has a different set of specifications for how they want a wedding or styled shoot submitted. Usually their requirements can be found under "Submit A Wedding" (or something similar) in the blog's menu bar.

- ✔ Submit the right kinds of photos. Wedding blogs are all about the fun and unique details of a wedding or styled shoot. So make sure to include plenty of those editorial-type photos, along with a few portraits.

Sending your work to wedding magazines

Another way to get your work published is to send your photos to wedding magazines. Though you've probably seen wedding magazines at the newsstand at your local market, here are a few that are available:

- **Brides:** www.brides.com
- **The Knot:** www.theknot.com
- **Martha Stewart Weddings:** www.marthastewartweddings.com
- **Weddings Magazine:** www.weddings-magazine.com

The requirements for submitting weddings photos to a magazine are similar to those of a wedding blog (see the preceding section), but here are a few differences:

- Wedding magazines want exclusive content only. If your wedding has been featured anywhere else (including your own website or blog), your submission will not be accepted.

- Most magazine editors ask for fewer than 20 images that best represent the wedding, but that number varies from magazine to magazine, so be sure to follow the submission guidelines to the letter.

- Be prepared to include a brief write-up of the wedding that highlights the special details and moments of the day.

- Keep in mind that you will only be contacted by the editorial department if they want to use your photos, so if you don't hear back from the wedding magazine, it's safe to assume they have decided to pass on your submission.

Note: If you try to get a wedding published in a magazine, keep in mind that the editors receive hundreds of submissions every month. If your weddings aren't chosen, don't feel discouraged!

Part V
The Part of Tens

The 5th Wave By Rich Tennant

"Do you suppose the camera survived the fall?"

In this part . . .

The Part of Tens is a *For Dummies* tradition. Each chapter in this part delivers little morsels of information in a ten-item list. Here I list common mistakes wedding photographers make, so you don't have to make them yourself, along with ten tips on how to hire and work with a second shooter.

17

Avoiding Ten Common Wedding Photography Mistakes

In This Chapter

▶ Going to each wedding with a plan

▶ Keeping an eye on lighting and backgrounds

▶ Directing your subjects

▶ Thinking through postproduction

*W*hen I was younger, my mom used to tell me, "It's good to learn from your own mistakes, but it's better to learn from someone else's mistakes." Now that I'm older, I see the value of that statement, and I agree that letting someone else make mistakes for you saves you time and trouble. In this chapter, I outline ten common mistakes wedding photographers make, in hopes that you'll be able to avoid the hassle that they can bring and easily transition into shooting weddings.

Arrive at the Wedding with a Plan

Photographing a wedding can be compared to taking a final exam. After months of learning and preparation, it's time to show that you have a good grasp of the material. And showing up to a wedding without a plan is like coming to the test having not studied and without your #2 pencil! Keep in mind that you have one chance and one chance only to capture the wedding for your glowing couple. Coming prepared is so very important.

For each wedding that you photograph, make sure that you have a detailed schedule of the day and a list of people for the formal portraits (for more info see Chapter 8), along with a knowledge of your location and some ideas for different poses you want to try. Not only will planning ahead make the wedding go more smoothly for you and the wedding party, but it also often helps to ease some of the "Oh my gosh I'm shooting a wedding" nerves.

Stay Out of the Way during the Ceremony

A while back I attended a wedding and was utterly dismayed at the amount of attention that the photographer was drawing during the ceremony. This photographer was laying in aisles and shooting in awkward positions fit for a contortionist. This photographer even made her way to the front, squeezed between the groomsmen, and photographed the couple from the stage. Folks, that is a big no-no. I understand that capturing the ceremony is important and that you may want to get some great creative shots. However, being a distraction during the ceremony is unacceptable. The attention of the guests should be solely on the couple as they make their vows, and your goal should be to remain as quiet and invisible as possible.

To help you get those close-up shots without climbing up on the stage, consider buying or renting a telephoto zoom lens, such as a 70–200mm. That way you can still get the desired photos without drawing too much attention. (Chapter 2 provides more guidance on different lenses you can use.)

Train the Couple on the Kiss at the End of the Ceremony

You absolutely don't want to miss a couple of must-have moments during every wedding, such as the kiss at the ceremony, and you may need the couple to help you capture those moments. You may be thinking, "I'm sure people know how to kiss; why do I need to train them?" The problem arises when the kiss is just a quick peck on the lips, which doesn't leave you much time to take photos!

Before the ceremony starts, consider mentioning to your couple that because you want a great kiss photo, you need them to "hold the kiss" for five seconds to give you enough time to take the pictures. Five seconds seems like a long time, but chances are they'll count a little fast, so it's a good starting point.

Take Advantage of Sufficient Lighting

I've seen this scenario several times: A beautiful couple is posed outdoors in the shade of a lovely tree on a bright and sunny day. But instead of using the sunlight, the photographer chooses to light the couple with a direct flash instead. Note that a direct flash is a hard source of light, which you want to avoid as much as you can (see Chapter 3 for more on hard and soft light). Always be looking for a source of diffused lighting (like sunlight bouncing off a wall or pavement, or the open sky, which acts as a giant diffuser), which is much more flattering on your subjects.

Keep in mind that good lighting is often all about positioning. If you're shooting outdoors and need your subjects to be in the shade, instead of using a flash to lighten the shadows, place your subjects at the edge of shade and turn them so that they are facing a bright area, such as the open sky or a reflective wall. This positioning helps to illuminate them evenly, resulting in a much better photo.

Be Aware of the Background

As you set up the formal portraits on any given wedding day, it's easy to become so focused on how you arrange and pose your subjects (especially the large group photos) that you forget to take a look at the background. I can't tell you how many times I've seen an otherwise great picture ruined by something in the background, such as an ugly sign (see Figure 17-1) or a tree that perfectly matched the groom's hair and made him look like he had antlers.

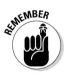

Always be aware of what is happening in every aspect of your photo.

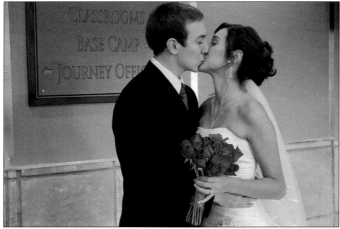

46mm, 1/80 sec., f/4.0, 500

Figure 17-1: An ugly sign can ruin an otherwise great photo.

Give Good Direction during Group Photos

The group photos can definitely be the craziest part of the wedding day for the photographer. To make it a little easier for everyone, be sure to give very clear directions of exactly what you want the group to do. Otherwise you may have the family standing awkwardly around the bride and groom, looking around while wondering whether to smile and where to put their hands. As you arrange each grouping, spell out where you want each person to stand, which direction you want him to face, what to do with his hands, and so on. Keep in mind that these people probably aren't photographers, so they are relying on you to tell them, kindly but firmly, what to do to make them look great. For more on managing the group portraits, take a look at Chapter 8.

Get Permission to Shoot at Offsite Locations

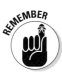

Couples often request to have some of their photos taken somewhere other than where the ceremony or reception is being held. In this situation, always make sure to find out ahead of time whether or not you need permission from the offsite location. Suppose you didn't think to check and you and the wedding party arrive at the location, only to find a photographer snapping

photos of another wedding party, or an official who tells you that you must have a reservation to take photos at that spot. Can you image the stress and panic it would cause, not only to you, but to the couple and their wedding party as well? To avoid that situation entirely, check out the location in the months leading up to the wedding and get the appropriate permissions if necessary.

Avoid the "I'll Just Fix It Later" Approach

The technology we have these days is amazing, and the types of editing that can be done in programs like Adobe Lightroom and Photoshop are pretty cool. However, sometimes photographers rely on these powerhouse programs too heavily.

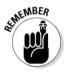

As you shoot a wedding, I urge you not to think "I'll fix it later" instead of trying to make each photo great the first time around, straight out of the camera. Not only will having great images to start off with make your post-production process move a lot faster, but the overall quality of your images will be better in the end, as well. (See Chapters 11 and 13 for more on using editing programs.)

Edit Images with a Light Hand

Right along with the fix-it-later attitude in the preceding section comes another common mistake: being too heavy-handed with editing effects. As you go through the postproduction process for every wedding, keep in mind that these photos should be timeless throughout the couples' lives. Many trends arrive on the editing scene that look pretty neat at the time, but the problem is that trends come and go. If you apply too many trendy edits to your photos instead of giving them a clean and classic look, your wedding photos may quickly become dated.

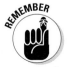

When it comes to editing, you don't want to be too obvious. Make the needed adjustments to make your photo perfect, and then leave it be.

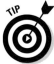

If you would like to give your couple a few photos with trendy edits, you can do so, but make sure to also give them those same shots edited with a more classic finish. That way they have the option to use both kinds of photos.

Give the Couple Their Photos in a Timely Manner

Most couples I've met are quite eager and excited to see their photos of the wedding. Though guests may snap pictures here and there with their point-and-shoot cameras or cellphones, they don't quite compare with the beautifully polished professional photos that you can deliver. For this reason, I urge you to make your turnaround time for the wedding pictures as fast as you can. The timeline is different from person to person (three weeks for some, two months for others), but don't make your couple wait too long. Keep in mind that the faster you hand over your high-quality product, the more likely your clients are to be impressed and refer you to others.

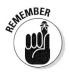

18

Ten Tips for Working with a Second Shooter

In This Chapter

▶ Choosing a second shooter and managing expectations

▶ Giving specific instructions

▶ Being gracious to your second shooter

You've probably heard the saying, "Many hands make light work," and it definitely applies to wedding photography. Although you can shoot a wedding on your own, it can often be much easier if you have someone there to help you. Bringing a second shooter along to a wedding allows you to capture a broader variety of photos than you could have done alone, and just knowing you're not tackling the entire wedding all by yourself can ease your mind. In this chapter, I go over ten things to think through as you choose a second shooter to accompany you on the job.

Choosing Someone Reliable

Because choosing a second shooter is supposed to make your job a little easier, you want to make sure that you find someone reliable. The last thing you want to get is a call from your second shooter saying, "Oh hey, I'll be about two hours late."

REMEMBER

As you look for someone to hire for the job, keep an eye out for people who are responsible, friendly, punctual, and easy to work with. If you're hiring someone you don't already know, you may even want to ask for professional or personal references, just to make sure the person you hire is a good fit for you.

To find a second shooter, consider asking other photographers you know who they've used in the past, or you can even mention that you're looking to hire on your Twitter and Facebook pages. When you receive referrals or responses, check out the prospective hires' portfolios on their websites to make sure that they have some experience with photography. Note that they don't necessarily need wedding photography experience (because that's probably what they're trying to gain through second shooting), but hiring someone who knows how to use a camera is a must.

Spelling Out the Details in a Contract

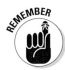

When you hire a second shooter to accompany you on the job, make sure to outline some specific details in a contract. Signing a contract in advance helps both parties manage expectations, and it gives you something in writing to refer to later if a problem arises. Consider including the following basics in the contract:

- ✔ How much you will pay the second shooter, if you plan on paying at all.

- ✔ Detail what your second shooter can (and can't) do with the images. For example, if you're okay with the second shooter putting the photos in her portfolio or on a blog but not on Facebook, make sure those specifics are covered.

- ✔ A place for both you and the second shooter to sign and date the agreement.

Knowing What Gear Your Second Shooter Has

When you hire a second shooter, try to find out before the wedding what kind of gear he owns. Certain kinds of great pictures can be taken with any type of camera, but sometimes a photographer can be limited by the kind of gear he has. For example, if your second shooter has a basic DSLR that doesn't have good low-light capabilities, you may assign him to other tasks when photographing in a dimly lit room. Also, you may also want to consider the number of pixels the second shooter's camera has. Keep in mind that pixels can determine print size (for more on pixels, see Chapter 2), so it may matter if your couple wants a print from a photo that your second shooter took.

Outlining the Proper Attire

In the weeks leading up to the wedding, communicate with your second shooter to outline the proper attire for the job (such as a nice shirt and pants along with some comfortable shoes). Note that anyone who comes along with you to a wedding is a reflection of you and your business. Even if you arrive dressed to the nines, if your second shooter shows up wearing jeans and a wrinkled shirt, you look unprofessional. So make sure to tell your helper what exactly you want her to wear.

Understanding Your Second Shooter's Skill Level

Knowing your second shooter's skill level is important so that you can give him tasks accordingly. For example, if you know that your second shooter has never photographed a wedding before and just wants some exposure to the whole process, you may just want to have him stick by your side and help with fluffing the wedding dress, holding bouquets, and taking candid shots. However, if you know that your second shooter is experienced and has worked several weddings, you can probably divvy up certain tasks, like sending him to do the portraits of the groom getting ready while you photograph the bride and bridesmaids.

Planning Ahead to Maximize Coverage

When you know your second shooter's skill level (see the preceding section), the next thing you can do is to plan ahead by thinking of a role for your second shooter to maximize coverage during the wedding day. Delegating tasks can not only help to ease some of the pressure that comes with the time constraints of the schedule but also help to broaden the variety of photos you give to your newlyweds.

For example, you may decide to assign the role of "photojournalistic photographer" to your second shooter for the formal portrait segment of the day. That way you can get portraits and also some sweet candid photos of moments that you would have missed had you been shooting the wedding alone. Another great example of maximizing coverage is during the ceremony. If you place yourself at the front of the church or venue to snap pictures of the wedding party coming toward you, consider placing your second shooter at the back or up on a balcony to take photos from another perspective.

Being Specific about What You Want Your Second Shooter to Do

If you assign a role to your second shooter and decide that you'll have her photograph something on her own, make sure to communicate the specifics. For example, if your second shooter is taking the photos of the groom and you know you want a photo of the groom's shoes and his funky socks, make sure to tell the second shooter exactly what you want. If you don't, and you realize at the end of the wedding that you never got some of the photos you wanted, it's your fault — not the second shooter's.

Obtaining Your Second Shooter's Images Before the Day Is Done

When the wedding day is over and you prepare to leave, consider taking a moment to get the photos from your second shooter before calling it a night. One easy way to do so is to bring your laptop and a card reader with you and get the second shooter's photos immediately. Taking care of it on the day of the wedding can save you both time and hassle in a couple of ways:

- You can get the postproduction process started without having to wait around for the second shooter's photos.

- Your second shooter can be completely done with the job at the end of the day, without either of you having to worry about transferring the photos later.

Recalling What It Felt Like When You First Started

As you become more comfortable doing your job, you can easily forget what it was like when you started. But remembering how you felt when you shot your first few weddings can help you relate to your second shooter and foster a great business relationship down the road.

Think back to when you photographed your first wedding. If you're anything like me, you were a ball of nerves. If your second shooter is doing her first (or even second) wedding, try to put yourself in her shoes. She may make mistakes and may not take the most amazing pictures, but I encourage you to be kind and understanding.

I also encourage you to give your second shooters a chance to grow. Be approachable when they ask you questions about how you handle situations during a wedding, or what settings you use on your camera at different times during the day. When you're in the midst of shooting, give your second shooters a chance to take a picture as well.

Giving Recognition to Your Second Shooter

One way to establish a great relationship with your second shooters is to give them some recognition if you use their photos in an online capacity, such as on your blog. This acknowledgement makes your second shooters feel appreciated and proud of the good work they have done.

At the beginning of each blog post, I do a write-up of the wedding. At the end of the write-up, I give a little shout-out to my second shooter, thanking him for all his work and providing a link to his own website or blog.

Index

• Q •

• R •

• T •

Math & Science

Algebra I For Dummies,
2nd Edition
978-0-470-55964-2

Anatomy and Physiology
For Dummies,
2nd Edition
978-0-470-92326-9

Astronomy For Dummies,
3rd Edition
978-1-118-37697-3

Biology For Dummies,
2nd Edition
978-0-470-59875-7

Chemistry For Dummies,
2nd Edition
978-1-1180-0730-3

Pre-Algebra Essentials
For Dummies
978-0-470-61838-7

Microsoft Office

Excel 2013 For Dummies
978-1-118-51012-4

Office 2013 All-in-One
For Dummies
978-1-118-51636-2

PowerPoint 2013
For Dummies
978-1-118-50253-2

Word 2013 For Dummies
978-1-118-49123-2

Music

Blues Harmonica
For Dummies
978-1-118-25269-7

Guitar For Dummies,
3rd Edition
978-1-118-11554-1

iPod & iTunes
For Dummies,
10th Edition
978-1-118-50864-0

Programming

Android Application
Development For
Dummies, 2nd Edition
978-1-118-38710-8

iOS 6 Application
Development For Dummies
978-1-118-50880-0

Java For Dummies,
5th Edition
978-0-470-37173-2

Religion & Inspiration

The Bible For Dummies
978-0-7645-5296-0

Buddhism For Dummies,
2nd Edition
978-1-118-02379-2

Catholicism For Dummies,
2nd Edition
978-1-118-07778-8

Self-Help & Relationships

Bipolar Disorder
For Dummies,
2nd Edition
978-1-118-33882-7

Meditation For Dummies,
3rd Edition
978-1-118-29144-3

Seniors

Computers For Seniors
For Dummies,
3rd Edition
978-1-118-11553-4

iPad For Seniors
For Dummies,
5th Edition
978-1-118-49708-1

Social Security
For Dummies
978-1-118-20573-0

Smartphones & Tablets

Android Phones
For Dummies
978-1-118-16952-0

Kindle Fire HD
For Dummies
978-1-118-42223-6

NOOK HD For Dummies,
Portable Edition
978-1-118-39498-4

Surface For Dummies
978-1-118-49634-3

Test Prep

ASVAB For Dummies,
3rd Edition
978-0-470-63760-9

GRE For Dummies,
7th Edition
978-0-470-88921-3

Officer Candidate Tests,
For Dummies
978-0-470-59876-4

Physician's Assistant Exam
For Dummies
978-1-118-11556-5

Series 7 Exam
For Dummies
978-0-470-09932-2

Windows 8

Windows 8 For Dummies
978-1-118-13461-0

Windows 8 For Dummies,
Book + DVD Bundle
978-1-118-27167-4

Windows 8 All-in-One
For Dummies
978-1-118-11920-4

Available in print and e-book formats.

Available wherever books are sold. For more information or to order direct: U.S. customers visit www.Dummies.com or call 1-877-762-2974.
U.K. customers visit www.Wileyeurope.com or call (0) 1243 843291. Canadian customers visit www.Wiley.ca or call 1-800-567-4797.
Connect with us online at www.facebook.com/fordummies or @fordummies